COVERING THE '60s
GEORGE LOIS
THE ESQUIRE ERA

THE MONACELLI PRESS

To the loving memory
of three great men in my life:
Haralambos (my papa)
Harry (my son)
and Harold (my pal)

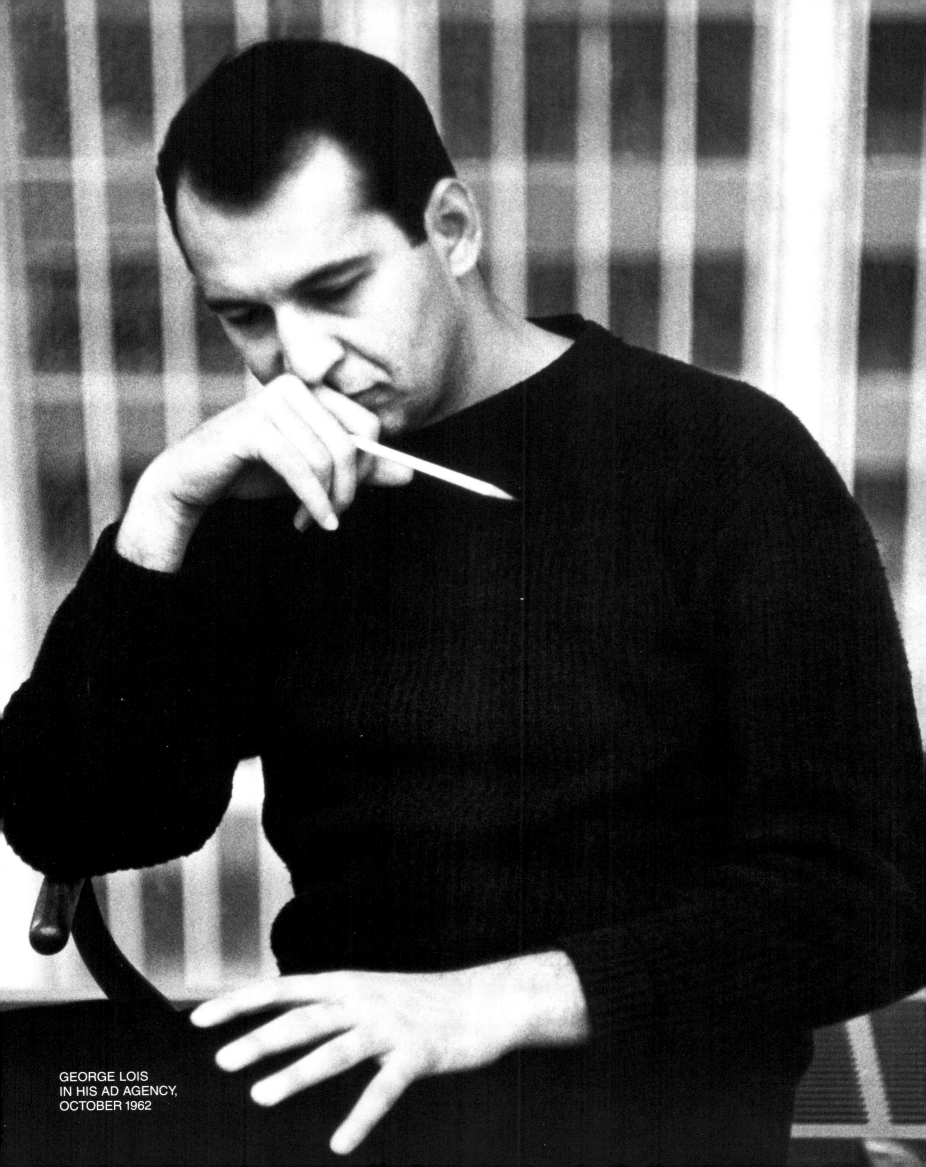

GEORGE LOIS
IN HIS AD AGENCY,
OCTOBER 1962

It never occurred before. It has never happened since.
Here is a full decade, arguably America's most roisterous and chaotic,
nailed and impaled on 70 disruptive covers of Esquire magazine.
How staggering to think that in the same time period dissected by these covers
four hundred and seventy-five thousand other covers,
on other magazines, were published by the millions and sank without a ripple.
But George Lois' Esquire covers are immutable. They encapsulate
each tumult and retrieve it at a glance. Some are scorched into our memory...
like the boyish Lt. Calley, appallingly casual amid the ghosts of the irresistible
Vietnamese toddlers he ordered machine-gunned. Others delight us anew...
like the shameless Nixon, being made-up to the eyeballs, lusting after the office
he would predictably besmirch.
The story of how these covers came to be is as riveting as the works themselves.
They are the sole creation of one man, yet somehow the product of two:
George Lois and his great pal, editor Harold Hayes. Both talented and urbane,
both acutely, even painfully, sensitive to the seismic changes unfolding around them.
Hayes was obsessed with editing and navigating his magazine
until it became a publication like no other, standing alone as the reflective
and articulate conscience of a time gone awry.
But it wasn't until Hayes importuned Lois to reinvent the magazine cover,
imprinting it as personally and irrevocably as he had revolutionized
the world of advertising, that we readers understood and hopped on board.
Intuitively, George grasped the essence of each issue, transforming it
into a jarring image that instantly informed and disturbed. Month after month,
new covers leapt from the newsstands, grabbing our eyes and
dunking our minds into yet another hairpin turn of those rollercoaster '60s.
So turn these pages and turn back the years, with these haunting,
taunting monthly works of art. And be grateful
you aren't rationed to viewing them one at a time, with an endless
four weeks between each new one, as my generation was,
awaiting with joy (and the cover price) the next graphic miracle
that George Lois would spring on us.

RON HOLLAND

First published in the United States of America in 1996 by
The Monacelli Press, Inc.,
10 East 92nd Street, New York, New York 10128.

Library of Congress Cataloging-in-Publication Data
Lois, George.
Covering the '60s: George Lois, the Esquire era.
p. cm.
ISBN 1-885254-24-5 (pbk.)
1. Lois, George.
2. Magazine covers–United States.
3. United States–Civilization–1945– –Pictorial works.
4. Esquire (New York, N.Y.)–Illustrations.
I. Title.
NC999.4.L64A4 1996
741.6'52'092–dc20
95-48003

Printed and bound in Italy

TABLE OF CONTENTS

MOM & POP CULTURE

MY LONELY WAR PROTEST

HEROES AND ANTI-HEROES

DEBUNKERS

WOMEN (WITH A VENGEANCE)

ATHLETES–THE AGONY AND THE ECSTASY

JOE'S BOYS

GOOD AND BAD NOSTALGIA

MORALITY

MARTYRS

MY RELUCTANT PINUPS

RACE

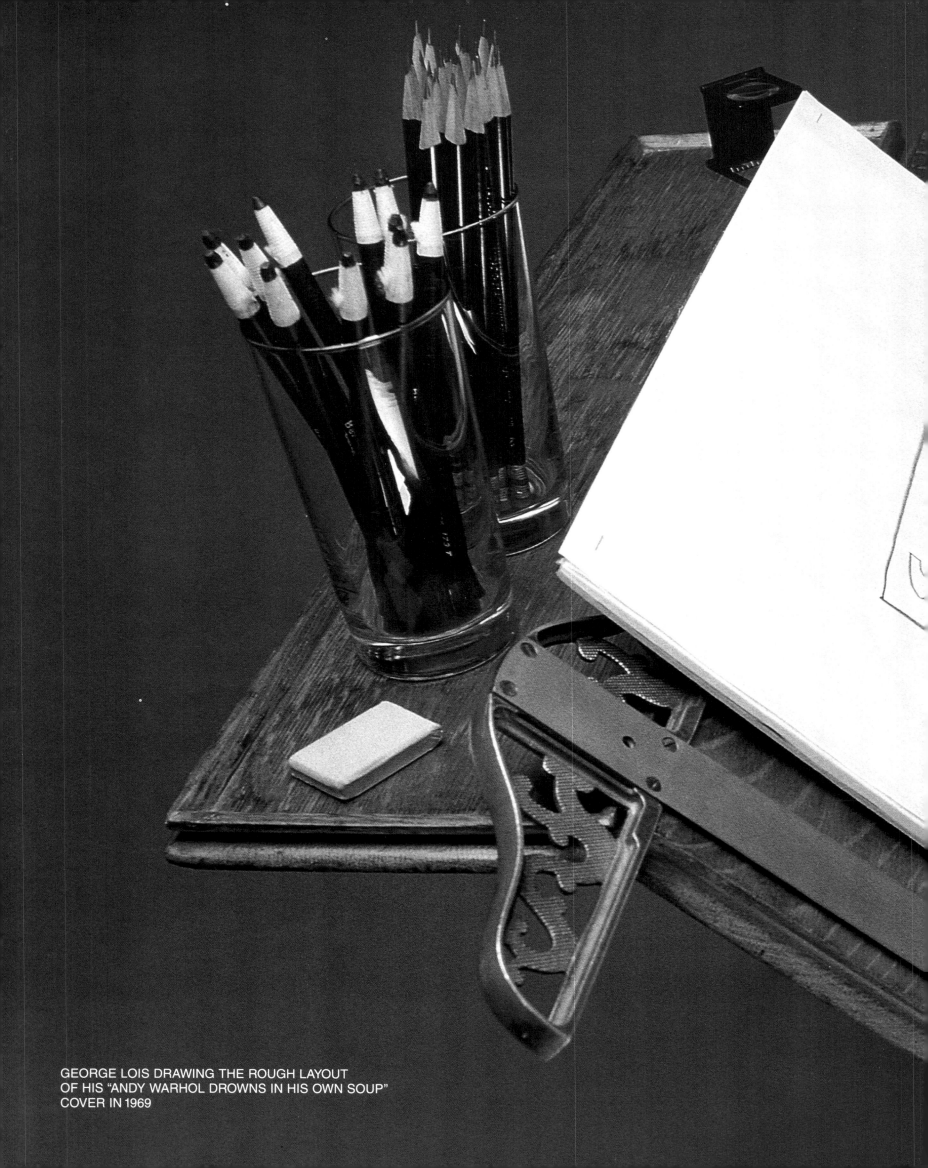

GEORGE LOIS DRAWING THE ROUGH LAYOUT
OF HIS "ANDY WARHOL DROWNS IN HIS OWN SOUP"
COVER IN 1969

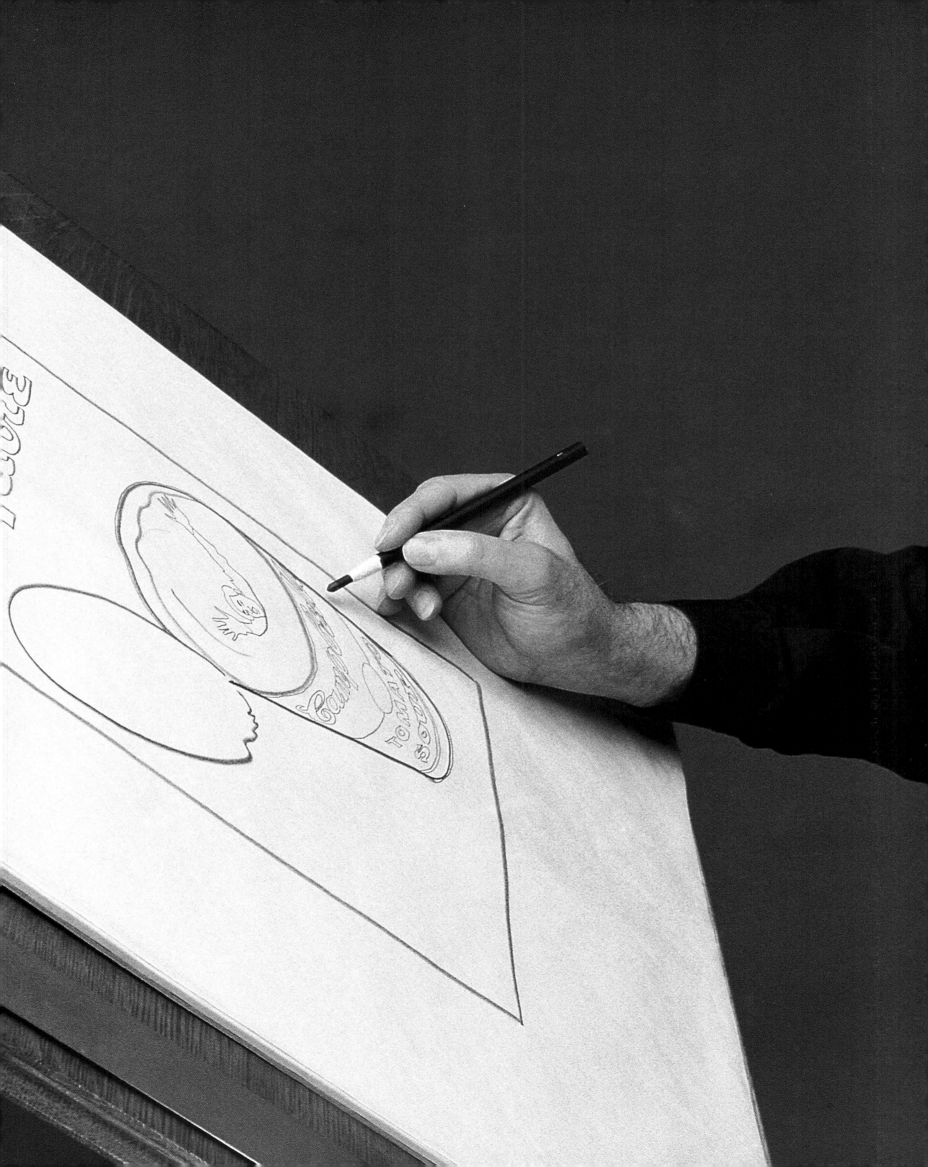

*This article,
reprinted from Adweek,
October 5, 1981,
shows Hayes at his
editorial best—
taking flak and deflating
specious criticism.*

HAROLD HAYES ON GEORGE LOIS
AND THOSE ESQUIRE COVERS

I remember walking George Lois' Sonny Liston cover around to all
the department heads; to the advertising director, the advertising promotion
manager, the circulation director, the circulation manager,
the publisher, the president and finally to the chairman of the board.
Since it was intended for the December issue, everyone understood that
I understood it was to be Christmasy.
No one at Esquire would ever try to tell the editor what to do, but
it would have been unthinkable for anyone,
from the chairman to the cleaning lady, to expect the December issue,
which traditionally marked the season with its heaviest yield of ad pages—
twice that of an ordinary issue—*not* to be Christmasy.
It goes without saying, I had said earlier to George Lois to make sure
he didn't forget that the December issue had to be Christmasy.
Since the magazine back then was put together three months in advance
of its appearance, and since the December issue,
in order to realize its maximum selling force, was moved back
an extra week or so to come out before Thanksgiving,
the climate in keeping with the true calendar, was hot and sticky,
as I recall, decidedly unfestive. Of these several gentlemen with whom
I was obliged to discuss the proposed cover,
the most direct was the circulation manager, a veteran hawker
who in Yuletides past had favored encasing the issue in a gold-tinsel box.
"Jesus Christ, Hayes," he said now, "you call *that* Christmasy?
What the hell are you trying to *do* to us?"
I have never known a talent quite as pure as that of George Lois.
It is impossible to control or regulate, and I suspect that if anyone or anything
ever succeeded completely in doing so, it would simply disappear.
That George is himself one of his own most enthusiastic admirers
doesn't have anything to do with it; he is every bit as good as he thinks he is.
In the ten years we worked together (he in his office usually, I in mine),
we collaborated only to the extent that
I took pains to be sure he knew what we would be doing inside the issue.
After that his imagination could be trusted to do its work alone.

With his very first cover for Esquire, in October 1962, the 31-year-old Lois
had earned that unusual freedom. Robert Benton was the art director
in those days, and it is no disservice to Benton,
now a successful film director and writer, to disclose that neither he
nor I had the slightest idea of how to make a cover work.
Both of us were young and inexperienced, with enough authority to produce
the magazine but not enough of whatever it took to persuade
anyone else, ourselves included, we knew how to produce effective covers.
So, in desperation, we tried producing three for an issue, then five,
and finally, near wit's end, ten, hoping somehow
through diversity to smother our ineptitude.
The consequence of such extremes of course was the resolution
of choice by committee vote, and inevitably, as any dummy
could have told us, the least effective of the ten was chosen.
Lois changed all that. He talked about the issue with me,
and a week later called over to say what he wanted to do. Then he did it.
A week after that, a messenger brought over the cover,
a full-sized color print of a defeated athlete in an empty arena
tying neatly into a Lois sports-prediction featured inside.
The photograph had been assigned, directed by Lois on location,
frame-matted and covered with glistening acetate.
All the type was in place, the logo, the cover line (which George had written)
and the cover date. It was superb!
Even the department heads could see this was work better than anything
Benton or I could do, and from that time on, George Lois,
12 blocks away in his advertising office, conceived and produced
some 92 covers for Esquire magazine. Getting back to the Liston cover...
"Well, what the hell," I said to the circulation guy and his stunned colleagues
down the hall, "It *is* Christmasy. Look at the Santa Claus hat."
Nobody thought that was very funny, or that there was any wit to be granted
in the magazine's mockery of its own commercial intent.
Strong as it remains even now, you need to do some remembering to appreciate
how strong it was back then. Sonny Liston was a bad black

who beat up good blacks, like Floyd Patterson; there was no telling what he might do
to a white man. In 1963, when this was the sort of possibility that preyed
on white men's minds everywhere, George Lois' Christmasy cover was something
more than an inducement for readers to buy Dad extra shaving soap.
In the national climate of 1963, thick with racial fear, Lois' angry icon insisted on
several things: the split in our culture was showing; the notion of racial
equality was a bad joke; the felicitations of this season—goodwill to all men, etc.—
carried irony more than sentiment. What it was, the intervening years
now make clear, was the perfect magazine cover—a single, textless image that measured
our lives and the time we lived them in quite precisely to the moment.
From one of the survivors of those times the claim now comes that the
Liston cover cost Esquire $750,000 in cancelled advertising.
That's some price to pay for having tried to say something on a magazine cover...
and magazines, as everyone knows who works with them,
are in business to make money, not lose it. There are, of course, all sorts of grand
and lofty ideals by which one may justify principle over profit.
Nevertheless, under circumstances I have come better to understand over the years,
the proprietors of Esquire were pretty forbearing about the Liston cover fallout
inasmuch as I did keep my job and George Lois did continue designing our covers.
The real question that arises from all this, with implications
as appropriate to the Falwellian Age as the Listonian, is: did Esquire management
make the right business decision? Here, hindsight may be more helpful than
a two-year symposium at Harvard Business School.
Lois stayed (and, if anything, grew more troublesome to handle)
but the business prospered! It is therefore reasonable to suggest that the
growing number of advertisers who found that particular magazine
in those years congenial to their commercial interests might not have if George Lois
had *not* been designing its covers. Try as I might, I am unable to conceive
of the Esquire of the '60s without George Lois.
I suspect the same is true for others who remember it today. One might even go so far
as to conclude, then, that with the loss of this inimitable element,
Esquire could have ceased to be Esquire. And if there should have been no Esquire,
how could anything have been made or lost from it?

In this reprint from
Esquire's Editor Page,
September 1972,
Hayes muses over the trials
and triumphs of the
decade we worked together.
Six months later,
Hayes quit Esquire and I quit
doing Esquire covers.

Breakfast last Tuesday at the Park Lane to discuss with George Lois
the cover for next month's issue. Uncharacteristically, he showed up about
eight minutes late, apologizing because his earlier meeting
had run long. Earlier by how much, I asked. What time had it begun?
"Six," George said without flinching. To mind came a blackout from *New Faces of 1952*
in which a jazz musician is hauled into court for disturbing the peace.
"We was just having a little party in my flat on Saturday night, your honor,"
the musician says. "Yes, well, when did the party end?" the judge asks.
The musician grins, stomps on the floor and cries, "*Thursday!*"
Lois' delivery is more casual. He does not expect the world to set its watch
by his work schedules; on the other hand, if it doesn't, he sees
no reason why it should get in his way.
George Lois is a tough and loving Greek, an advertising man
and an amateur basketball player roughly in that order.
Next month he will publish an autobiography of a sort, *George, Be Careful,*
and at the same time mark his tenth year of producing Esquire's covers –
a lively period during which he has persuaded Andy Warhol to jump into a can
of Campbell's soup, Roy Cohn to wear an angel's halo, Ed Sullivan a Beatle's wig
and mean Sonny Liston a Santa Claus hat.
Lois himself never wears anything on his head, perhaps with good reason.
His talent is spread over many enterprises – his own advertising agency,
a film production company, a design firm – yet his own artistry is instantly identifiable,
his effort limitless, his attention to detail obsessively meticulous.
His sense of morality – a pertinent factor, since people constantly ask why
we do those things we do on our covers – was formed in the house of his father,
a florist in the Bronx, and in the streets outside. When he was twelve,
a gang from another block came to his neighborhood and took off his pants.
In an effort to subdue him, one of the members of the gang broke George's arm.
He waited for months until his attacker returned to his neighborhood.
Then what did you do, I asked him. "Then I followed him until he was alone
and I broke *his* arm," Lois said.
The image of the soul-rotted adman, trembling before the wrath of his client
in order to keep his ranch house in Westport, is not the image of George Lois.

To destroy Lois it would first be necessary to shoot him through the heart
with a silver bullet, and then you couldn't be absolutely sure.
His visual excellence springs from two sources: a) his belief that a picture
is dependent upon some accompanying statement in order to project an idea;
b) his intuitive grasp of the idea to be rendered.
What is left unaccounted for within these parameters may be summarized as talent.
More than any other single element within this period—more than
The Confessions of Lieutenant Calley, the reporting of social and historical disasters,
the outrageousness of some of our titles—his covers for Esquire
have drawn fire either because they have been considered controversial,
or irreverent, or tasteless.
Yet in retrospect it is more often his critic whom time proves the fool.
In December of '63, the famous Liston Santa Claus portrait prophetically challenged
the illusions of racism.
In March of '65, Virna Lisi, lathered up and shaving before the camera,
signaled the sexist war soon to follow.
In November of '66, Hubert Humphrey was posed as a ventriloquist's dummy
on the knee of Lyndon Johnson.
Lieutenant Calley smiling and surrounded by four Vietnamese children,
in November of 1970, sought to make the point that Calley's assumed lack of guilt
was a stupid innocence shared by us all.
A tough cover but George had the full freedom we traditionally offered
our best talent. He has always signed his name to his covers, when I was able
to convince him, down there in the lower left-hand corner, in four-point type.
So have we, with the standard Esquire script across the top.
And always with great enthusiasm on both our parts. It's hard to think who else
might better have expressed what this magazine is all about.
But trouble? Oh Lord, the trouble he has caused.
Late one Sunday evening several months ago, I received a call from Harold Conrad,
a fight promoter who happened to be a friend of mine and of Norman Mailer as well.
"Harold," growled the other Harold, "I had a card fall out on me for a promotion in Zurich.
I was up to Norman's house and he's into boxing now.
I asked him if he wanted to fight an exhibition match. He said he would if he

could fight who he wanted and he wants to fight you. How about it?"
Of the many Byzantine objections developed by Mailer toward Esquire over the years,
Lois' September cover of last year (1971) is doubtless among the most galling.
There was Mailer, montaged into a King Kong suit, tenderly cradling
an ecstatic Germaine Greer—all provocatively arranged for the reader to consider
Greer's response inside to Mailer's "The Prisoner of Sex."
It was one of George's most inspired covers—Mailer, the king of machismo,
as seen by one of the great graphic artists of our time.
On past occasions it has been noted here that the editor is really
not much more than a surrogate reader, one who appreciates in advance
the best of what is offered him to publish, the Mailers of our time,
the Buckleys, the Vidals, the Hatfields and the McCoys.
His role is that of an honest broker, and in this case ol' George deserves all the credit.
So what the hell, I say; eliminate the middleman!
Norman, George can be found any morning in his office after 6 am,
688-1525.

H.T.P.H.

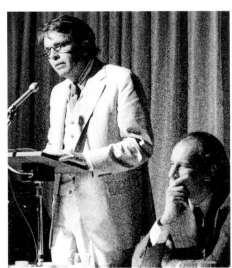

HAROLD T. P. HAYES DELIVERS OPINIONS ON GEORGE LOIS
AT A UNITED NATIONS ROAST IN GEORGE'S DISHONOR, 1972

GEORGE LOIS ON HAROLD HAYES
AND THOSE ESQUIRE COVERS

In 1962 my ad agency was spearheading the change in advertising
known as "The Creative Revolution!" That's when Esquire's editor first
approached me for advice on how to create a great cover.
When I met him for lunch at The Four Seasons he was stylishly decked out
in a white suit and waggling a skinny stogie, in keeping with his getup,
southern drawl and poker-playing eyes. I told him that every
"package design" should be at least as good as the product inside.
And his Esquire was the best magazine product I ever read.
"You don't get great stuff from Baldwin and Capote and Talese and Wolfe with
a management committee stumbling over each other, voting for the
safest syntax." Harold understood and that was the beginning of a *beautiful* friendship.
I instinctively understood that a trombone–playing Southern liberal who was
also a Marine reserve officer was one rare bird.
During the turbulent '60s, starting in 1962, I produced 92 covers for Esquire.
Every time a new visual editorial was delivered to Harold from my drawing table,
Esquire's publishers, editors, ad directors and assorted bureaucrats crossed their hearts
and fingers. I had always telegraphed the cover idea to Harold,
usually over the phone – while it was Harold who often suggested the cover subject.
We spoke in shorthand and communicated with economy:
For Christmas, Hayes pleaded, fingering his pencil stogie,
"Ol' buddy, ya gotta compromise *this* time. Y'all gotta give me a goddam *Christmas* cover!"
This led to America's first black Santa: Sonny Liston, the meanest man in the world.
Respirators were rushed to Esquire's ad offices.
"Do a job on Svetlana," he asked.
"Oh, no," I moaned. "Not *another* magazine cover with her fink mug!"
Thus it came to pass that I painted her father's mustache on Svetlana Stalin;
the family resemblance was awesome.
For an issue that featured John Sack's account of an infantry company
from basic training to Nam, I lifted a cry of pain from a young GI–
"Oh my God – we hit a little girl!" – and set it starkly in white against black.
When I asked Harold if he thought we would piss off America, he said,
"If they don't like what's on the cover, they can always buy Vogue, sweetheart."
That was 1966, a premature time for indicting that evil war.

For an issue on the decline of the American avant garde, we showed
Andy Warhol drowning, literally, in his own soup.
And Harold knew he'd find himself in deep water when I showed Muhammad Ali
as the martyr St. Sebastian for refusing to fight in a bad war.
Harold lined up his fine Carolinian nose against my Bronx schnoz
and put his Dixie neck on the chopping block once again.
When a critical piece was being prepared on Humphrey for parroting
his boss, I sat a Hubert dummy on ventriloquist LBJ's knee.
It was a needed jab at Humphrey's failure to speak out against Vietnam.
When the article wound up being laudatory, Hayes added a compromising
"But in fairness to our Vice President, see page 106,"
because he couldn't bear to lose the cover.
When I slapped a theater marquee on St. Paddy's Cathedral to illustrate an article
on "Movies, the New Religion," Harold did the sign of the cross and took the heat.
But the cover that truly tested the mettle of Esquire's staff (and, indeed,
the mettle of America itself) was a portrait of Lieutenant Calley, in the flesh.
There he was, awaiting trial for his role in the My Lai massacre, posing
with an obscene grin, surrounded by Asian kids.
After receiving the cover, Harold called—as he always did after the smoke cleared.
With a deep sigh, he gave me the verdict:
"Most detest it, George. But the smart ones love it."
"You going to chicken out?" I asked. "Nope," he said.
"That cover is what Esquire is all about." After one of his college campus
lectures, Harold said about the notorious Calley cover,
"The kids are having fistfights over this one, Lois. It's great!"
When Roy Cohn wrote a self-serving piece on his gofer years with Joe McCarthy,
I shot him with a tinsel halo, visibly pinned to his noggin
by photographer Carl Fischer. Oblivious to its slashing irony, Cohn posed obligingly.
The next day Harold called me, "Oh, you really nailed that sonofabitch."
For one issue, an unexpected change of tone came over Harold.
"They're clamoring for a girlie cover," he pleaded.
I complied by showing a naked dame, squashed in a garbage can,
headlined, "The New American Woman: Through at 21."

"Well, pal," was Harold's reaction, "you sure didn't disappoint me."
And then there was Nixon. When he ran for President in 1968,
we showed him being made up like a movie star.
"Nixon's last chance," went the caption. "This time he'd better look right!"
Promptly, Harold got an indignant call from Nixon's staff,
complaining that Esquire was trying to depict their boss as a homosexual.
When I perpetrated a sham sighting of the elusive Howard Hughes,
the media crowd fell for it, not realizing it was a put-on.
Esquire's ad department went apoplectic. Harold merely chortled.
Obviously, Esquire's brass put up with my shenanigans because
during those Hayes years circulation went from 750,000 to almost 2 million
(dumping right back down to 750,000 when Hayes and I bailed out).
The Esquire covers were uncensored commentaries on serious issues in our own style.
Under the benign and courtly aegis of Publisher Arnold Gingrich,
Harold gave me greater latitude than anyone before or since thought possible
from a mass periodical. "Pictorial Zola," he used to call them.
The covers outraged the mighty, angered advertisers and infuriated readers—
but they visualized the changes in America and needled our hypocrisies.
And Harold never let anyone or anything diddle with the work.
The ruder the raspberry, the happier was Hayes. That time is called
the Golden Years of magazine journalism, the birth of "The New Journalism."
Because it was *Harold's* time! Harold hit the torrid issues of race,
war and politics. He blasted the silly pretensions of pop culture and deflated
the synthetic images of celebrities.
His Esquire, always on the cutting edge of cultural awareness,
owed something to the times, but the times owed something to Esquire!
People ask me all the time why there aren't any more great
magazine covers like Esquire's. I tell them
because there aren't any more buccaneering badboys like Harold Hayes.
That brave North Carolina country boy nailed down that
messy, turbulent decade and his brave work will remain the toughest
antidote to revisionist historians.
Long may my remarkable pal, Harold Hayes, be remembered.

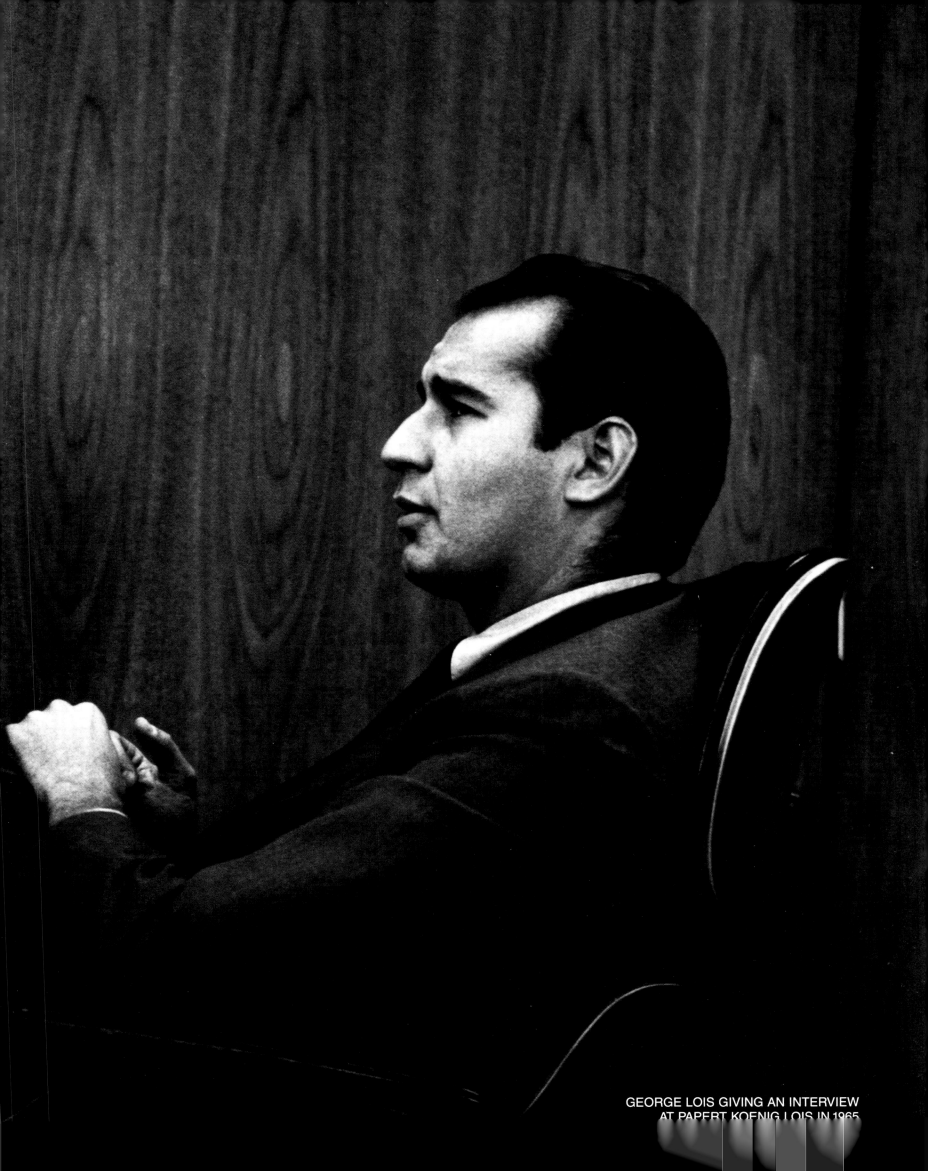

GEORGE LOIS GIVING AN INTERVIEW
AT PAPERT KOENIG LOIS IN 1965

MOM & POP CULTURE

ED SULLIVAN WIGS OUT

Watching showman Ed Sullivan introduce Beatlemania to America
on his Sunday night TV variety show, I knew Esquire
had to acknowledge this establishment elder, with his uncanny
knack for being on the cutting edge of popular culture.
The Liverpool Fab Four with their outrageous bowl cuts had landed,
and they would soon reach the apex of pop music.
So, that Monday morning, I tried to go through channels at CBS
and ask the impresario to pose...in a Beatles wig!
My first job as a Korean vet was at CBS working for the all-powerful
image maker, Bill Golden, the creator of the CBS eye. And I knew
my old boss, Bill Paley, the chairman of CBS, was a fan of my Esquire covers.
But Paley brushed me off, not quite understanding what effect
the imagery of that *really big* showman wearing
a Beatles wig would have. So I decided to amble over to The Ed Sullivan
Theater (where David Letterman now cavorts)
and camp at the entrance, right there on Broadway.
When Sullivan finally came out, I shoved a sketch of my proposed
Esquire cover in his face and talked fast. He took a long look
and grinned ear to ear, just like the final shot we took the next day.
He wore his wig with gusto and smiled like Ringo.

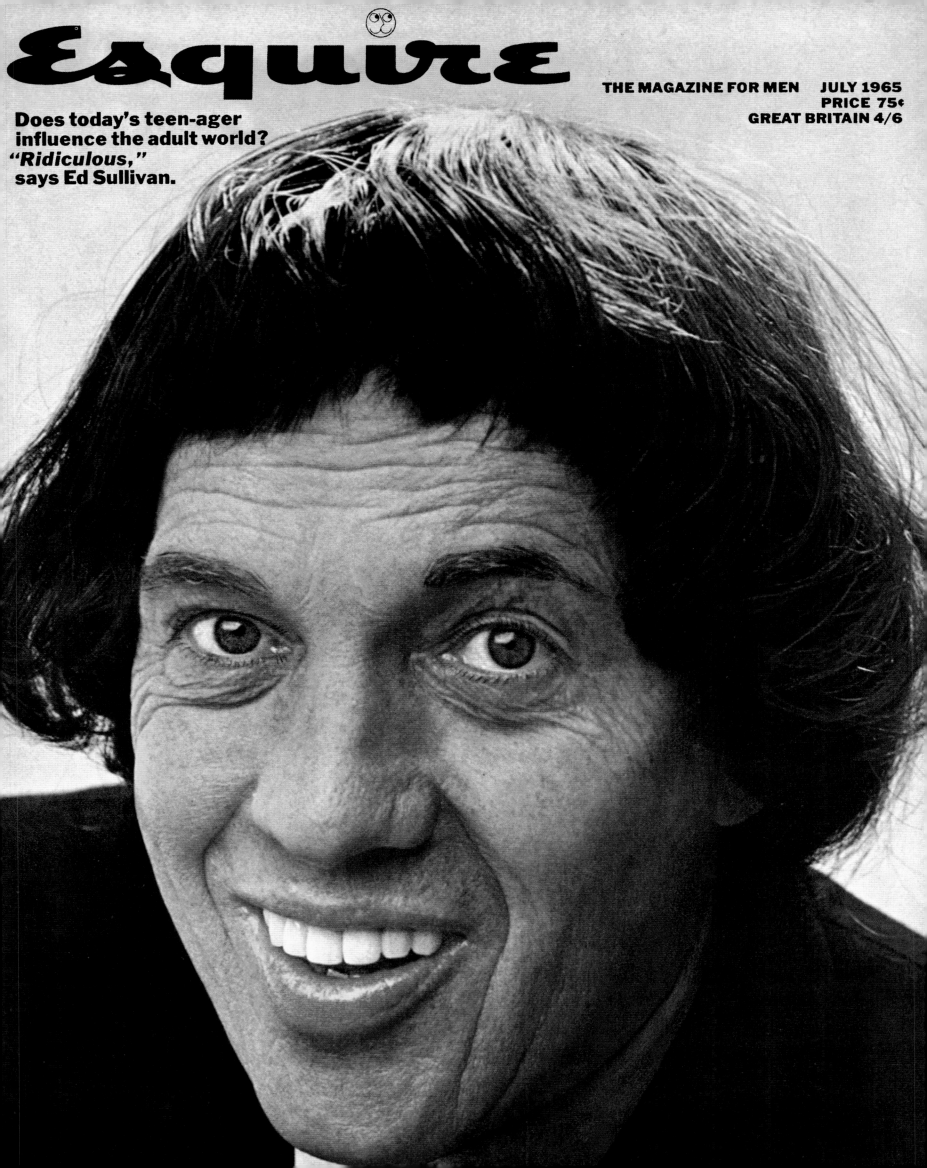

Esquire

THE MAGAZINE FOR MEN **JULY 1965**
PRICE 75¢
GREAT BRITAIN 4/6

Does today's teen-ager
influence the adult world?
"Ridiculous,"
says Ed Sullivan.

2

HER FATHER'S MUSTACHE

When Joe Stalin's daughter came to the U.S. in 1967, her face
showed up on the cover of every magazine except Popular Mechanics.
Newsstands from New York to California were transformed into
photo galleries of a motherly Svetlana Stalin. And she was becoming a bore.
I felt that anyone who told stories on her old man was a lousy fink.
Then Esquire ran a lead article on Stalin's little girl, and I was
stuck with the deadly problem of coming up with *another* Svetlana cover.
Garry Wills' story was at least a skeptical piece. It described her
weirdo hangups with assorted religions. It analyzed how she was taken in hand
by the smart boys in publishing and our Red-baiting State Department
when she came to the United States with her hot manuscript about
Life with Father Josef. I developed a mental block against Svetlana, and the cover idea
just wouldn't materialize. I covered my wall with all the
previous magazine covers of Svetlana, and they were all alike.
Then it came to me. I grabbed a grease pencil and scribbled away.
Some people were offended by this cover because
Svetlana had been elevated to sainthood by the time it appeared.
To these people I can only say: your father's mustache.

NOVEMBER 1967
PRICE $1
GREAT BRITAIN 6/-

Esquire

THE MAGAZINE FOR MEN

The Svetlana Papers

or: the advantage of being Stalin's daughter.

PHOOEY ON
THE 1964 WORLD'S FAIR

Inside this issue, Esquire welcomed the 1964 World's Fair,
brandishing its Unisphere, a big skeletal
metal globe that looked like the world had imploded.
But to me there was only *one* Fair.
A fantasy of showmanship, the epitome of stagecraft,
a real-life Land of Oz, the 1939 Fair had become
indelibly etched in the memories of all who attended.
Born of national tragedy, it signaled the end
of the American Depression and reflected our boundless
belief in "The World of Tomorrow."
The Trylon and the Perisphere, an enormous white,
futuristic temple, became the Fair's centerpiece,
architectural symbol and visual logo.
Designed by Wallace Harrison and André Fouilhoux,
it symbolized a beacon of hope that had endured
one storm of conflict (as we were about to enter another).
It remains the stuff of memories!
This thinking man's cover, using that memorable and beautiful
symbol of the 1939 Fair, with nostalgic references
to the original, to the *real* Fair, said phooey to the '64 Fair!
(And double phooey to their phony slogan:
Peace Through Understanding.)
Read my captions very carefully. If you're too young
to decipher them, ask your grandfather.

April 1964, price 60¢

Esquire

Exclusive! A flashback guide to the best world's fair ever.

"They say by 1960,
the sidewalks will be
20 feet above the roads.
Aah, we'll all own autogiros
by then, anyway."

"Guess who we saw
at the Aquacade.
Cary Grant.
He still looks nifty
and I'll bet he's forty."

"If you want to
relax for a minute,
go see the Japanese Pavilion.
It's so peaceful."

"Look, I didn't drive 800 miles
just to see
Elsie The Cow. I want to get
a World's Fair penny.

"How can Grover Whalen
run this whole Fair
and remain such a nice guy.
Holy Moses!"

FRANK LOSES HIS KOOL

Editor Harold Hayes dispatched Gay Talese, one of his brilliant
young finds, to pursue Frank Sinatra and write a tough piece
on the Chairman of the Board's power in the pop music world,
in Hollywood, Las Vegas and Washington.
It inspired this cover on the brown-nosing sicko-phants
that light up the world of celebrities.
The honor of one of my few illustrated covers for Esquire
went to my talented buddy, Ed Sorel, who nailed it
with his first sketch.
Word got back to Esquire that Ol' Blue Eyes was plenty burnt.

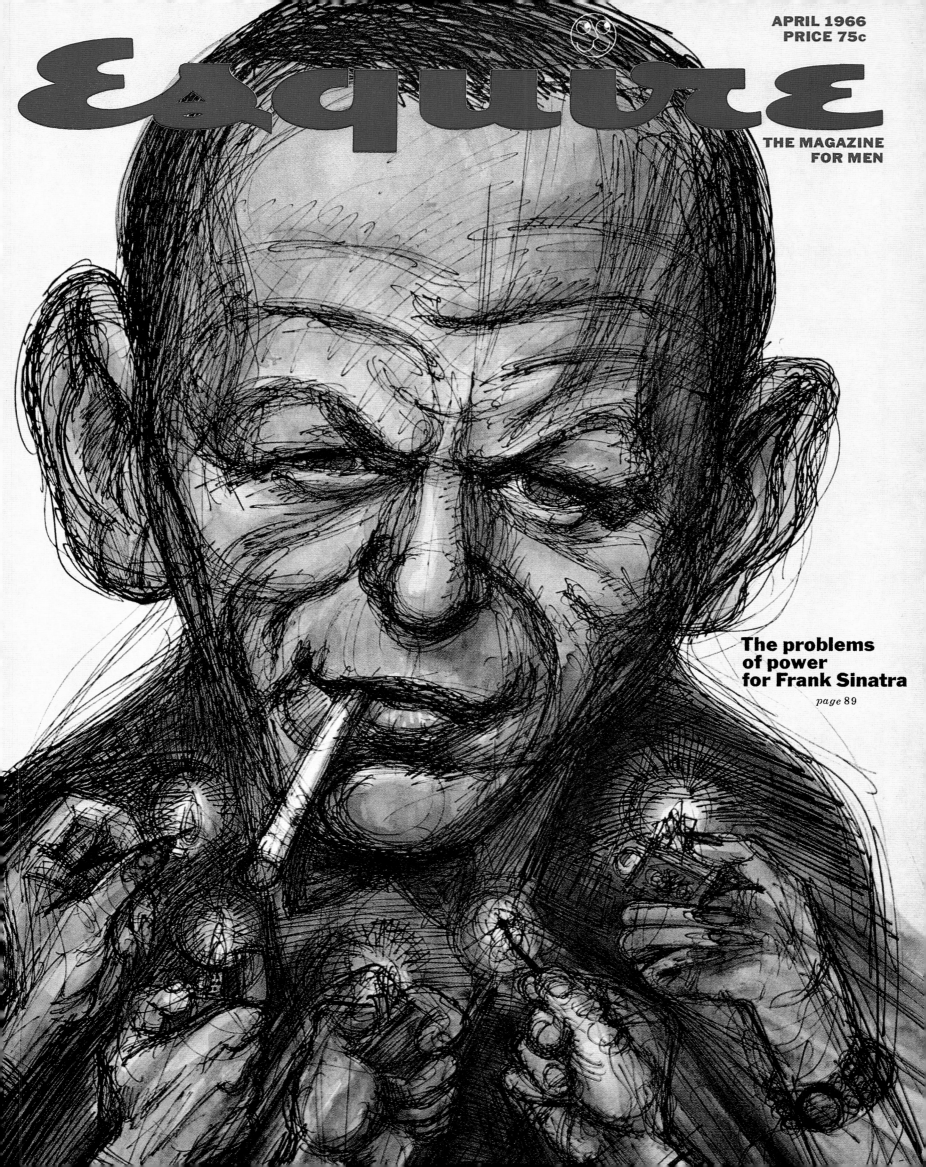

APRIL 1966
PRICE 75c

Esquire

THE MAGAZINE
FOR MEN

**The problems
of power
for Frank Sinatra**

page 89

TAMEST EVENT ON KIDS TV THAT DAY: RUBY KILLS OSWALD

November 24, 1963 was a decisive TV moment,
as Jack Ruby shot Lee Harvey Oswald dead,
live, in front of millions, old and young. I was showing
the moment when an all-American kid
started to grow up with live violence in his carpeted den,
complete with an all-American hamburger and Coke.

Esquire

THE MAGAZINE FOR MEN

MAY 1967
PRICE 75c

**Why Jack Ruby
killed Lee Oswald…
an untold story.**

see page 79

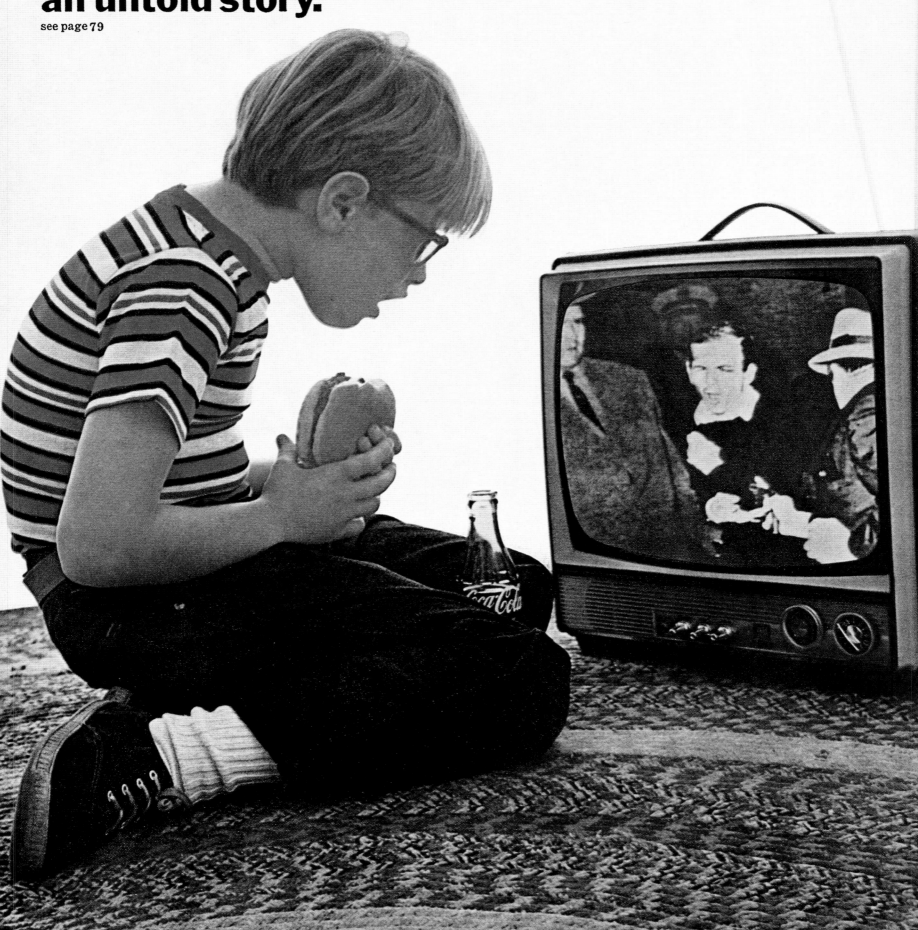

ANDY WARHOL DROWNS IN HIS OWN SOUP

This cover has become a symbol
of Esquire's juxtaposition of the celebration of pop culture...
as it deconstructed celebrity.
The Pop Art movement in America was launched in 1962,
with one-man shows by Roy Lichtenstein, James Rosenquist,
Tom Wesselmann, Robert Indiana and Andy Warhol,
who became the best known Pop artist of his time.
The pervading symbol of the whole Pop Art movement of that era
was Warhol's Campbell's soup can.
I've never been able to regard Pop Art as a serious movement.
It was the Dada of our time (but not as talented as its father).
It used billboards, packages, brand symbols, comic strips, typefaces
and you name it to make its "statements."
I've always thought of Andy as a bold innovator and a smart thinker,
but he was a far cry from a Marcel Duchamp or a Man Ray.
There's no question, however, that Warhol was a major-league showman.
Any guy who can parlay a soup can (not to mention the Brillo box)
into personal superstardom may not fit my definition of an artist but
he's certainly hot stuff. When this article in Esquire came up,
I decided to show him drowning in his own soup.
He knew it was a friendly spoof of his original claim to fame,
but he still enjoyed that fame enough
to welcome his puss on one of those Esquire covers.
We photographed Warhol and the open can of soup separately.
When we put Andy into the soup, we almost lost him.

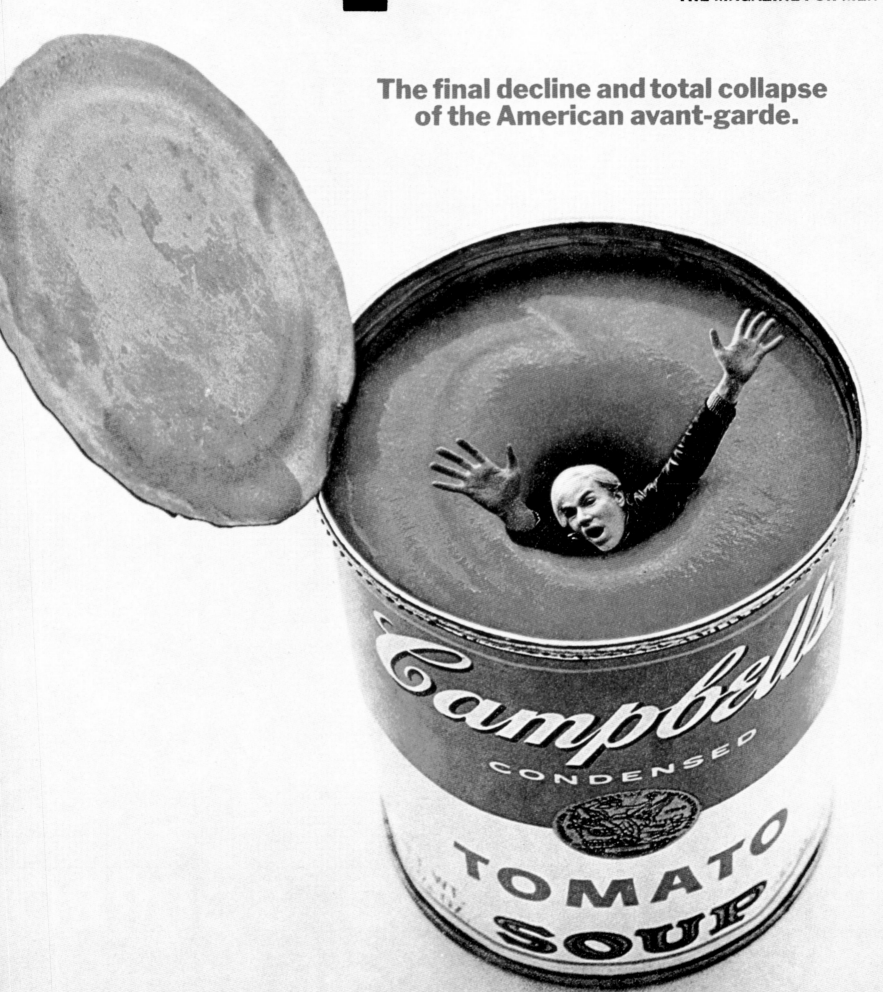

MAY 1969
PRICE $1

Esquire

THE MAGAZINE FOR MEN

The final decline and total collapse
of the American avant-garde.

WRITE ON!

In those literate days before T-shirts became
a substitute for insight and substance,
Harold Hayes created this issue to reaffirm Esquire
as the champion of those who live to read.
He forecast a literary boom for the '60s and he was *right.*
Spending freely, Hayes acquired works-in-progress
from giants like Vladimir Nabokov, Robert Penn Warren,
Saul Bellow, Flannery O'Connor and Edward Albee.
He included stirring reminiscences of Hemingway, Faulkner,
Fitzgerald and Edmund Wilson—
plus a photographic seating of the last of the Lost Generation,
including Marcel Duchamp, Man Ray,
Kay Boyle and Virgil Thompson. And for an added fillip,
Hayes had Norman Mailer happily dumping
on nine of his fellow authors.
Esquire readers OD'd on this triple tribute to good writing,
the pursuit of excellence and the promise of the future.
My cover transformed this comprehensive issue into a chichi
(but inviting) party for the literati and glitterati—
causing even Allen Ginsberg, the transcendental priest
of high culture, to postpone his search
for the meaning of life (at least until he got into
this watershed issue of Esquire).

Esquire

THE MAGAZINE FOR MEN

WRITERS! HOW CAN THEY LIVE LIKE THAT AND WORK, TOO? THIS ISSUE TELLS ALL.

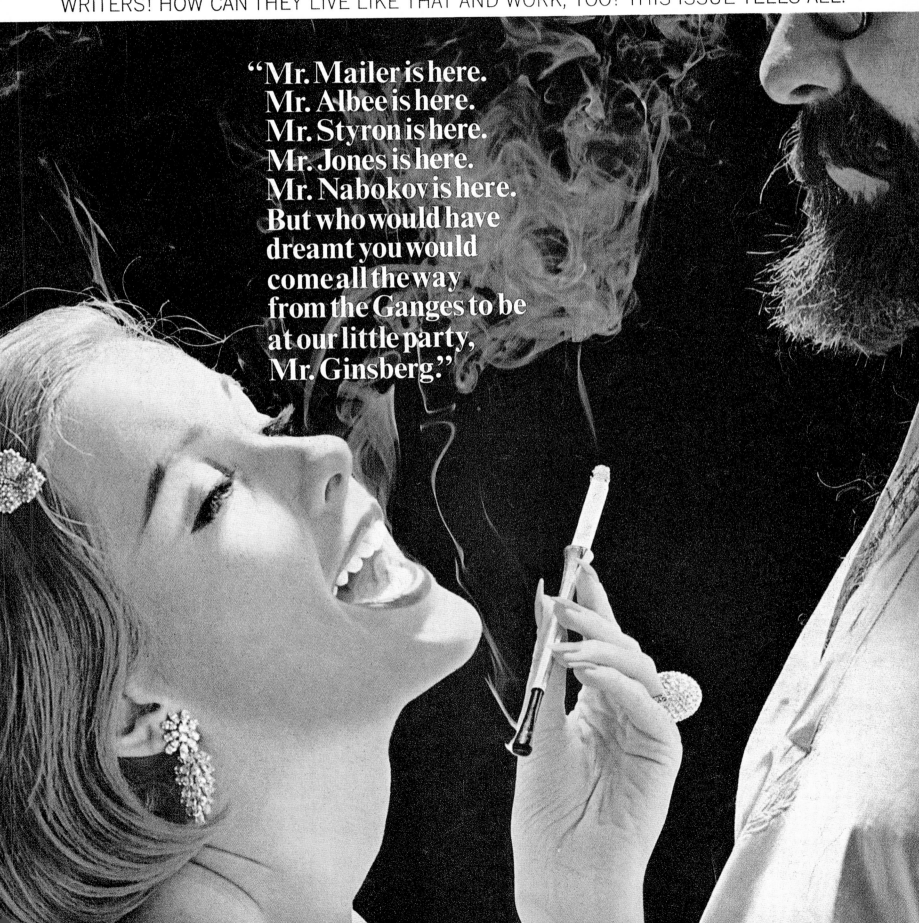

"Mr. Mailer is here. Mr. Albee is here. Mr. Styron is here. Mr. Jones is here. Mr. Nabokov is here. But who would have dreamt you would come all the way from the Ganges to be at our little party, Mr. Ginsberg."

ROCKETING TO FAME

In one metallic phrase, Winston Churchill slammed down his Iron Curtain,
separating East from West for a half-century of Cold War.
Eisenhower continued Truman's economic buildup against yesterday's
deadly enemies; expending endless effort to outdo and outscrew
our feared adversary, the scheming Soviet Union.
Constantly raising the ante, both sides squirreled away enough H-bombs
to waste the world a hundred times over.
The Russians hurled a Sputnik and themselves into space as their
first cosmonaut, Yuri Gagarin, loftily chanted, "I am Eagle! I am Eagle!"
Their dizzying success made our heads spin.
An abashed JFK decided the way to reclaimed glory was "to the moon, baby."
We had to beat the USSR to the future and the future was space.
Multibillions were pumped into the space race, manic and conspicuous
consumption to beat out the Russkies. A lunar landing by a manned Apollo 11
would symbolize capitalism's triumph over Godless communism, by God.
But what American would rocket to fame and what words should
he utter as he became the first human to step in the dust of another world?
Esquire's July 1969 issue reported on (and fueled) the national dialogue.
But none of the vaunted literary, political and celebrity minds
came close to Neil Armstrong's pithy message on July 21, 1969,
traveling farther than any words in history:
"That's one small step for man; one giant leap for mankind."
America got its rocks off.

PS: As America cavorted emptily and expensively on the moon,
a wily Japan kept its sun rising by stressing, endlessly, earthbound technology.
Inattentive Presidents Nixon, Ford, Carter, Reagan and Bush
squandered more of our human and financial treasure on the dark sciences
of the military, including a spaced-out "Star Wars" folly.
Today, an unfluttering moonflag is the lonely reminder that we won out
in space, bankrupting and obliterating the Soviet Union.
Not much solace in the face of being outmaneuvered by Japan for leadership
in consumer products, trade deficits and international markets.

Esquire

JULY 1969
PRICE $1

THE MAGAZINE FOR MEN

We asked Marshall McLuhan, W. H. Auden, Marianne Moore, R. Buckminster Fuller, Robert Graves, Ayn Rand, Bob Hope, Hubert H. Humphrey, Tiny Tim, Sal Mineo, Vladimir Nabokov, John Kenneth Galbraith, Muhammad Ali, Truman Capote, and U Thant:

What words should the first man on the moon utter that will ring through the ages?

Samuel Finley Morse

Alexander Graham Bell

Henry Morton Stanley

"What hath God wrought."

"Watson, come here— I need you."

"Dr. Livingstone, I presume?"

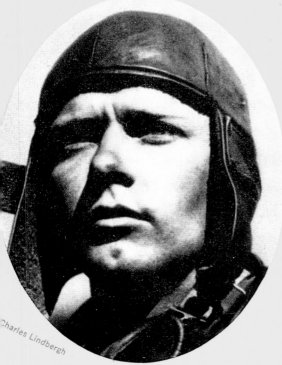

Charles Lindbergh

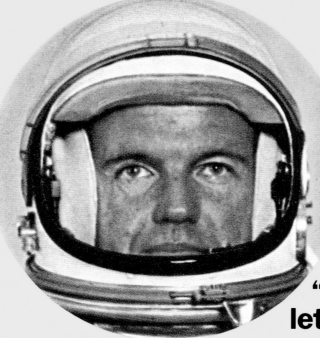

"Er...ah...well, II, let's see now."

"Well, I made it."

LITTLE BIG MAN

Grab any magazine and cover its logo. They all look the same
(and these days, smell the same). That's because every journalism "expert"
preaches that if you choose the latest hot star,
and your lucky stars are right, that issue will be a best-seller.
I refused to produce a celebrity cover, as such.
To me, that would have been the kiss of death to the "outside-inside"
transformation Hayes and I had accomplished for Esquire.
(The magazine had exploded in circulation as editor Harold Hayes molded
Esquire to reflect the attitude, aspirations and adrenaline of the American male.)
To this day, nine out of ten magazines choose celebrities
for their covers and nine out of ten are wrong.
(Oh, I had my fun with famous people, but always for a purpose:
Ed Sullivan in a Beatles wig, Warhol drowning in his own soup,
Svetlana with her father's mustache, Muhammad Ali agonizing as St. Sebastian.)
Nevertheless, eight years into my Esquire covers, Hayes had a request.
He had just seen a rough cut of Arthur Penn's *Little Big Man*
and begged me to slap Dustin's mush on the cover.
Hoffman, one of America's foremost actors, had a notorious rep with
producers and directors for refusing to promote his films.
But Esquire covers were hot, so he agreed to pose. The young superstar
had adopted New York as his home, so I adapted
the *Little Big Man* theme for the cover. I showed the diminutive Hoffman
standing tall, eyeball-to-eyeball with the Chrysler Building.
Twenty years later, I found myself having breakfast
with Hoffman and Steve Ross, the chairman of Time Warner,
during the period my ad campaign "Make time for Time"
was a hit of the ad world. Gobbling up my cereal (and feeling my oats)
I proudly preened to Hoffman:
"Remember me? I'm the guy who did that Esquire cover of you in 1970."
Dusty replied, "Esquire cover? I was never on an Esquire cover!"
Ouch.

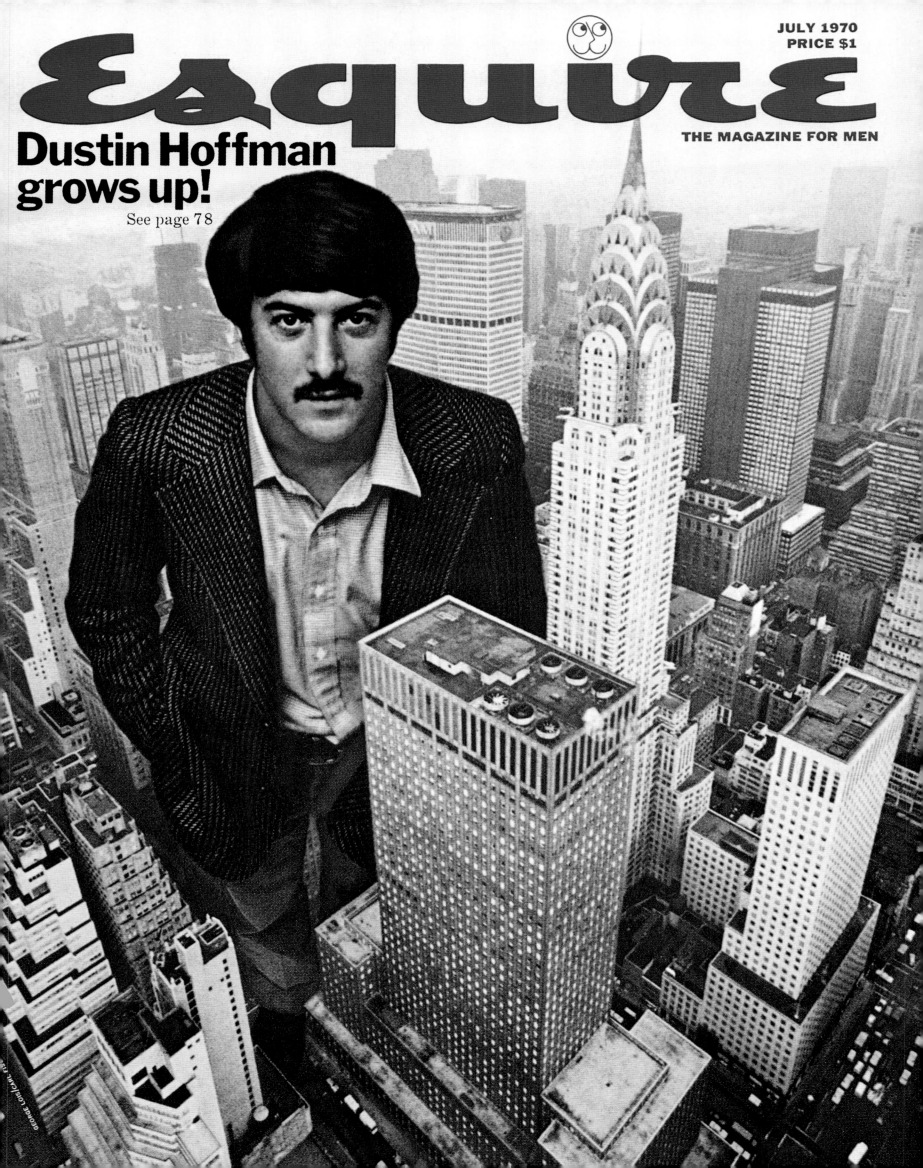

JULY 1970
PRICE $1

Esquire

THE MAGAZINE FOR MEN

Dustin Hoffman
grows up!

See page 78

THE RKO ST. PATRICK'S MARQUEE

A good magazine cover, like a strong package design,
usually explains what's inside.
A good issue of Esquire enabled me to make a personal comment
about what I thought the magazine was trying to say.
And this wildly inventive, deadly serious publication was
magazine journalism at its peak of achievement.
This issue featured a sheaf of articles on the spreading youth culture,
but it seemed to lack a definitive point of view.
To my mind, American postwar films basically remained white-bread
until a stoned Jack Nicholson, Peter Fonda, Dennis Hopper
and crew brought the biggie Hollywood studios to their knees
with the cheapo, culture-crashing *Easy Rider*.
So I gave it one. I focused on the new movies and
called it "The Faith of Our Children."
Then I superimposed the marquee of that low-budget runaway hit
over the majestic doors of St. Patrick's Cathedral.
To American kids, *Easy Rider* had become a cult film.
The Archdiocese of New York was not pleased.
To this day, whenever I stroll past St. Paddy's
I always pull out eight bucks if I feel like going in.

Esquire

AUGUST 1970
PRICE $1

THE MAGAZINE FOR MEN

The New Movies:
Faith of Our
Children
See page 59

PETER FONDA DENNIS HOPPER

JACK NICHOLSON

IN EASY RIDER

MY LONELY WAR PROTEST

THE COVER THAT NEVER RAN

Editor Harold Hayes and I only debated two covers I created for him.
The first was an infamous "black rage" cover
where I enlarged the original logo of Aunt Jemima Pancakes,
and superimposed a photo of her black hand
wielding a cleaver (a reference to the volatile Eldridge Cleaver).
I was trying to say that the pre-'60s "mammy" image
many whites had of subservient blacks had been transformed
into a defiant, violent, Black Revolutionary.
It scared the hell out of Harold, enough to make me throw it out.
The only other "rejected" cover was this early warning signal on Vietnam.
In the fall of 1962, I sent this mock-up to Harold.
I wanted to use the actual 100th GI who had lost his life in Nam,
but the State Department refused. So I dusted off
a Korean War snapshot of me, hoping the power of Esquire could force
the War Department to release the actual photo of the GI.
In those days Vietnam was considered a minor fracas.
"It'll be over by Christmas" was the war cry.
Since Esquire covers had to be prepared two months in advance,
Harold was afraid we might end up with egg on our face.
So, very reluctantly, I killed my 100th GI cover.
By the time we evacuated Vietnam 12 years later,
with our tails between our legs, more than 58,000 American GIs
had been killed or were missing in action.

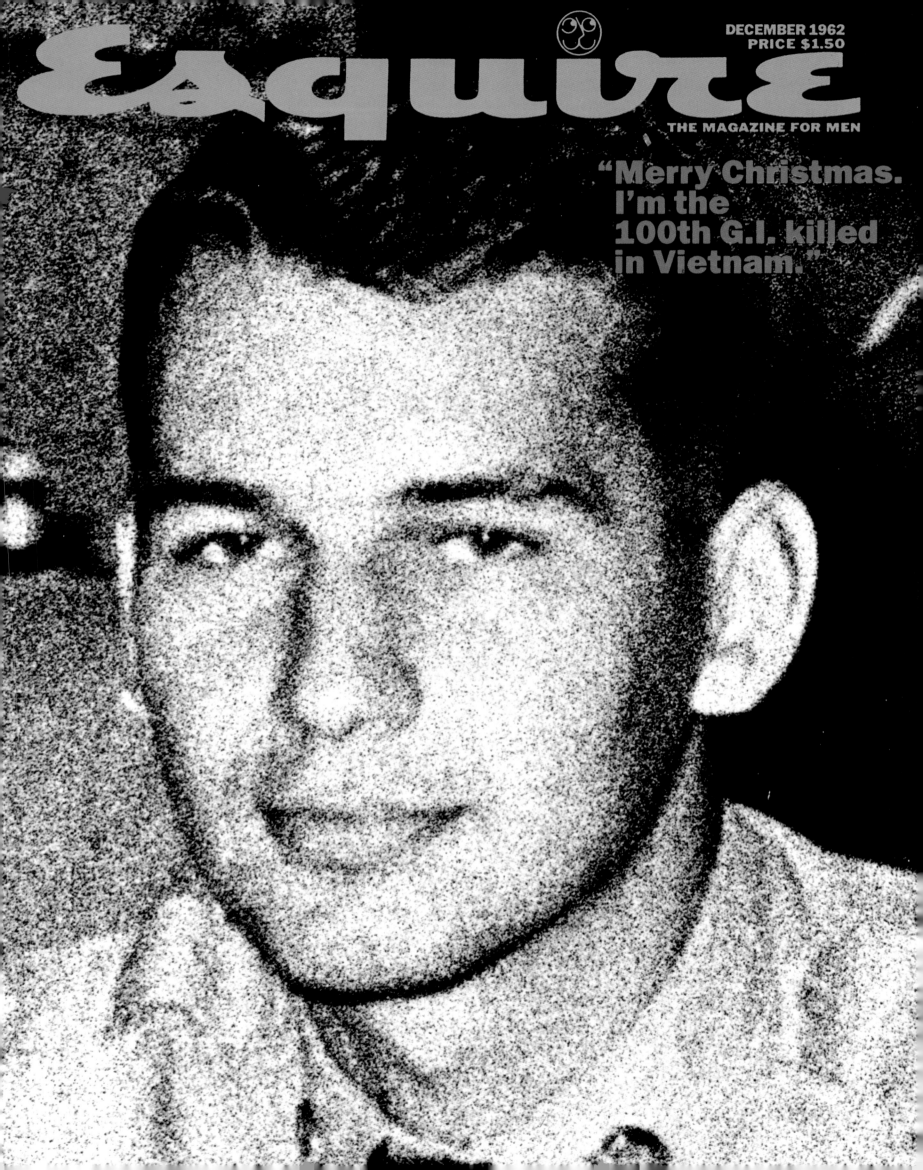

Esquire

DECEMBER 1962
PRICE $1.50

THE MAGAZINE FOR MEN

"Merry Christmas.
I'm the
100th G.I. killed
in Vietnam."

THE GAY WAY TO DODGE THE DRAFT

This expressed the deep-down knowledge among
college students that the Vietnam War stunk,
that any way to stay out of it was (supposedly)
morally acceptable. The model was a Columbia University
football player, a very tough hetero.

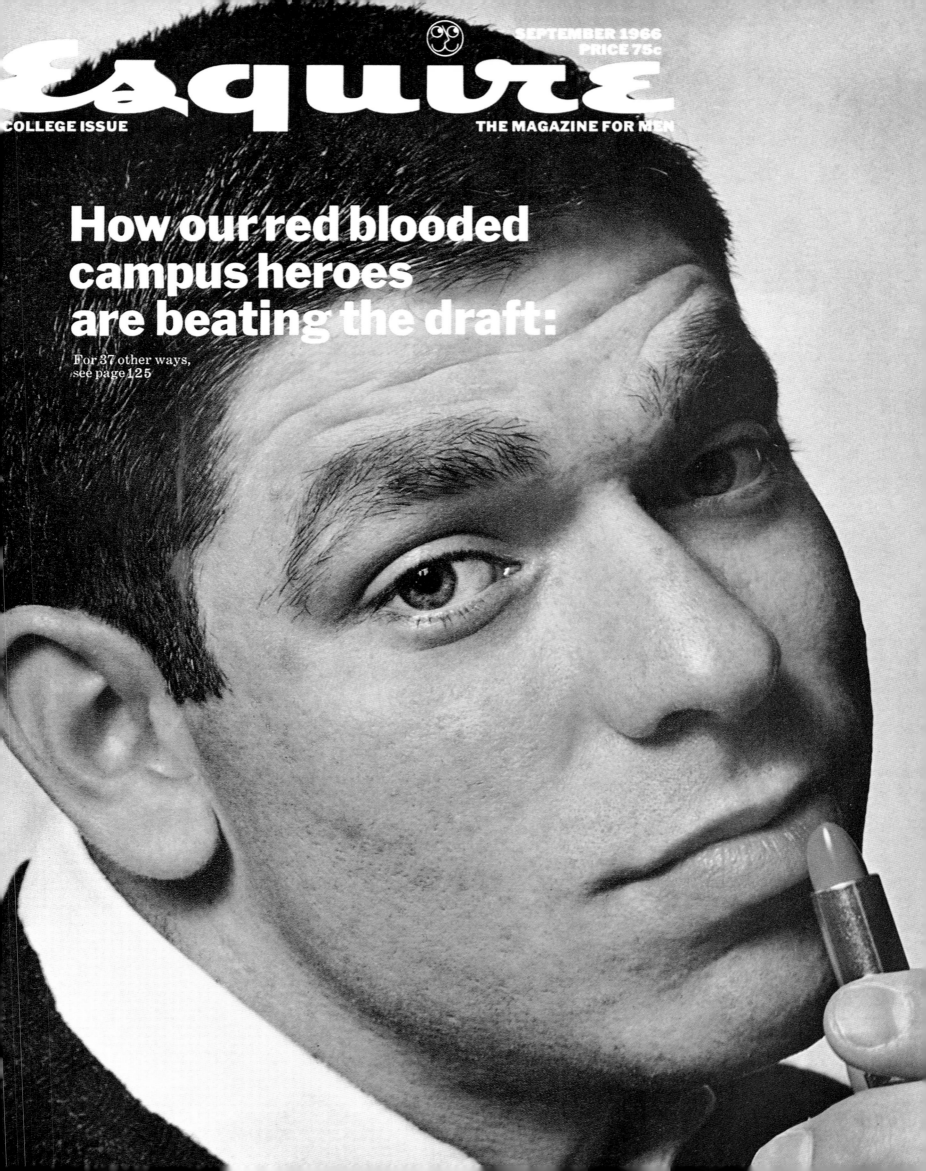

SEPTEMBER 1966
PRICE 75c

Esquire

COLLEGE ISSUE

THE MAGAZINE FOR MEN

How our red blooded campus heroes are beating the draft:

For 37 other ways, see page 125

A PREMATURE INDICTMENT OF THE VIETNAM WAR

The words are those of an American soldier in Vietnam,
as reported by John Sack in a lengthy article
about an infantry company, from basic training through combat.
This sentence leaped out at me
from Sack's description of a search-and-destroy mission.
The words are a GI's horrified reaction
as he comes upon the body of a dead Vietnamese child.
This cover appeared early in the war, more than two years
before the world heard of MyLai (where over three hundred old men,
women, children and babies were slaughtered by GIs).
But in 1966 "only" 350,000 Americans were in Vietnam
and "only" 6,000 had died there. The outcry against the war
was getting louder, but mostly on the campuses.
As a nation we were still in a deep sleep, and we never dreamed of MyLai.
In fact, the notion that just one American soldier could kill
just one Asian child, even inadvertently, was bitter medicine in 1966.
The cover screamed to the world that something was wrong,
terribly wrong. Good American boys were trapped in an evil war, with no end in sight.
Esquire was sharply criticized by many readers for this
"premature" indictment of the war itself.
As the carnage dragged on for years to come, concern
about killing a child became quaint.
(Small potatoes. What the hell, we were killing a little country.)
30 years later, Secretary of Defense war guru Robert McNamara,
whose number-crunching lies and blind obedience to
"his president" prolonged and exacerbated this brutally immoral war,
disingenuously told us "we" were wrong.
Big Mac's book sales totaled more than 58,000 American deaths
(but considerably less than the three million slaughtered Vietnamese).

OCTOBER 1966
PRICE 75c
GREAT BRITAIN 4/6

Esquire

THE MAGAZINE FOR MEN

"Oh my God –we hit a little girl."

The true story of M Company. From Fort Dix to Vietnam.

CHICAGO: BUTCHER OF THE WORLD

Only Harold Hayes had the guts and the nuts
to assemble this stunning team of underground intellectual
mavericks to go to the fateful Democratic Convention
in Chicago in 1968 and report to the nation.
A debilitated and despondent LBJ had shocked the nation
by quitting, lobbing his Vietnam hot potato
to a succeeding President. The television coverage of bitter wrangling
in the arena, intercut with Chicago cops splitting open young
demonstrators' heads as they chanted "The whole world is watching,"
laced together by film footage of GIs in mortal combat
in Vietnam, traumatized the nation.
Originally, Carl Fischer had been sent to Chicago to simply shoot
the unholy quartet at the Convention.
But watching the Chicago carnage, I came up with my cover idea
of a Christ-like image of a jeans-clad student,
lying in a bloody gutter at the feet of the wildest literary men of the time;
Jean Genet (the French high priest of decadence),
William Burroughs (the Beat Generation expatriate spokesman),
Terry Southern (the irreverent "Candy" man)
and John Sack (the antiwar war correspondent).
I called Carl and described the shot. When he tried to stage it in Chicago,
he damn near got himself and Esquire's reporting team arrested.
So I told them to hotjet it back to New York,
and we grabbed this dramatic image in the safe streets of Harlem.
(The convention went on to nominate the shell
of Hubert Humphrey, who had shrunk to being a yes-man
to his President. HHH fell victim to the bitterness of the fray,
ran an inept campaign and got beat by Tricky Dick's
"secret plan" that promised to bring our boys home by Christmas.
27,000 dead GIs later, home they came.)

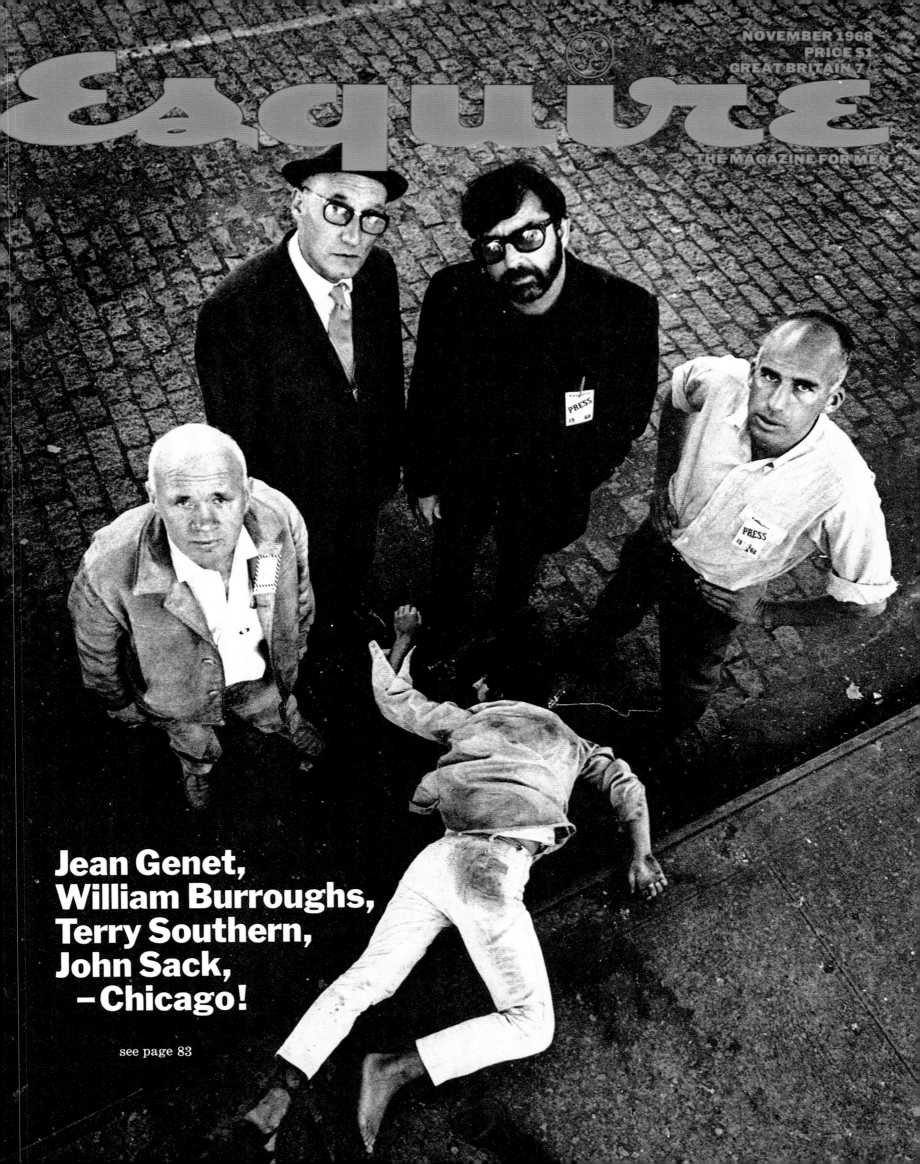

NOVEMBER 1968
PRICE $1
GREAT BRITAIN 7

Esquire

THE MAGAZINE FOR MEN

**Jean Genet,
William Burroughs,
Terry Southern,
John Sack,
–Chicago!**

see page 83

THE KILLER COVER

In November 1970, while William Calley was awaiting trial
for his role in the massacre at My Lai, Esquire scheduled an excerpt from
The Confessions of Lieutenant Calley, a book by John Sack.
"Tough subject for a cover," said editor Harold Hayes.
"He's innocent until the Army decides. And besides, he's a fall guy,
a scapegoat for an atrocious war. Think about it."
"Can we get Calley to New York for a sitting?" I asked.
"Sack probably can," he said, "but it depends on what you have in mind."
I explained the shot: "We'll show him with a bunch of Vietnamese kids.
Those who think he's innocent will say that proves it.
Those who think he's guilty will say that proves it."
Sack came to Carl Fischer's studio with the infamous lieutenant,
who was eager to oblige. Calley was edgy, almost suspicious.
The presence of this young nobody who had suddenly caught the attention of the world
and put a magnifying glass on the war gave that place an eerie feeling.
I took Calley aside to calm him down. I explained the shoot:
"Lieutenant, this picture will show that you're not afraid as far as your guilt
is concerned. The picture will say: 'Here I am with these kids
you're accusing me of killing. Whether you believe I'm guilty or innocent,
at least read about my background and motivations.'"
Calley grinned on cue, and we completed the session. When I sent
the finished cover to Hayes he called to let me know
that his office staff and Esquire's masthead bureaucrats were plenty shook up.
"Some detest it and some love it," he said.
"You going to chicken out?" I asked.
"Nope," he said. "We'll lose advertisers and we'll lose subscribers,
but I have no choice. I'll never sleep again
if I don't muster the courage to run it."

NOVEMBER 1970
PRICE $1

Esquire

THE MAGAZINE FOR MEN

The Confessions of Lt.Calley

See page 113

THE DUMMY ON LYNDON'S KNEE

When Hubert Humphrey was defending LBJ's Vietnam War
escalations, Harold Hayes assigned a writer to do a major piece
on the Vice President. As the article was being written,
I designed this punishing image of HHH as LBJ's dummy
(sculpted by the talented Stan Glaubach).
Lyndon Johnson was tied up at the time picking out mudhuts
to bomb in North Vietnam so I never asked him to pose.
The photograph was shot in a studio, using a model as large as LBJ.
Then I decapitated the photograph and substituted
the President's head (one of my notorious transplants).
When Hayes read the article, he called me to kill the cover. The writer had
done a *sympathetic* pro-Humphrey piece. But Harold thought my cover
was too good to kill. So on the right hand corner of the foldout
we inserted those three lines that we hoped would do right by Hubert.
Two years later, when I was in the Veep's office
in Washington for a meeting on political advertising,
I was astounded to see the cover hanging on the wall of his anteroom.
I told Humphrey that I was the author of that masterpiece.
"You no good sonofabitch," he told me straight out.
"Well then why do you have it on your wall?" I asked the Vice President.
"Because," he said, "maybe it's right."

NOVEMBER 1966
PRICE 75c
GREAT BRITAIN 4/6

Esquire

THE MAGAZINE FOR MEN

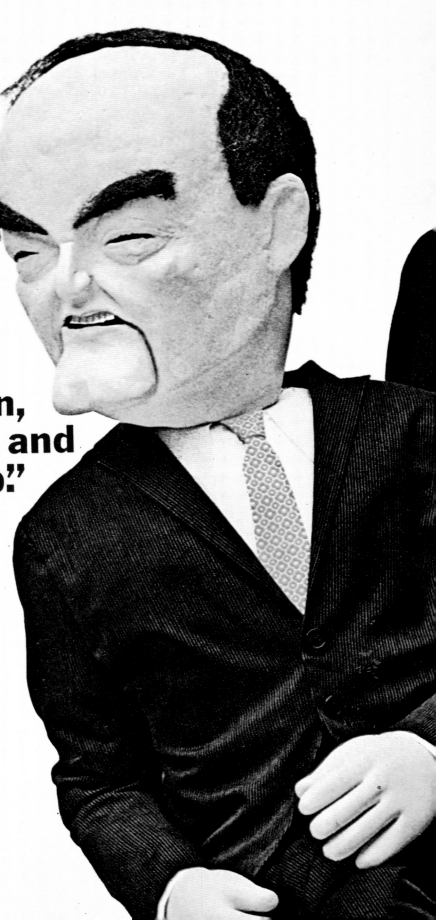

"I have known for 16 years his courage, his wisdom, his tact, his persuasion, his judgment, and his leadership."

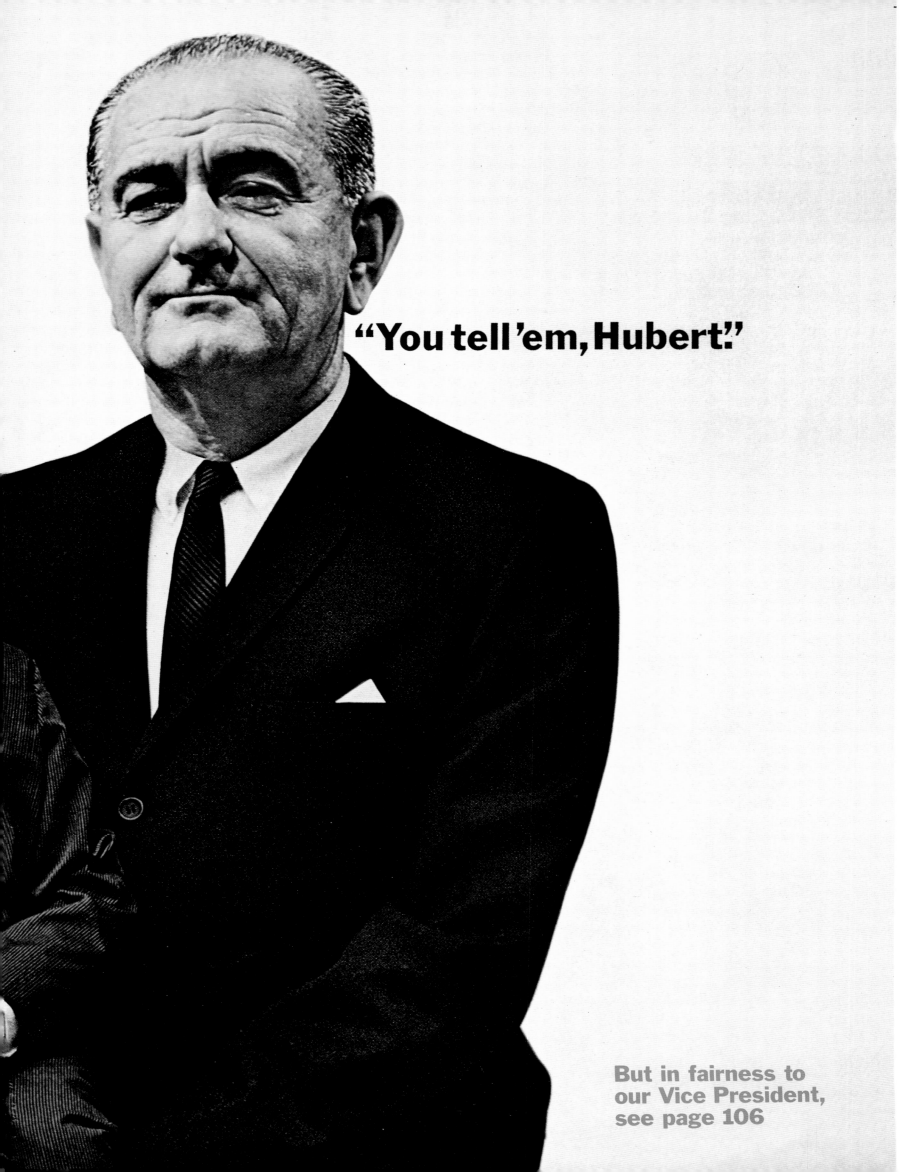

"You tell 'em, Hubert."

But in fairness to
our Vice President,
see page 106

HEROES AND ANTI-HEROES

UNCLE SAM AS ANTI-HERO

After the military folly called the "Bay of Pigs Invasion,"
a shaken but wiser President Kennedy showed new steel.
He powerfully and painstakingly maneuvered
Khrushchev into packing up his nuclear missiles and sailing back
to Moscow. The Cuban missile crisis scared
the hell out of America, especially us prime-target New Yorkers.
In our nation's capital, murderous and covert plots
against Fidel Castro kept the lights burning until the wee hours.
That was the atmosphere around this 1963 cover
of a vengeful Uncle Sam exhorting America to overthrow
the revolutionary populist government
that overthrew the corrupt and despotic Batista.
Predictably, it infuriated the top brass in the Pentagon.
They denied, but could not squelch, the hot, persistent rumors
of secret CIA hit squads conspiring against Fidel.
When my Uncle Sam whipped up the flames,
Semper Fi Marine Lieutenant Harold Hayes was bombarded
with telephone death threats, all in thick Cuban accents.
Hayes didn't dare inform his bosses of the threats,
for fear management would chicken out when Harold next went over
the editorial edge. He also swore me to secrecy.
By transforming the great (and patriotic) James Montgomery Flagg's
WWI poster, changing an altruistic Uncle Sam
into a symbol of American colonial arrogance, we sent out a signal.
The cover helped set the political tone and attitude
of Esquire for years to come. Six short months later,
not Castro but JFK was shot to death.
Makes you think.

JUNE, 1963

PRICE 60c

Esquire

THE MAGAZINE FOR MEN

THE C.I.A. WANTS YOU

JOIN UP FOR THE MARCH THROUGH HAVANA

FOR FURTHER RECRUITING INFORMATION SEE INSIDE

THE INDIAN NICKEL FLIES MOHAWK

I spotted an article on the American Indian in the advance draft of this Esquire.
On a lark, I phoned the Bureau of Indian Affairs in Washington
to find out if they had the remotest notion as to what Native American
posed for the Indian/buffalo nickel, and if he might still be alive!
I felt that I was on the verge of a major historical find, especially when
the Washington paleface called back and stammered on the phone in shock,
"His name is Chief Johnny Big Tree...he m-m-may still be alive...
if so, he should be on the Onondaga Reservation."
My father-in-law, a Syracusan, completed my research.
He drove out to the reservation, where he found Chief Johnny Big Tree
in the flesh, toting twigs to light a fire in his primitive, dirt-floor cabin.
He was a vigorous 87 years old and stood six-foot-two.
I couldn't wait to catch the first plane up there but Chief John loved to fly.
He showed up at Carl Fischer's studio in a business suit, sporting a crewcut.
In 1912, the sculptor James Earl Fraser spotted the Chief in a Coney Island
Wild West show and asked him to pose for his Indian head nickel,
destined to become the greatest coin designed since ancient Greece.
The Chief was a Seneca, a descendant of the Iroquois Confederacy,
which dates back to the 1500s. At the shoot, we dressed him in a black wig
and built up his toothless mouth with cotton wads. He looked awesome.
We shot his historic profile and he flew back to Syracuse on Mohawk Airlines.
It was vintage Americana—the legendary Chief Johnny Big Tree
a half-century after he posed for the Indian nickel!

March, 1964
price 60¢

Esquire

THE MAGAZINE FOR MEN

Good Indians we got (page 58). Bad Indians you can have (page 76).

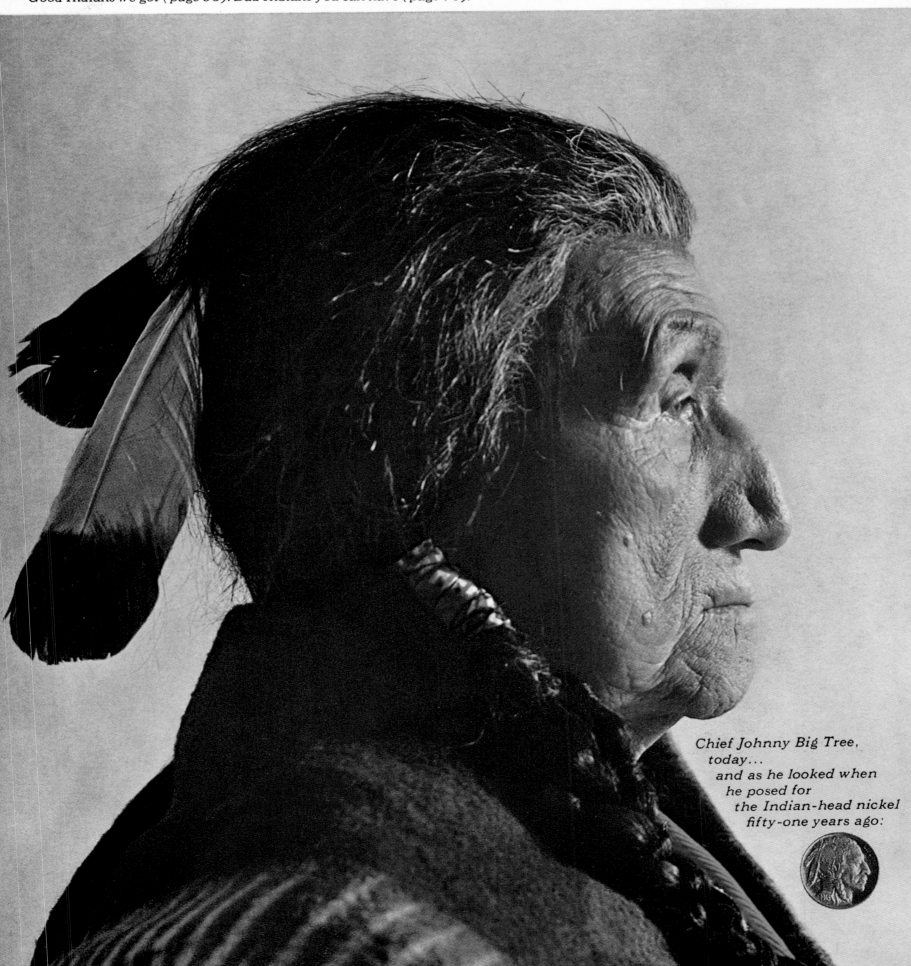

Chief Johnny Big Tree,
today...
and as he looked when
he posed for
the Indian-head nickel
fifty-one years ago:

THE FACE OF A HERO

For this Esquire College Issue, in a time
when we still embraced heroes,
I created this composite of the men I chose as the
leading heroes in the eyes of American youth.
Bob Dylan, Malcolm X, Fidel Castro and John Kennedy are divided
(and joined) by the crosshairs of a rifle sight.
Kennedy and Malcolm had been murdered, and Castro
(we now know) escaped several assassination attempts,
and has been named as a possible source
of JFK's assassination. Dylan remained to compose
and sing of that violent, revolting age.
(Today, alas, without heroes, we must make do with celebrities.)

BACK TO COLLEGE ISSUE
SEPTEMBER 1965 PRICE 75c

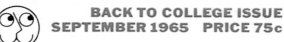

Esquire

THE MAGAZINE FOR MEN

4 of the 28 who count most with the college rebels:

(for the others see page 97)

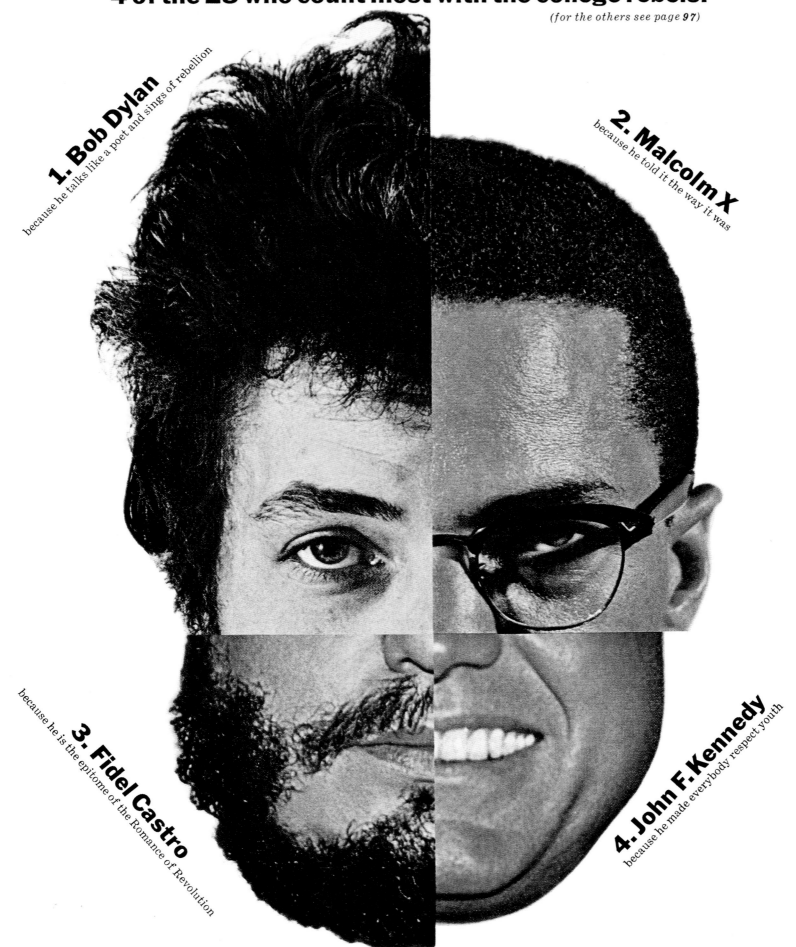

1. Bob Dylan
because he talks like a poet and sings of rebellion

2. Malcolm X
because he told it the way it was

3. Fidel Castro
because he is the epitome of the Romance of Revolution

4. John F. Kennedy
because he made everybody respect youth

ALSO IN THIS ISSUE: WHAT EVERY IVY-LEAGUE GIRL SHOULD KNOW; STEALING AS A WAY OF COLLEGE LIFE;
THE INSIDE STORY OF THE BIG BEACHBOY CAPER; A FIRST LOOK AT S.P.I.D.E.R. MAGAZINE

FAMOUS PEOPLE BEYOND REPROACH

The '60s were a time when
Americans were becoming suspicious of celebrities,
politicians, even their sports heroes.
From a balcony above these "Unknockables"
(Helen Hayes, Jimmy Durante, Kate Smith, Marianne Moore,
Eddie Bracken, John Cameron Swayze, Joe Louis and Norman Thomas),
Carl Fischer asked them to look up at his camera.
Norman Thomas was suffering from a painful
spinal paralysis and couldn't move his neck.
Joe Louis leaned over and said gently to the old socialist,
"Oh, Mr. Thomas, you never had trouble
sticking your neck out *before.*"

JUNE 1966
PRICE 75c

Esquire

THE MAGAZINE FOR MEN

In a time when everybody hates somebody — nobody hates

The Unknockables

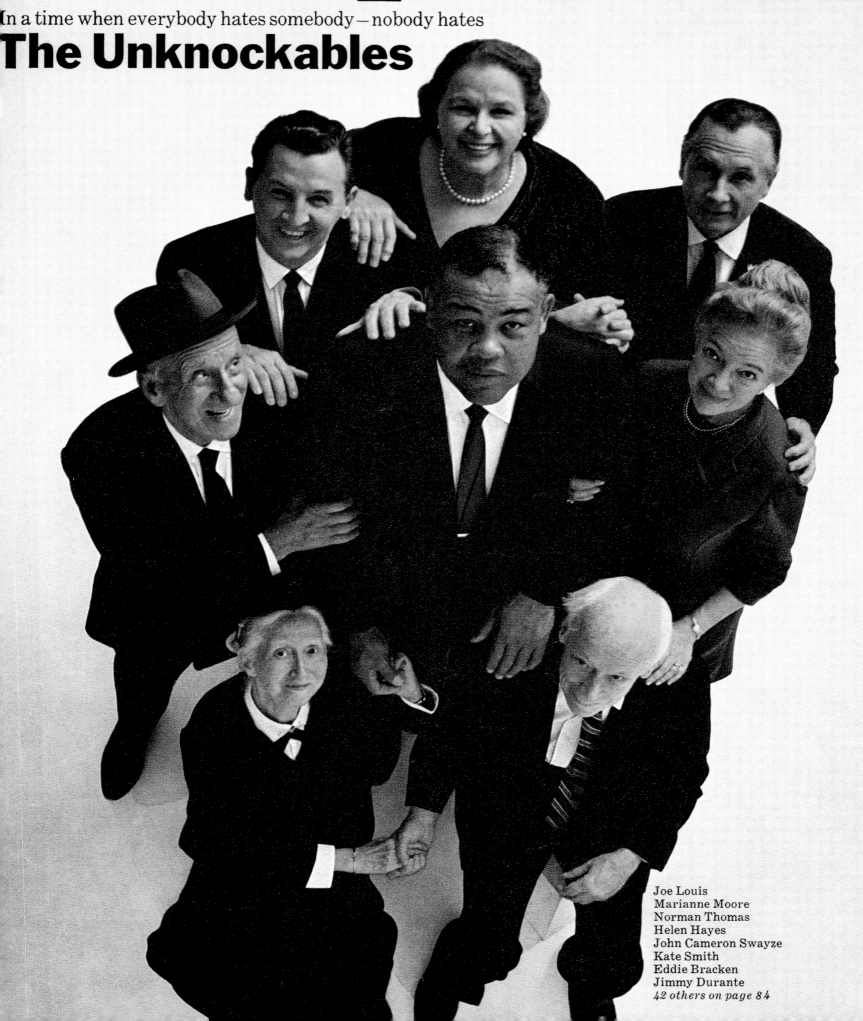

Joe Louis
Marianne Moore
Norman Thomas
Helen Hayes
John Cameron Swayze
Kate Smith
Eddie Bracken
Jimmy Durante

42 others on page 84

THE ANGEL COHN

To illustrate a self-serving piece by Roy Cohn
in which he rationalized his skullduggery
as the demagogue Senator Joe McCarthy's
favorite gofer during the '50s,
I asked him to pose as the angel he thought he was.
I made no bones about the photo:
he was to be shown wearing a halo that was visibly
pinned on, a self-applied halo.
He posed for the shot and said as he was leaving the studio:
"I suppose you're going to pick the ugliest one."
"You bet," I said. "I hate your guts."
For once in his life he was speechless.

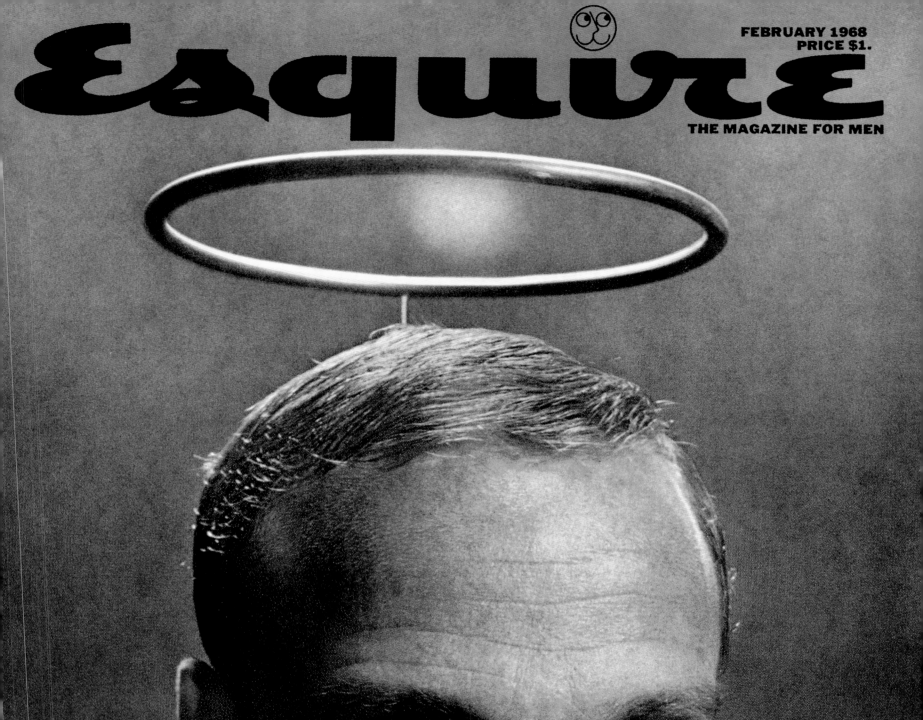

FEBRUARY 1968
PRICE $1.

Esquire
THE MAGAZINE FOR MEN

*Joe McCarthy's Roy Cohn
tells it like it was.*

YO!

The very thought that the U.S. Army,
mid-war, could be *unionized* surely warranted
an Esquire cover. And that's why
this ethnic GI, recently drafted, chewing out
a waspy four-star General,
commanded a lot of attention.

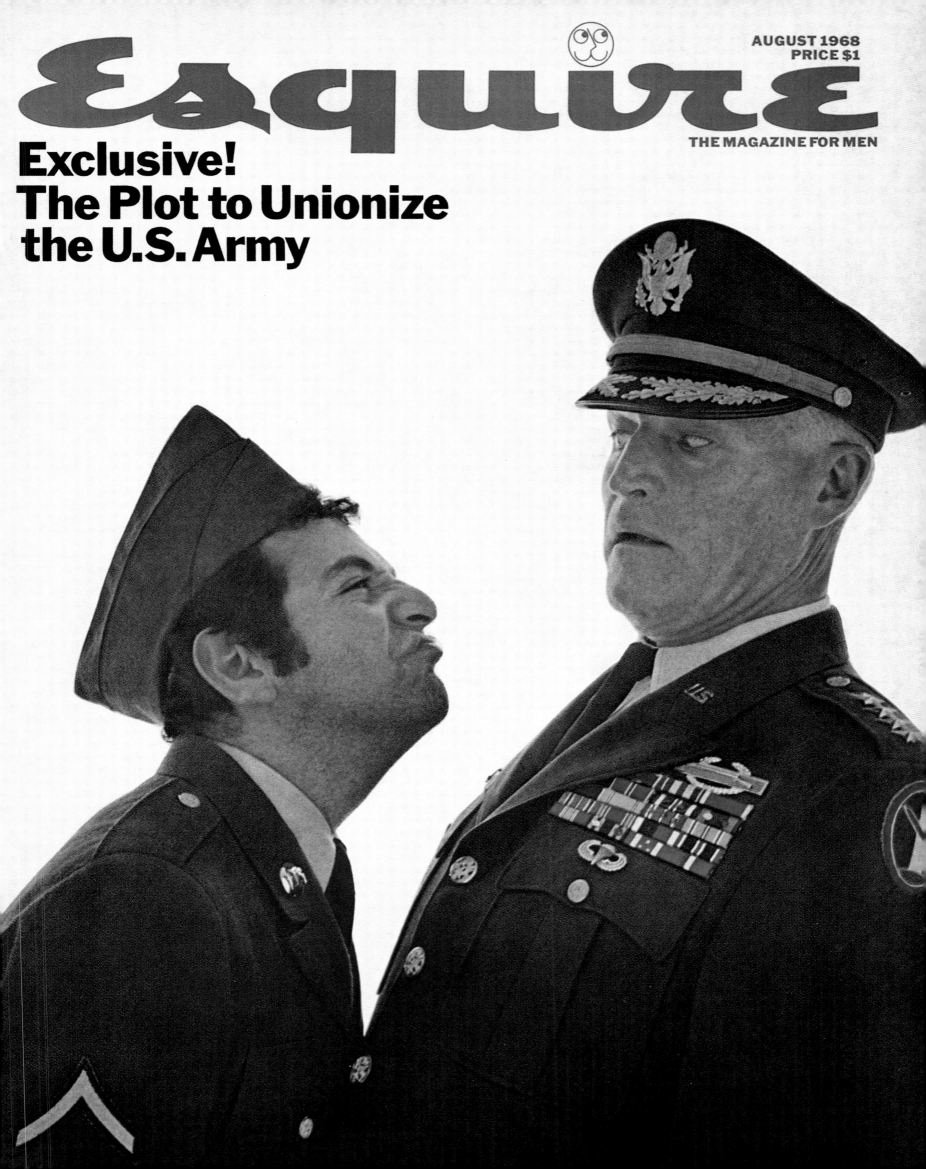

AUGUST 1968
PRICE $1

Esquire

THE MAGAZINE FOR MEN

Exclusive!
The Plot to Unionize
the U.S. Army

YOU SHOULDA HEARD
THE COPS SQUEAL

During those nasty years when antiwar
demonstrations were met by derision,
spit and street violence,
the youth of America vented their disrespect
on the mean-spirited arm
of the authorities, the police.
Cops were so severely scorned that
this cover was considered by
many to be an insult to the animal kingdom.
Esquire got bagfuls of hate mail
from cops, but the cover became a favorite
of the college crowd,
and hung in dorms for years.

Back to College Issue

SEPTEMBER 1969
PRICE $1

Esquire

THE MAGAZINE FOR MEN

The Kids VS The Pigs

Freshman Orientation Package

See page 85

12 ANGRY MEN AND A NO-SHOW

In November 1969 I did my third Ali cover
(see Covers 46 and 61). At the time, the great heavyweight champion
remained stripped of his title for refusing military service.
We enlisted twelve good souls to climb into the boxing ring
and publicly support Ali's right to go back to work.
One giant who had agreed to join the protest
was his fellow Muslim, Kareem Abdul-Jabbar of the L.A. Lakers.
I envisioned the seven-footer standing tall in the midst of the literary great
Truman Capote, Pop artist Roy Lichtenstein, sports announcer
Howard Cosell, and anti-Vietnam War Senator Ernest Gruening.
My dozen heroic combatants patiently waited for over two hours,
but Jabbar, alas, was a no-show.
His explanation to me for his embarrassing absence was that
he feared "retaliation," not by the white establishment,
but by competing factions in his Muslim world.
Finally, in 1970, the Supreme Court stood in Ali's corner
and Muhammad went back to work.

Esquire
THE MAGAZINE FOR MEN

We believe this:
Muhammad Ali deserves the right to defend his title.

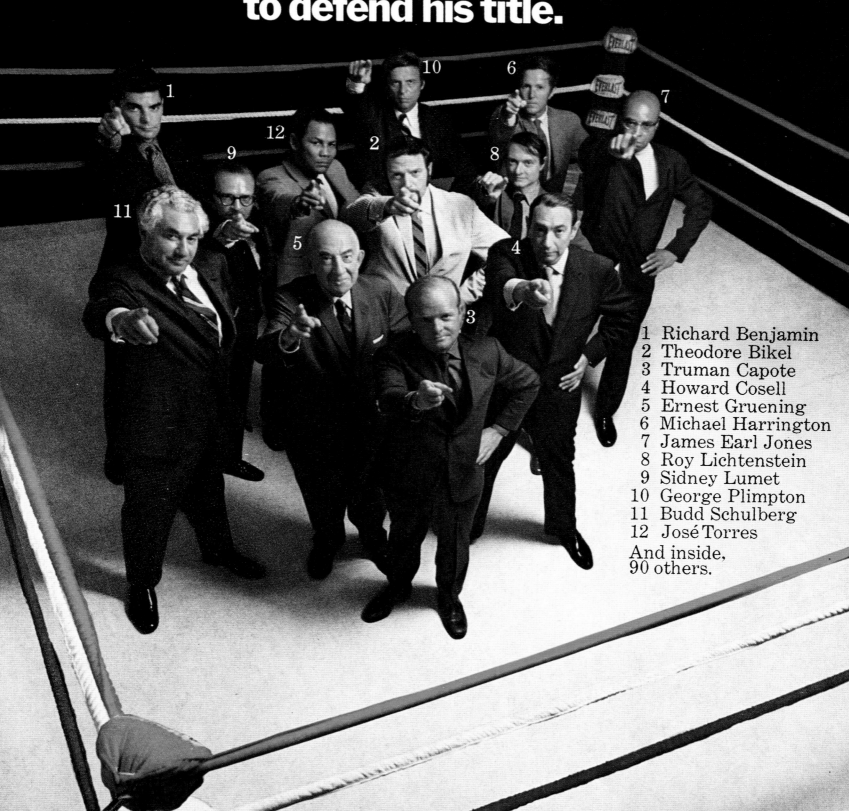

1 Richard Benjamin
2 Theodore Bikel
3 Truman Capote
4 Howard Cosell
5 Ernest Gruening
6 Michael Harrington
7 James Earl Jones
8 Roy Lichtenstein
9 Sidney Lumet
10 George Plimpton
11 Budd Schulberg
12 José Torres
And inside,
90 others.

PORTRAIT OF A LOVING PARENT

Before Gay Talese's *Honor Thy Father* was published,
Esquire ran a lengthy excerpt from the book on the
Joe Bonanno family, a labor of love that had taken six years to write.
When I read the piece, I realized that its title was incredibly apt.
Although *Honor Thy Father* was a major study of an Italian-American family
enmeshed in the Mafia over two generations,
it caught the deep love and loyalty between son and father,
between Joe Bonanno Jr., then in federal prison, and Joe Sr.,
who died a ruined man. I felt the subject should be handled with a shocking
reverence, rather than with Mafia-reporting sensationalism.
So I got Talese to get me an entrée into the Bonanno home in New Jersey,
where I hoped to get a family photo of the elder Joe Bonanno.
His widow was suspicious, but Gay explained in his lush Italian
what we were after and why. Mamma Bonanno dug up a few
'30s-style sepia shots, including this gem, and I knew I had the cover,
one that expressed perfectly a son's respect for his father,
no matter what the old man's line of work.

AUGUST 1971
PRICE $1

Esquire

THE MAGAZINE FOR MEN

Honor thy Father

The story of Joe Bonanno and his son
by Gay Talese

DEBUNKERS

CLEOPATRA'S ENORMOUS CLEAVAGE

Cleopatra was a $40 million production – the most expensive
movie ever made at that time. During its filming,
the affair between Richard Burton and Elizabeth Taylor
(while hubby Eddie Fisher was growing horns) was a worldwide sensation.
Esquire did a long piece on the stars' open romancing on the set.
The hotter their affair the better for Cleopatra's box office.
This is a closeup of a billboard in progress over the Rivoli Theatre
in Manhattan a few weeks before the premiere.
The painters had already finished Elizabeth Taylor's breasts,
so I slipped them a twenty to raise the scaffold
and get back to the focal point of that incredible farce.

AUGUST, 1963
PRICE 60c

Esquire

THE MAGAZINE FOR MEN

THE CLEOPATRA PAPERS. ABSOLUTELY, POSITIVELY THE LAST WORD. NO KIDDING. P. 33

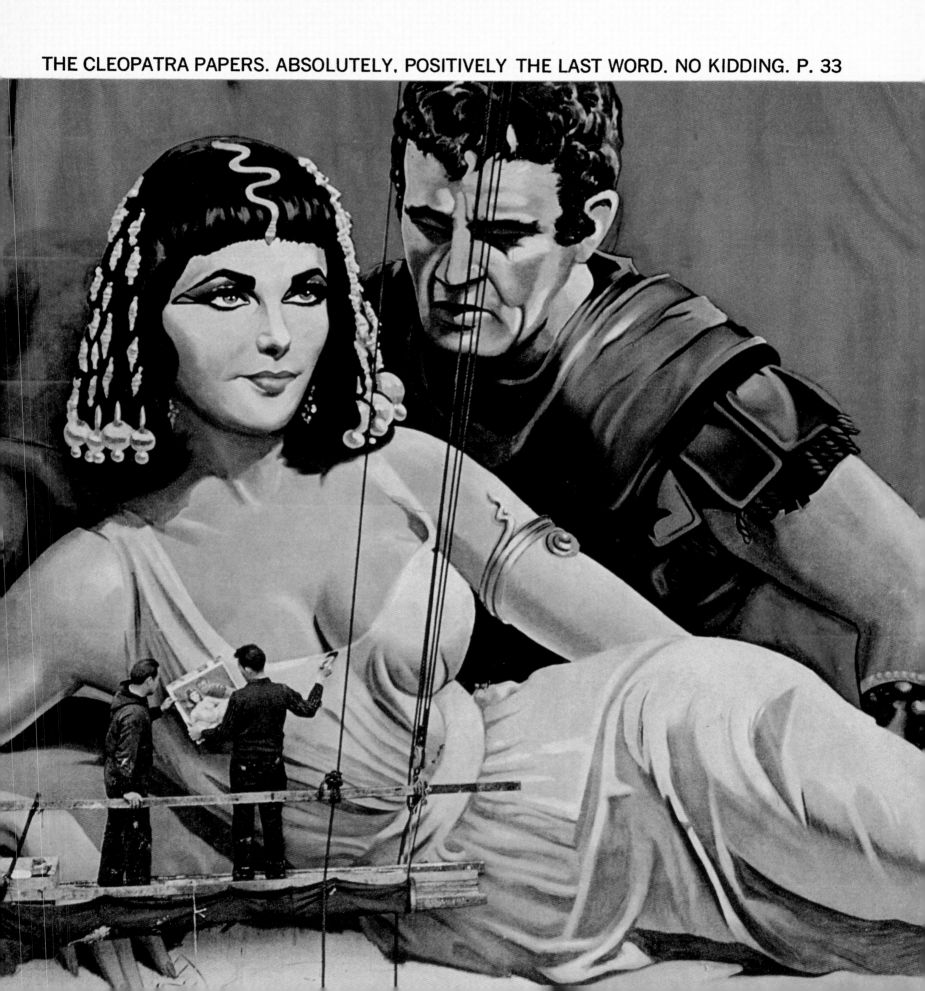

MY BIZARRE HARPER'S COVER

Esquire took a swipe at Vogue and Harper's Bazaar by showing
what truly goes on at a high–fashion shoot.
As trusty as calendars, the great fashion models are time-markers
of our fast-changing popular culture.
When I staged this cover to symbolize real versus imagined glamour,
Jean Shrimpton's fresh '60s look was replacing
haughty Suzy Parker as the new haute couture glamourpuss
(with Twiggy forecasting the coming of Kate Moss, sullen waif of the '90s).
As expected, both Parker and Shrimpton were appalled
by my debunking concept for an Esquire cover. In those days,
these stork-like mannequins, armed with designer creations,
lacquered nails, ruby lips and nylon legs up to their shoulders,
were not famous for their sense of humor.
But Delores Wettach, a beauty with a mind (and brains) of her own,
ignored the advice of her mentors at the Ford Model Agency.
She dug out her grungiest jeans and sneakers,
belted down a Pepsi, took a drag on her Benson & Hedges,
hunkered down on some milk crates and looked
magnificent for fashion photographer Art Kane's camera.

OCTOBER, 1963
PRICE 60c
GREAT BRITAIN 4/6

Esquire

THE MAGAZINE FOR MEN

INSIDE THE SQUARE: GLAMOR. OUTSIDE: REAL LIFE. TO LEARN THE DIFFERENCE, SEE PAGE 00

SIR LANCELOT HE'S NOT

Lyndon Johnson, thrust into the Presidency by Lee Harvey Oswald,
tried to carve out his own greatness with his proclamation
of America's "Great Society." To help win the South, Jack Kennedy had
cynically enlisted the garrulous Texan as his running mate in 1960,
then buried ambitious LBJ in traditional and inane VP duties with the
blessing of baby brother Robert, his young hard-charging
Attorney General. The promise of Camelot pervaded the White House
of John F. Kennedy and his ethereal first lady. When it all
turned to dust on November 22, 1963, a crude, shit-kicking Texan
and his low-flying Lady Bird moved into the nation's first home.
Compared to the royal style of young Jack and Jackie, Lyndon and Lady Bird
were hopelessly outclassed. Stuffing Lyndon's sour puss inside
a gleaming Sir Lancelot getup made him look as foolish as I had hoped.
A year before this cover, I had done Robert Kennedy's New York Senatorial campaign.
We had blunted the carpetbagger charges against Bobby and dramatized
his energy and humane-ness. Even so, I had pre-election fears, so in the last
two weeks, as Johnson's campaign against the extremist
Barry Goldwater caught fire, I convinced Bobby to sign off our TV spots with:
Get on the Johnson, Humphrey, Kennedy Team, hoping the "party line"
ploy would bring even those Democrats who didn't like Bobby into the fold.
After eking out his victory, Bobby hated Johnson's guts more than ever.
I don't think he ever forgave me (and maybe himself) for garnering
those last-minute coattail votes. Long after the election and the day
this cover hit the newsstands, I was having lunch at The Four Seasons
when a bottle of wine arrived at my table. The note read:
"Dear George,
I see you finally got off the Johnson-Humphrey team.
Love the Esquire cover!"
Looking across the pool to spot the donor, I saw
Senator Bobby rabbit-grinning at me.

esquire

THE MAGAZINE FOR MEN

Jack Kennedy was a prince among men. How do you feel about Lyndon Johnson?

see page 87

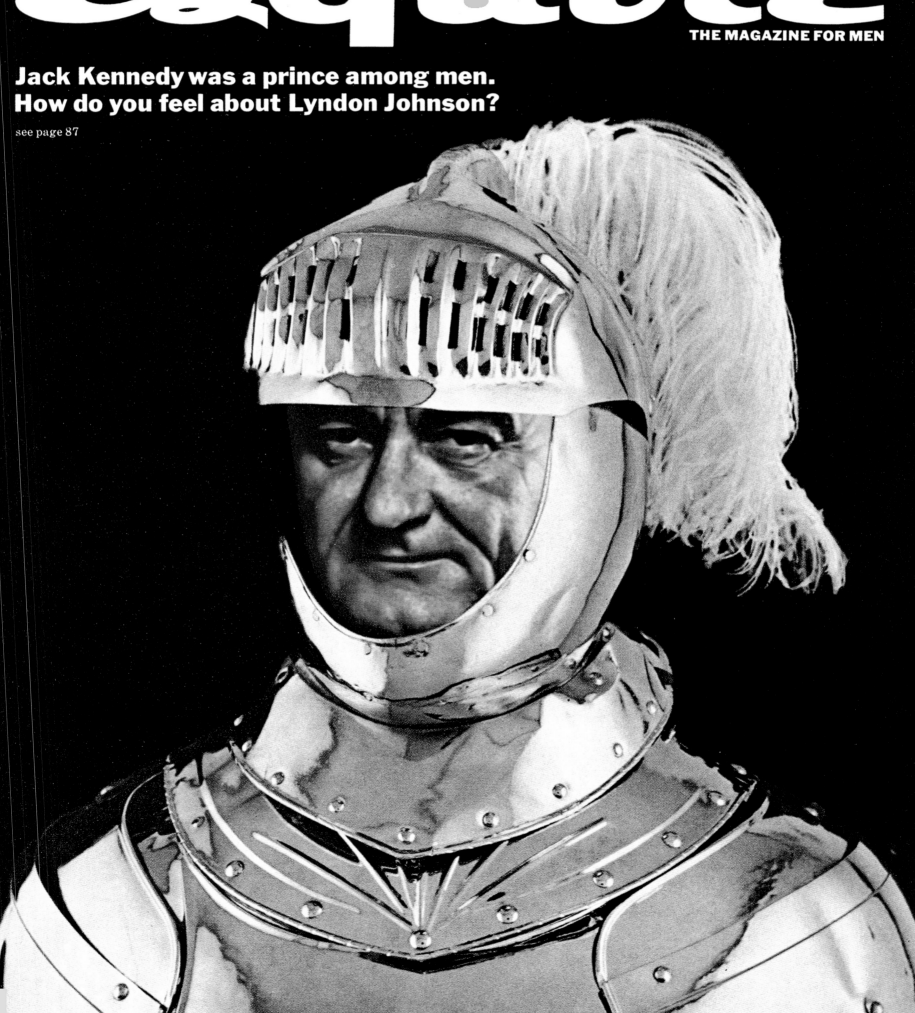

CAMPUS WARRIOR

After we won the great war against fascism, the scare of "the red menace"
plunged America into the fearful period of McCarthyism. Shamefully,
we were becoming exactly the kind of society we had fought so valiantly against.
Our "police action" against the North Koreans, which drew in the Chinese,
cost us almost 55,000 dead (roughly the same amount as Nam, and in one-third the time).
The American people had been apathetic about the Korean "Conflict,"
but grew sickened with the loss of life in Vietnam.
Fighting a war on foreign shores to protect against the encroachment
of communism didn't mean a damn to the average American,
and young men dodged the draft in droves. The poor got nailed
and college students were deferred. No other prominent magazine in America
questioned the war, let alone attacked it. The hawks were flying.
But Hayes let me run a half dozen Esquire covers that said the war sucked.
Many students loved America and idealized North Vietnam's role
in the war as a utopian experiment in freedom and self-determination.
On college faculties, many scholars of cultural and political
philosophy opposed the war. They watched television reports of American
firepower being used to suppress a peasant rebellion against oppression
that resembled the American Revolution we were so proud of!
I firmly believed all this and knew "The Domino Theory" was a con-job.
But in an unexpected flip-flop, this cover snidely took a shot at the antiwar
activists who were raising hell on campus.
I rationalized it as a parody of the self-righteousness and self-importance
of much of the growing antiwar movement. I depicted
"campus warriors" as long-haired nerds who were just trying to save their ass.
For the life of me, I couldn't figure out what possessed me
to do the cover until my rabbi, ex-Marine Lt. Harold Hayes, said,
"George, you couldn't help it. You're a pissed-off Korean vet!"
To this day, I take heat for the cover from my wife, Rosie,
a fighter against McCarthyism, a young Korean War wife
and a proto-demonstrator against the Vietnam War.

SEPTEMBER 1967
PRICE $1

Esquire

COLLEGE ISSUE

If you think the war in Vietnam is hell, you ought to see what's happening on campus, baby.

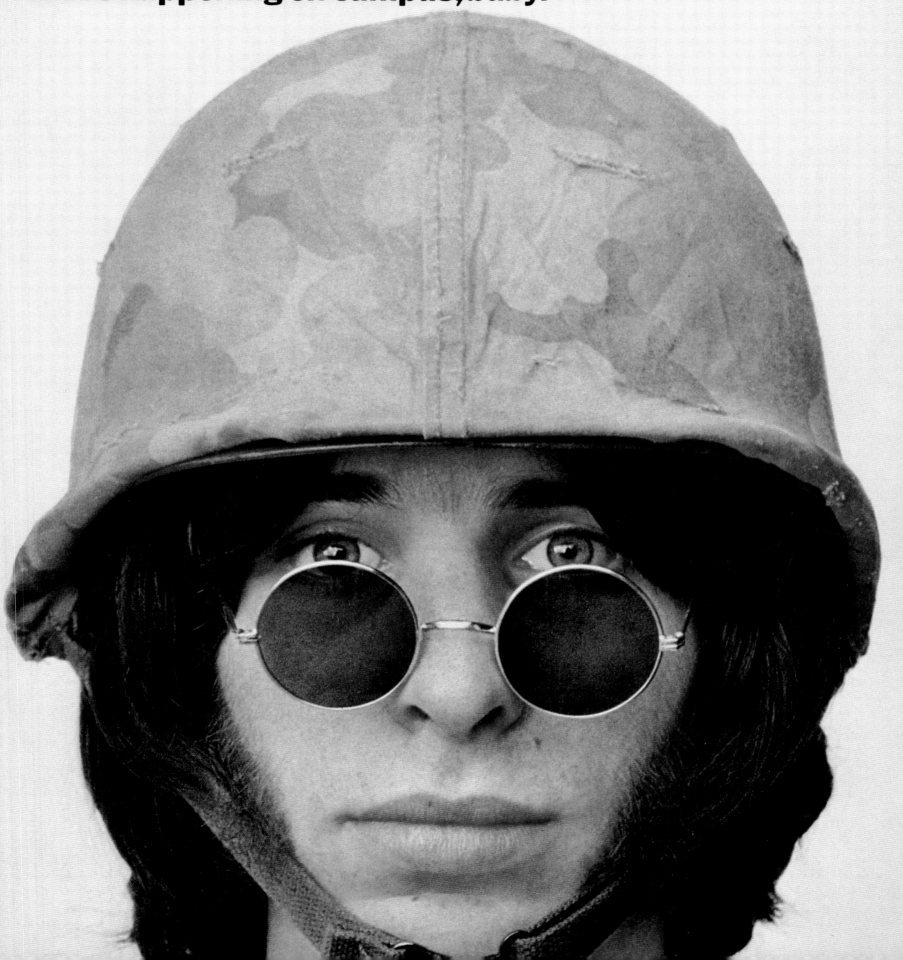

THE BALL(S) OF TRUMAN CAPOTE

On the night of November 28, 1966, Truman Capote threw "a little masked ball"
reminiscent of Versailles in 1788, in honor of
Washington Post President Katherine Graham, inviting 540 of his closest friends.
Rose Kennedy, Frank Sinatra and Mia Farrow,
William and Babe Paley, Andy Warhol, Tallulah Bankhead,
John Kenneth Galbraith, Harold Prince and William F. Buckley Jr. were among
those anointed and summoned to the Grand Ballroom of the
Plaza Hotel in New York, wearing masks and dressed in black and white.
They joined "Betty" Bacall and Jerry Robbins dancing the night away.
Years had gone by without any important writing by Capote.
He was a great writer, but consumed by hobnobbing with the rich and famous,
who treated him like a Pekingese sitting on a needlepoint pillow for them to pet.
An anonymous poem of the time went this way:

> Truman Ca-potty
> is not nearly as dotty
> As some of the people
> Who went to his party.

The complete guest list was, believe it or not, published in The New York Times.
A year later, the world was still abuzz about Truman's Ball.
The Gods of Power (celebrity, cultural and political)
spoke of it as Truman's greatest coup. Norman Mailer's deft
backstab was, "To me, that party was greater than any of his books!"
So I tried to put all the spin to rest with a final,
sour grapes cover depicting an eclectic and unmasked group
sweetly sticking their uninvited tongues out at Capote.
The only person with the hubris to ever outdo Truman Capote was
the flamboyant Malcolm Forbes with his airlift shindig
in Morocco for 880 pals in 1991. In an ad for No Excuses jeans,
I gave him one of my monthly No Excuses Awards:
"To Malcolm Forbes. For feeding 880 hungry people in Africa."
They don't give parties like that anymore.
Of course not. They're all dead.

The Party Poopers:
Screen Star Kim Novak
NFL Great Jim Brown
JFK Press Secretary Pierre Salinger
Baseball Legend Casey Stengel
"Georgy Girl" Lynn Redgrave
Broadway Reporter Ed Sullivan
California Governor Edmund "Pat" Brown
Leading Man Tony Curtis

DECEMBER 1967
PRICE $1
GREAT BRITAIN 6/-

Esquire

THE MAGAZINE FOR MEN

"We wouldn't have come even if you *had* invited us, Truman Capote!"

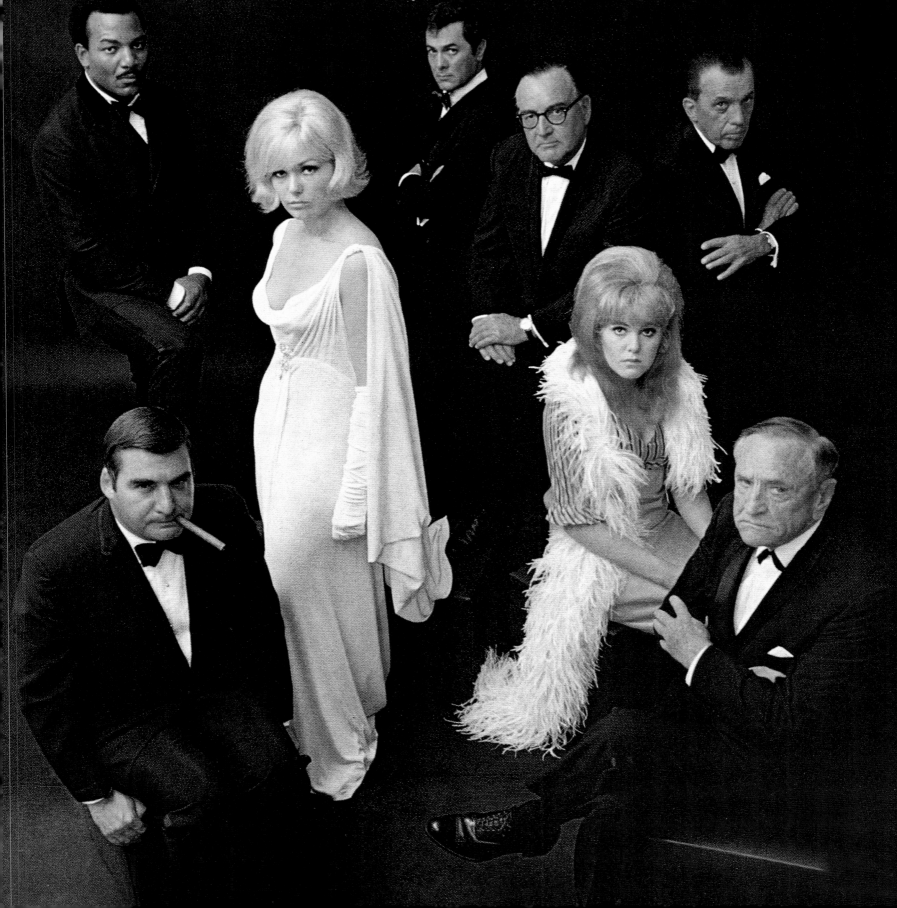

DUBIOUS ACHIEVEMENTS

A delighted Harold Hayes proclaimed that two things
kept Esquire on its new ballbusting course:
The monthly shock of my "graphic editorial" covers,
and the new Dubious Achievement Awards,
a kick-ass roundup of the previous year's events.
These Awards were always heralded by the running gag
"Why is this man laughing?" under a hyena-faced Nixon.
(Art director Robert Benton, a future Oscar-winning director,
and David Newman, a soon-to-be terrific screenwriter,
dreamed up this ever-popular feature.) When Esquire received
a National Magazine Award, The Atlantic Monthly commented:
"Esquire has waxed fat and prosperous on a formula:
Those Lois covers in calculated bad taste...
and those painfully unfunny Dubious Achievement Awards.
Mr. Hayes is some kind of alchemist who has
gone pop with his left hand and serious with his right...
and somehow made it work."
In her well-researched book on Esquire in the mid-'60s
(*It Wasn't Pretty, Folks, but Didn't We Have Fun?*)
Carol Polsgrove pointed out:
"For all Hayes' efforts to encourage varied points of view—
and Esquire's range outstretched any other magazine's—
Esquire did have a satiric stance, announced each month
in George Lois covers...
and at the start of every year in the Dubious Achievement Awards.
Readers expected Esquire to be, among other things,
funny, in a twisted, intelligent way."
This January 1968 cover was one fashionable way
they both came together, and *worked.*

Esquire

JANUARY 1968
PRICE $1.
GREAT BRITAIN 6/-

THE MAGAZINE FOR MEN

7th Annual Dubious Achievement Awards In Fashion:

To the Ku Kluxer who attended a rally in North Carolina wearing a white mini-robe. (Boo!)

To Geoffrey Beene who with stunning creativity transformed an elegant evening gown into Bob Lilly's football jersey.

To all those cute boy designers who turn full-fledged women into little orphan annies. (Arf!)

And for the skin you "Do Not Touch," we thank Cosmetic Body Paint. (Eecchh!!)

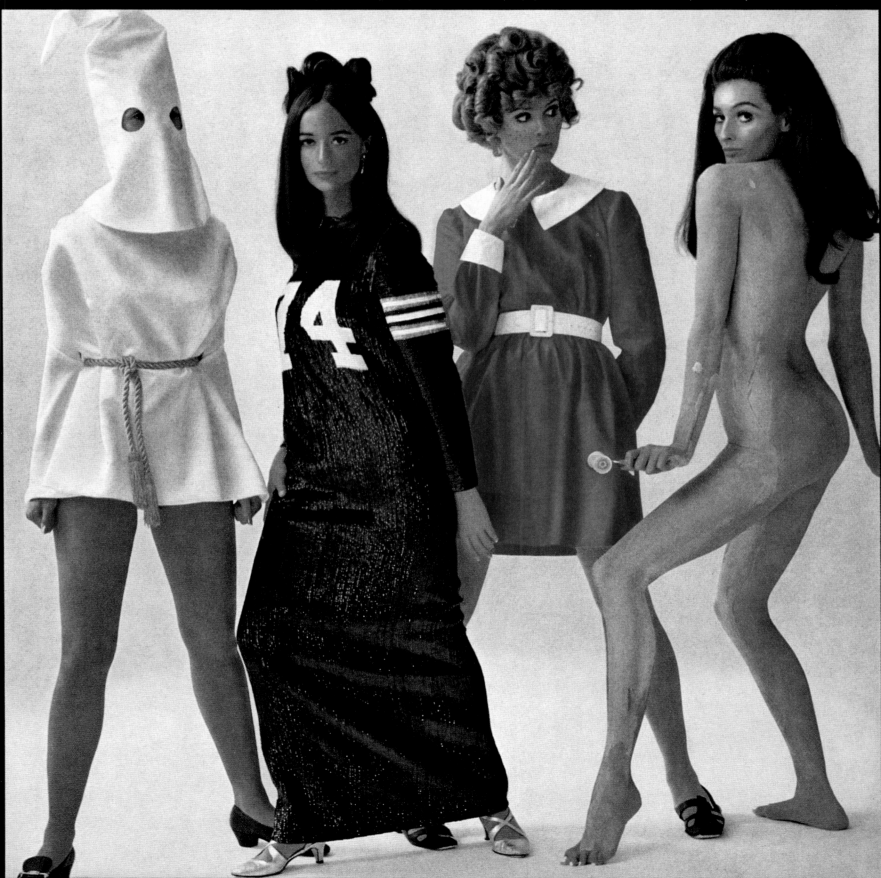

HOW I TAUGHT NIXON TO USE MAKEUP AND BECOME PRESIDENT

I did this cover in the spring of 1968, before Nixon was nominated,
while he was still hustling around the country begging for delegates.
This composite shot was a satirical comment on the 1960 TV debates
when the Whittier whiz lost to John Kennedy
by a five o'clock shadow because he looked evil in front of the cameras.
I located this profile shot in the wire service archives
and had Carl Fischer photograph the four hands, including the one
wielding the lipstick. What's interesting about this image
is the way Nixon's gang reacted to it. Shortly after it appeared, editor
Harold Hayes got a phone call from a guy on Nixon's staff.
He was miffed. In fact, he was incensed. You know why? The lipstick.
He said it was an attack on Nixon's masculinity.
Those birds in Nixon's corner didn't laugh too easily.
He called Hayes a "lousy liberal" and hung up.
The Watergate tapes later revealed the astounding paranoia
that consumed Nixon and his clean-cut goons.
I'm sorry Harold never wrote down the name of the 1968 caller,
because the bum probably went to jail,
or is a guest or a host of a talk show now.

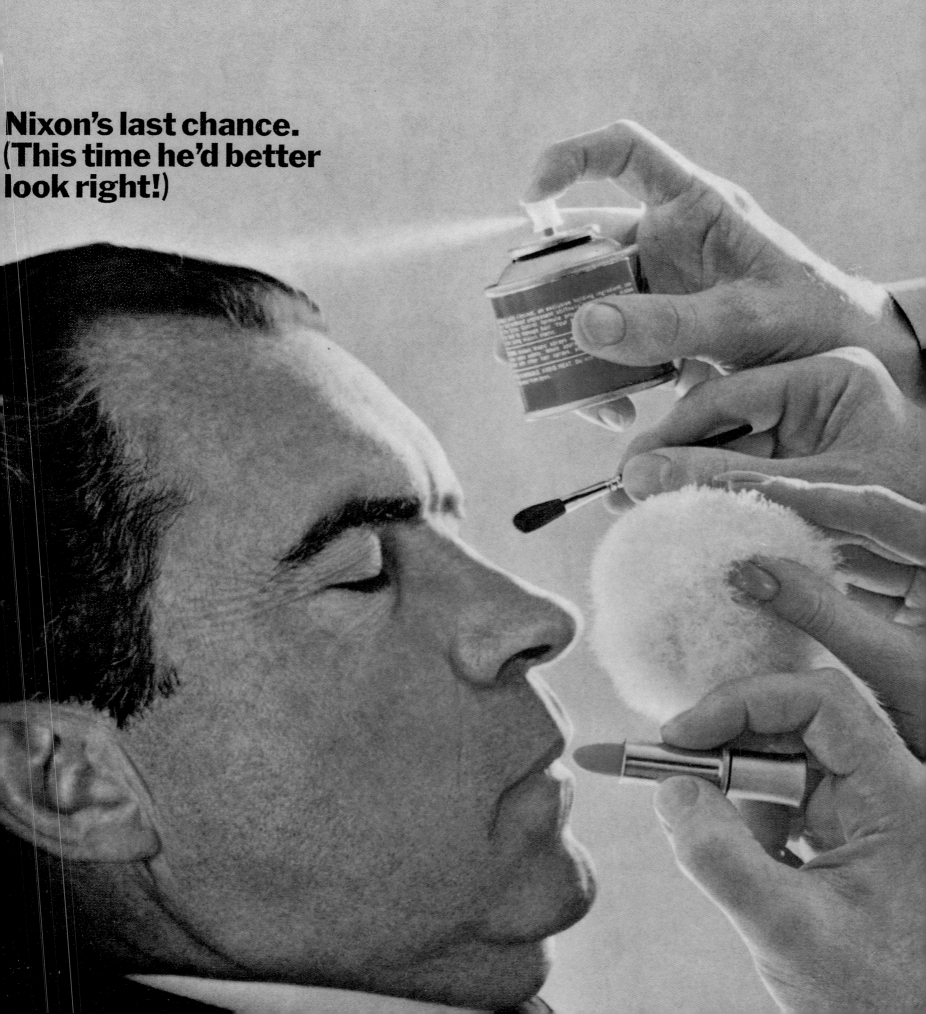

Esquire

MAY 1968
PRICE $1.

THE MAGAZINE FOR MEN

**Nixon's last chance.
(This time he'd better
look right!)**

NOT JUST 3 PRETTY FACES

There were seven million kids at college in 1968,
and their favorite performers included
the beautiful Tiny Tim (*Tiptoe through the Tulips*),
the beautiful Michael J. Pollard (*Bonnie & Clyde*)
and the beautiful Arlo Guthrie (*Alice's Restaurant*).
It wasn't easy to make them look even more beautiful
than they really happened to be,
but I do believe this cover succeeded beautifully.

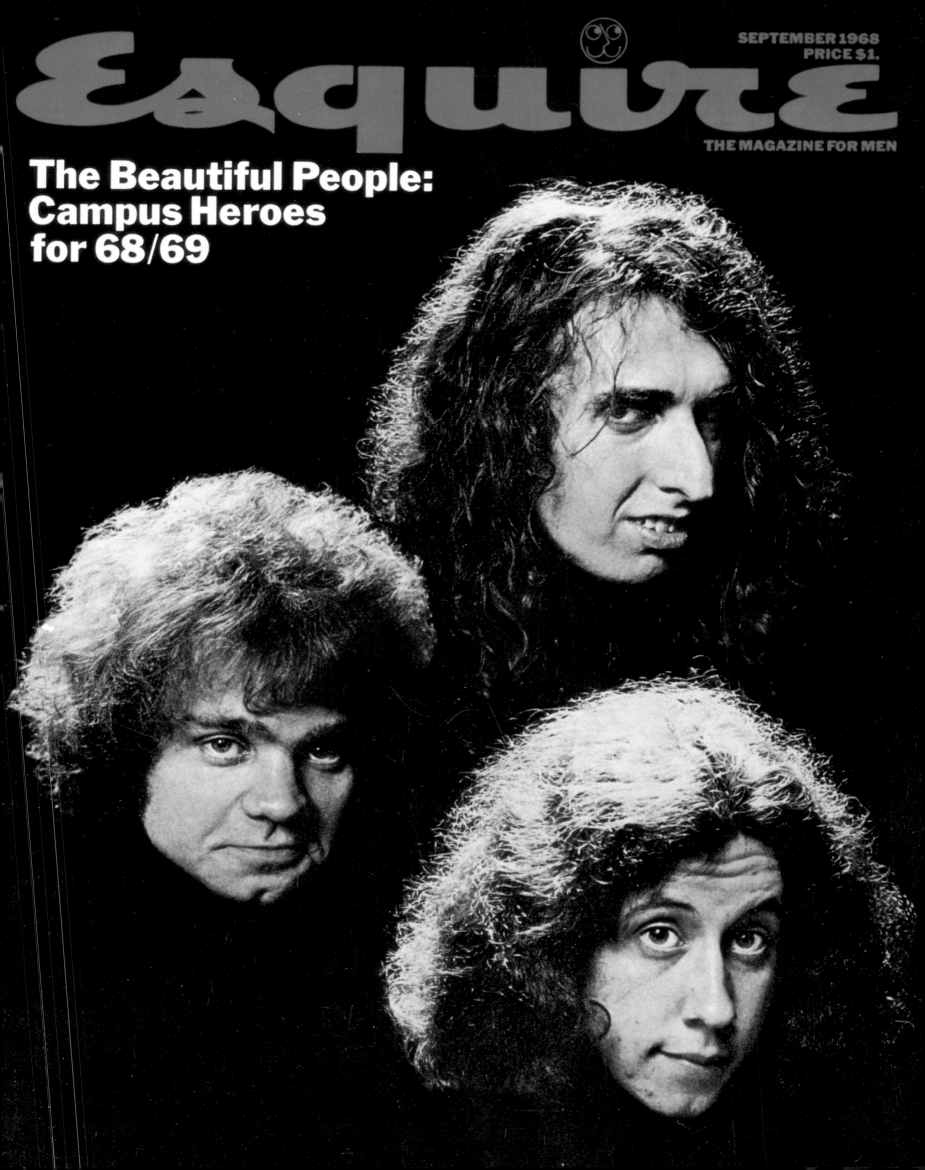

SEPTEMBER 1968
PRICE $1.

Esquire

THE MAGAZINE FOR MEN

The Beautiful People:
Campus Heroes
for 68/69

THE VERY FIRST HOWARD HUGHES HOAX

This issue sold like hotcakes because at long last
the "invisible" Howard Hughes was finally "discovered."
Which proves once more that you can fool all of the people all of the time.
I was simply trying to spoof the idiotic interest in America's
best-known, least-seen mystery man.
The guy in the white bathrobe is an actor playing Howard Hughes.
The woman in the bathing suit is an actress who looked
like Hughes' wife, Jean Peters. And the lug playing a bodyguard
came from central casting. (Photographer Tasso Vendikos
played the paparazzo so well he was detained by the Miami cops.)
Everyone thought it was the real thing when this issue came out,
but Time magazine managed to find out that it was all an elaborate put-on.
The press pounced on editor Harold Hayes for an explanation,
and he summed up the silly hoo-ha over the mystery celebrity:
"What we're doing is an attempt to satirize the whole obsession with
Mr. Hughes' anonymity, his idea that people are
constantly pursuing him when they're not trying to pursue him."
I wonder if Clifford Irving saw this cover back in 1969,
three years before he wrote his bogus "authorized" Hughes biography—
an incredible paper caper that landed him in the cooler.

MARCH 1969
PRICE $1

Esquire

THE MAGAZINE FOR MEN

Howard Hughes:
We see you!

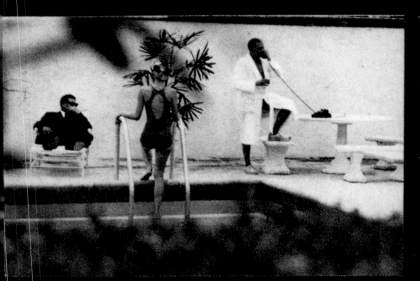
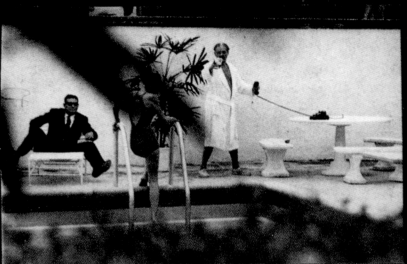

→ 3 → 3A → 4 → 4A → 5

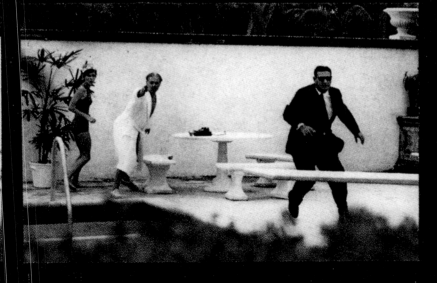

→ 33 → 33A → 34 → 34A

We see you!

See page 73

CHEWING GUM FOR THE MIND

Steve Allen's enlightened shenanigans
of the '50s opened our nights to a new era
of sleep-murdering TV habits.
Following Steverino, a malcontented Jack Paar
added his own dyspeptic viewpoints
to keep us insomniacs. But then, in the '60s,
Johnny Carson, Merv Griffin and Dick Cavett toddled in
and shifted the focus. These three
were precursors of today's gossipy world of TV,
magazine and entertainment celebrities.
Ed Sorel, whose drawing style has been outrageously
plagiarized by many lesser talents, kidded
the networks with this sweet yet biting cover
that pointed out how nighttime
TV talk shows had become (and remain to this day)
chewing gum for the mind.

MAY 1971
PRICE $1

Esquire

THE MAGAZINE FOR MEN

Cutesy talk at midnight: How Cavett, Carson & Griffin make you love them See Page 102

THE UNHOLY TRIO

J.Edgar Hoover billed himself as the crime-fighting Director
of the FBI for almost half a century.
Hoover spent the Depression glorifying his agency
(not to mention himself) by pursuing
two-bit crooks like Ma Barker and John Dillinger,
whom he labeled "Public Enemies." As for organized crime,
he steadfastly denied the existence of the Mob.
He either feared his G-men were powerless against
the underworld syndicate or the gangsters
owned pictorial evidence of you-know-who's homosexual activity.
J.Edgar had a cozy deal with the Mafia, playing
the horses with his constant companion, Clyde Tolson.
When he won, the mob paid off.
When he lost, they didn't collect.Cute.
In 1972, editor Harold Hayes, endlessly fascinated by the evil Roy Cohn,
printed a self-aggrandizing piece by him
which championed his partner in crime, J.Edgar Hoover,
and Senator Joe McCarthy, whose name to this day
stands for libel, slander, corruption and ultimate un-Americanism.
Just as incredulous as Hayes of Cohn's chutzpah,
I masqueraded the unholy trio as The Three Musketeers.
Get my point?

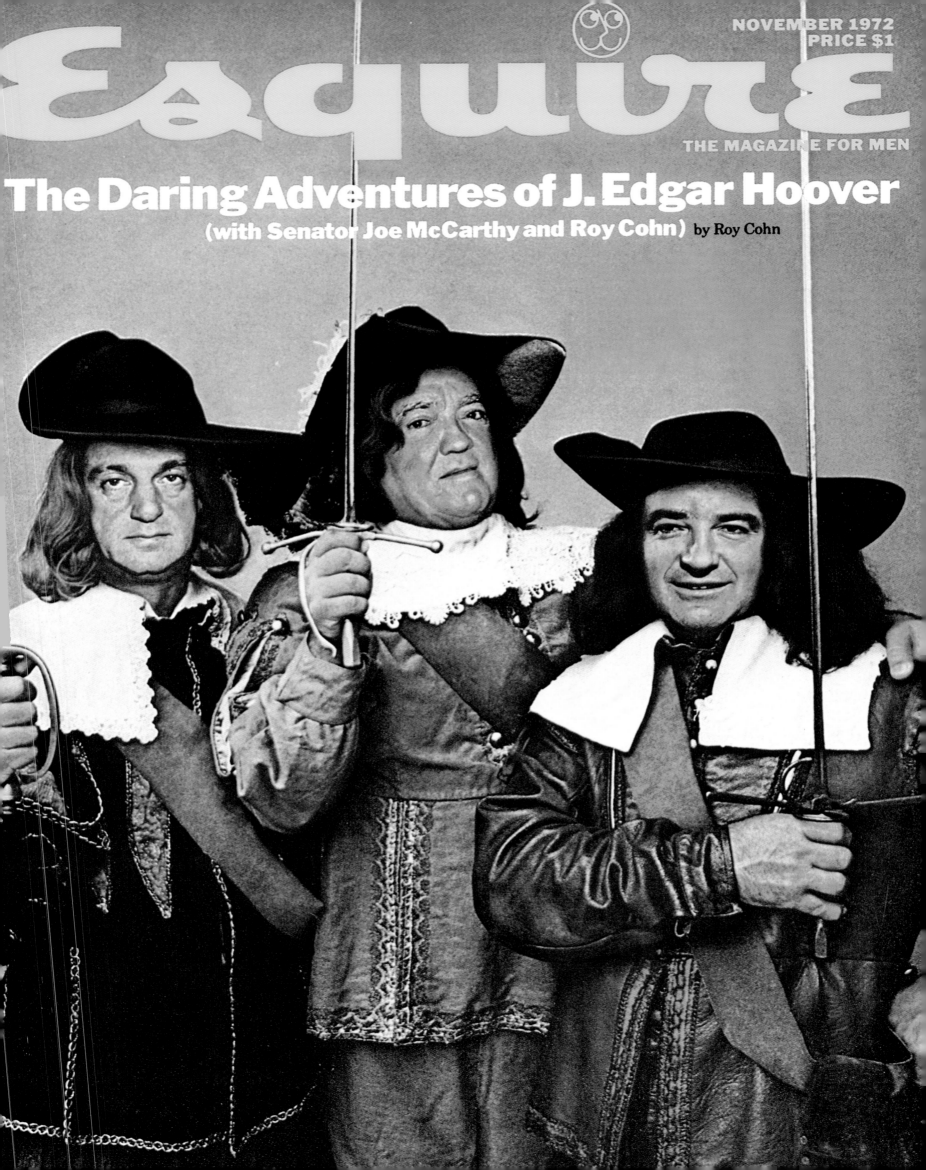

NOVEMBER 1972
PRICE $1

Esquire

THE MAGAZINE FOR MEN

The Daring Adventures of J. Edgar Hoover

(with Senator Joe McCarthy and Roy Cohn) by Roy Cohn

WOMEN (WITH A VENGEANCE)

WHY CAN'T A WOMAN BE MORE LIKE A MAN?

1965 was pre-Friedan, pre-Millet, pre-Greer, pre-Steinem, pre-Abzug.
This cover of the beautiful Virna Lisi taking it off was done before the hoopla
about the women's movement had caught the public's eye.
The movement wanted liberation from women's traditional roles.
Like any Greek male, I wondered where it would take us.
Was there a point where sexual equality would end and confusion begin?
Sometimes the best way to draw attention
to a trend on the horizon is with a cheeky cover.

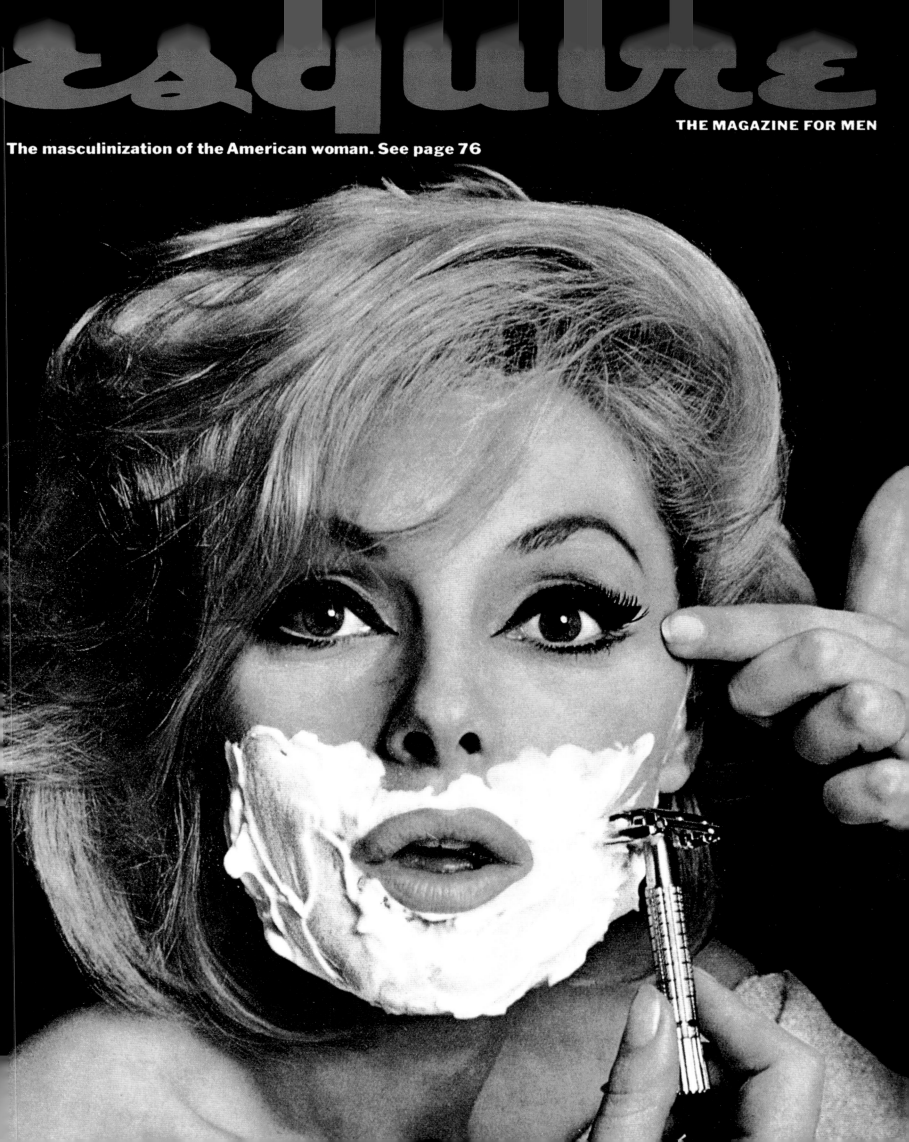

esquire

THE MAGAZINE FOR MEN

The masculinization of the American woman. See page 76

38

MY BATTERED BEAUTY

Wouldn't you think a 1967 cover where we dramatized
violence against women would be applauded by women's groups in America?
Not the National Organization for Women. They were plenty sore.
(Beats me why.) NOW's pioneering battle for women's rights and against
sexism in the late '60s was admirable, but I thought
at times misdirected. Any "battered woman" was considered taboo
and undiscussed in those days, so my visualization of it
on a men's magazine cover was a shocker. I simply slapped a Band-Aid
and a mournful look on Ursula Andress, the stunning beauty
of James Bond fame. I wanted Ms. Andress to sport a shiner, too,
but she begged me not to. I could have retouched
the photo, but I promised her I'd keep my mitts off.
Stacked next to the typically bland and inane Vogue,
Harper's Bazaar and McCall's covers,
my battered Esquire beauty was a knockout.

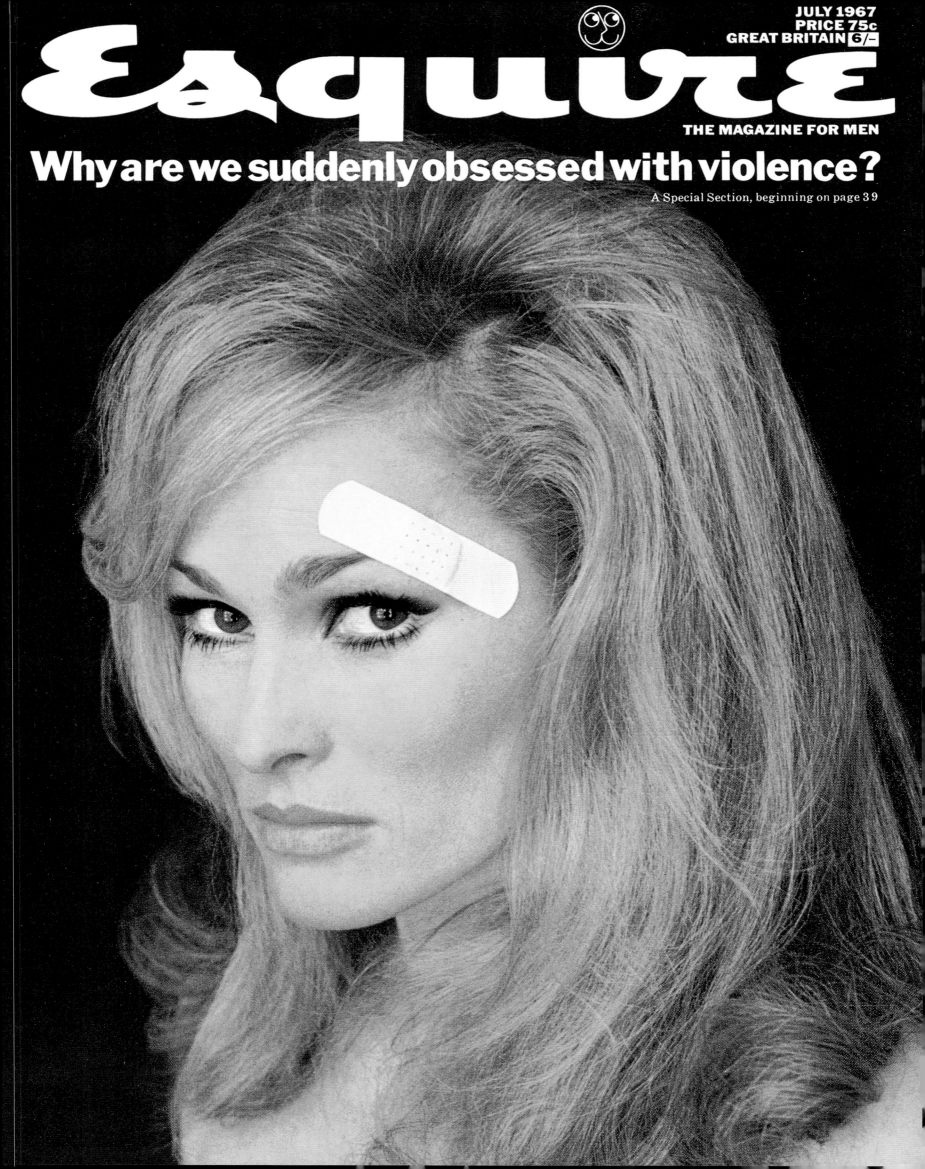

JULY 1967
PRICE 75c
GREAT BRITAIN 6/-

Esquire
THE MAGAZINE FOR MEN

Why are we suddenly obsessed with violence?

A Special Section, beginning on page 39

CALIFORNIA DREAMING

This salacious cover, obviously created
before the attack of the feminist bra burners,
made two points:
1 You can't believe everything you see,
especially in the fake,
opportunistic ambience of LaLa Land...
And **2** Esquire, even while deeply immersed
in their "New Journalism,"
wasn't averse to flashing a little of their own
pre-Madonna pointy T and A.
Boys will be boys.

MAY, 1963

PRICE 60c

GREAT BRITAIN 4/6

Esquire

THE MAGAZINE FOR MEN

TRUE AND FALSE VALUES IN THE STATE OF CALIFORNIA PAGE 00

DREAM GIRL
OR AX MURDERER?

This cover dealt with a macho piece in Esquire on fantasy women,
written almost instinctively as a defense
against the budding feminist war against the atmosphere
of sexism that had been a way of life in America.
In retrospect, through the Hayes years, Esquire had championed
the intelligent and accomplished woman.
But, while eschewing the '30s, '40s and '50s dirty-old-man
Esky tradition of depicting women as sex objects,
Hayes and his gang of bawdy editors
pricked a lot of sexual balloons with loads of lusty laughs.
I rose to the occasion by dealing with the traditional
dichotomy of a man's fantasy of women: that of the desire
for the woman who could play the part of the Madonna
and the whore to satisfy his body and soul.
The young supermodel Lauren Hutton and I dreamt up
a quartet of sexual types and melded them into one desirable woman.
That she wound up looking nuts, possibly an avenging
feminist ax murderer, added to its accuracy.
Oddly, this cover was a precursor of a legendary First Lady
who could shed skins faster than a snake.
In one decade, she went from a shy, little-girl-lost (Jacqueline Bouvier),
to a merry, caring mommy and most glamorous first lady (Jackie Kennedy),
to a bereaved saint (Mrs. Kennedy),
to a fortune-seeker, dragging her children to a decadent world
of gaudy appetites (Jackie Onassis)
culminating in her final role of Great Goddess,
a combination of all women (Jackie KO!).

Esquire

Season's Greetings! 4 naughty dreams to last you till March.

Dream 1: the Sadist

Dream 2: the Virgin

Dream 3: the Babysitter

Dream 4: the French Maid

JACKIE OH!

Two vivid images, frozen in our collective memories:
The widow of our murdered President, draped over her husband's
body in the fatal motorcade. Then, rigid in blood-splattered dress,
beside Lyndon Johnson as he is sworn in. Her elegance
under fire transformed a repulsive time of gore and national shame,
somehow elevating it to a gaunt beauty.
Then, Saint Jackie, the most public and revered woman
in America, did the unimaginable: While still
held heroic in her grief, this strangely spacey widow
of the glorious JFK leapt into the oily embrace
of the anti-hero, Aristotle Onassis. As she abandoned the walls
of the Kennedy compound for the blue waters of the Aegean,
she boggled the mind of even the loyalest Jackie-lovers among us.
Since, as far as we know, Ari possessed
no particular grace or attribute, we were forced to conclude
Mrs. Kennedy opted for the big bucks.
We felt betrayed, our adoration besmirched.
This special Esquire issue on Happiness displayed our dismay.
I rather vulgarly suggested what our Iconic Woman
might want to see in her new husband and protector.
Surprisingly, a business associate
very close to Onassis told me Aristotle laughed heartily
when shown the cover. Go figure.

Esquire

DECEMBER 1970
PRICE $1.50

THE MAGAZINE FOR MEN

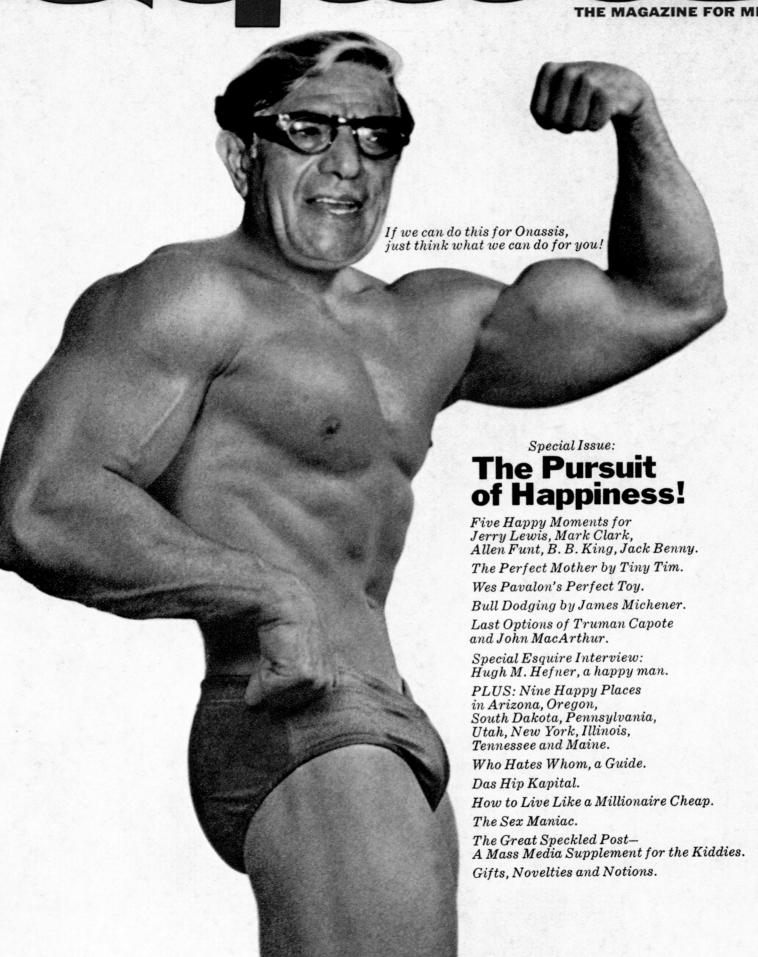

If we can do this for Onassis, just think what we can do for you!

Special Issue:

The Pursuit of Happiness!

Five Happy Moments for Jerry Lewis, Mark Clark, Allen Funt, B. B. King, Jack Benny.

The Perfect Mother by Tiny Tim.

Wes Pavalon's Perfect Toy.

Bull Dodging by James Michener.

Last Options of Truman Capote and John MacArthur.

Special Esquire Interview: Hugh M. Hefner, a happy man.

PLUS: Nine Happy Places in Arizona, Oregon, South Dakota, Pennsylvania, Utah, New York, Illinois, Tennessee and Maine.

Who Hates Whom, a Guide.

Das Hip Kapital.

How to Live Like a Millionaire Cheap.

The Sex Maniac.

The Great Speckled Post— A Mass Media Supplement for the Kiddies.

Gifts, Novelties and Notions.

GERMAINE GREER OGLES KING KONG MAILER

The literary male chauvinist monster
goes ape for the female liberationist doll.
Germaine Greer looks ecstatic
in the clutches of macho-Mailer.
When Norman Mailer saw this cover he called
Harold Hayes and challenged him to a brawl.
Hayes chickened out and asked me to take on Mailer.
I refused. I wanted Mailer
to qualify first by taking on Germaine.

PRICE $1
SEPTEMBER 1971

Esquire

THE MAGAZINE FOR MEN

**Censored scenes from King Kong and...
Germaine Greer
on
Norman Mailer!**

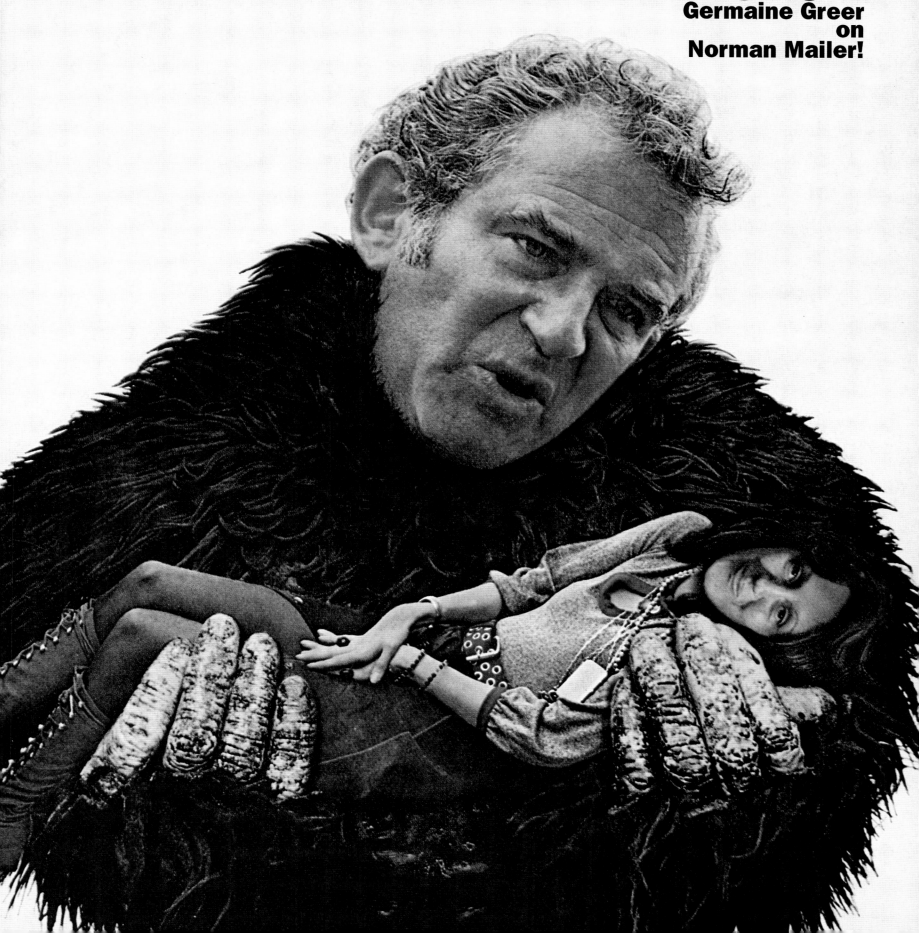

LIZ KISSES-OFF THE MEDIA

Cuckolding Eddie Fisher on the world's front pages,
Liz Cleopatra'd her way down the Nile with Richard Burton.
After doing everything else with him,
she married the raucous, hard-drinking Welshman.
Elizabeth Taylor proved, over and over again, that she
"never went to bed with a man she didn't end up marrying."
While the media had its tasteless field day,
I was after something different. Something sweet...and funny.
How could I possibly entice her?
Timothy Galfas, the great Hollywood cinematographer,
TV commercial director and still photographer, to the rescue!
I asked him if he could coax Mrs. Burton
to let us photograph her for a surprise pull-out cover,
where she would reveal that her "greatest love" was (heh-heh)...
her young daughter, Liza.
In his entrapping Southern drawl, Galfas convinced her
she'd come off as a feisty good sport, and
at the same time she'd tell the media world to kiss off.
Elizabeth Taylor went for it, Galfas photographed her lushly,
and the issue became a giant newsstand seller.

NOVEMBER 1964
PRICE 75c
GREAT BRITAIN 4/6

Esquï

THE MAGAZINE FOR MEN

**TURN THE PAGE
TO SEE
ELIZABETH TAYLOR'S
GREATEST LOVE:**

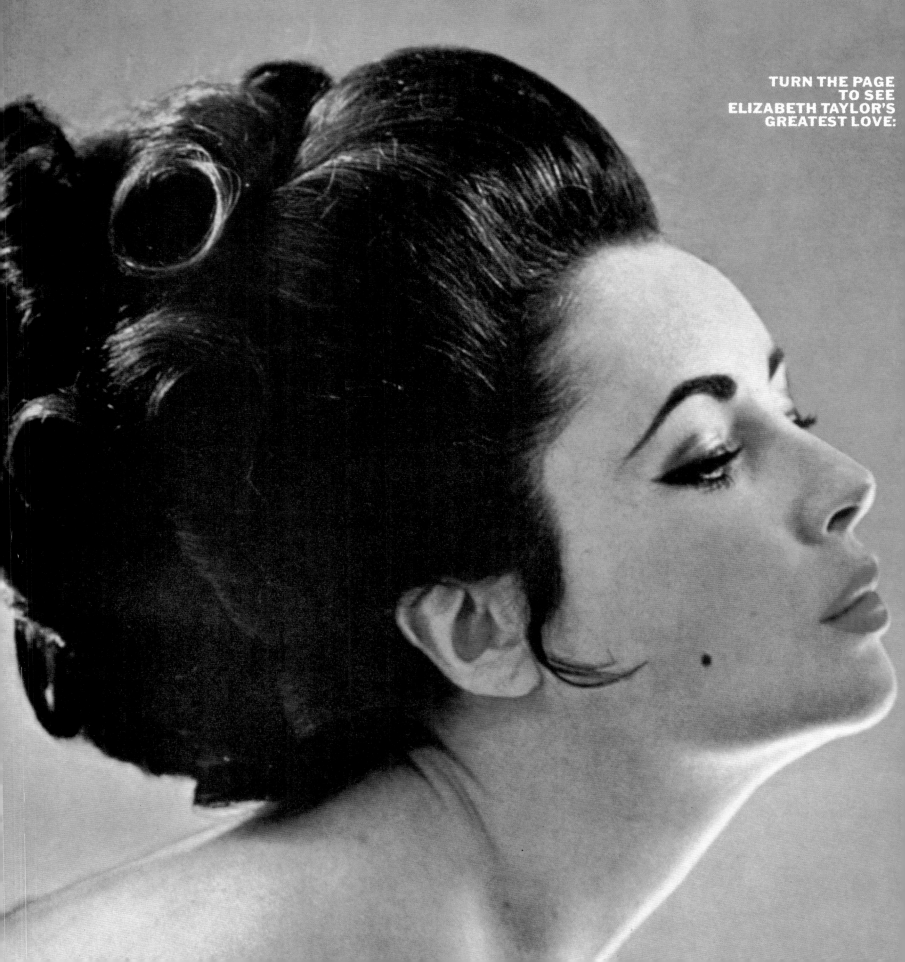

THIS IS LIZA
(SHE'S ONE-FIFTH OF IT)
SEE PAGE 118

ATHLETES—THE AGONY AND THE ECSTASY

CALLING A TITLE FIGHT
ON MY FIRST MAGAZINE COVER

Amid the articles slated to run in this issue was a short piece
on the upcoming world championship heavyweight bout
between the champion, Floyd Patterson, and his monster challenger, Sonny Liston.
I decided to do a surrealistic piece on defeat, on how people treat a loser–
in the ring, in business or in life. Harold Krieger photographed this scene in spooky
St. Nicholas Arena on West 66th Street just a few weeks before it was razed.
I used a black model who was built like Floyd Patterson.
I admired Patterson, but *knew* Liston would demolish him.
The cover called for a loser, and if I could I wanted to be accurate by choosing
the appropriate Everlast trunks (the champ's choice).
But Cus D'Amato, Patterson's manager, wouldn't tell us which Floyd would wear.
So we shot the scene twice, first in black trunks, then in white.
When I saw the two versions I liked them both, so I flipped a coin.
The black trunks won and Esquire ran it. A few weeks later,
after my first cover appeared, Liston KO'd Patterson in the first round.
The punched-out champ fell to the canvas in black Everlasts.
(I lucked out again!)
The press wrote about the chutzpah of calling a fight
on a magazine cover, and the issue was a sellout.
I may have called the fight, but I also showed what losing meant
in our tough world: being left for dead. Nobody loves a loser.

PS: In 1962, when this cover ran, Esquire was deeply in the red.
Four years later they were knocking down well over $3 million in profit.

OCTOBER, 1962

PRICE 60c

Esquire

THE MAGAZINE FOR MEN

LAST MAN IN THE RING: SONNY LISTON AND FLOYD PATTERSON TALK ABOUT BEING TOUGH AND SCARED

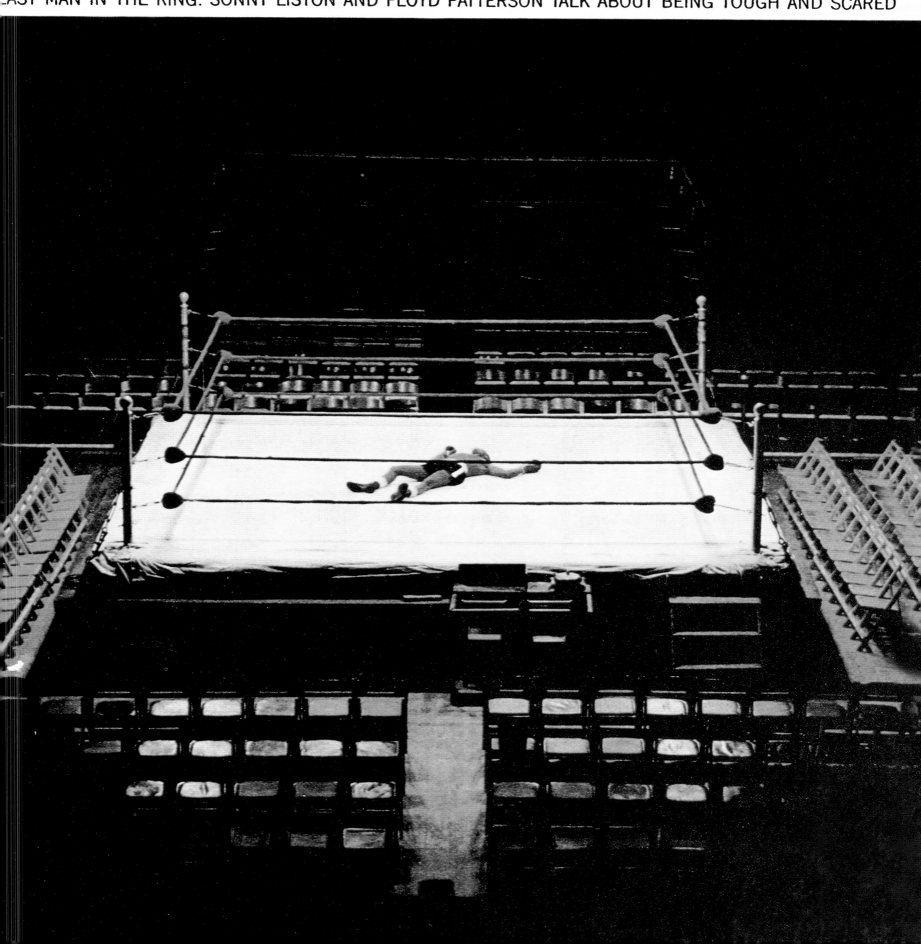

GODS AND GLADIATORS

This cover kicked off
an Esquire issue crammed full
of exhilarating sports writing.
I felt the need for a sports action cover.
So I photographed Darrel Dess,
a pugnacious New York Giants guard,
in the mood of a Renaissance painting.
In 60 minutes of pro football
a man could get killed.

OCTOBER 1965
PRICE 75c

Esquire

THE MAGAZINE FOR MEN

Heaven help him—he's going to play 60 minutes of pro ball

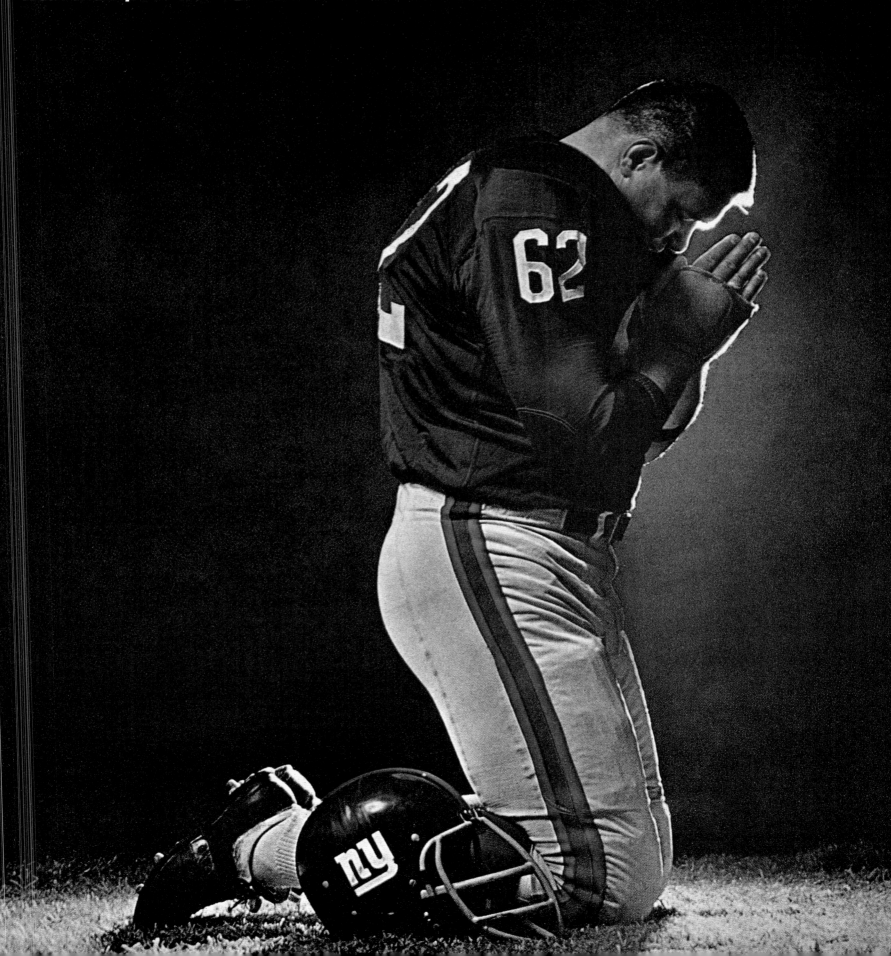

THE TRASH-TALKER AND THE GENTLEMAN

This cover united Muhammad Ali, the first trash-talker in sports,
and Floyd Patterson, the last gentleman in boxing. Here's the story, blow by blow:
After defeating Sonny Liston in 1964, the new champion,
who was then known by his Kentucky slave name, Cassius Marcellus Clay,
announced to the world that he had become a Muslim, changing his
name to Muhammad Ali. The unread but highly literate kid who played the fool to build
his gates refused to become a soldier because of his religious beliefs.
Convicted of draft evasion, he waited for his appeal to reach the Supreme Court.
Ali was getting the shaft and was hanging in limbo, stripped of his title
and not allowed to fight for a living.
Before his conviction, he had been severely ridiculed by the press, by most white
Americans and by many of his own race, including
sweet-natured ex-champ Floyd Patterson. Before their November 1965
championship bout, Floyd foolishly taunted Ali by continually referring to him
as "Cassius." For this disrespect of his religion, Muhammad vowed
he would not only beat Patterson, he would "whup" him. And so he did.
Holding up the near-unconscious Patterson, punctuating blow after crippling blow
with the mantra "What's my name! What's my name!" until, in the
12th round, Patterson fell to the canvas—not merely beaten, but humiliated.
Eight months later, Harold Hayes, knowing Floyd was a fair man and
a good Christian, convinced him to speak out in defense of the Muslim preacher.
When I called Floyd to make a date for a photo shoot with his tormentor,
he agreed. But the ex-champion (who skulked around Bed-Stuy
wearing a beard as a disguise after losing face by blowing a title bout
to "foreigner" Ingemar Johansson) insisted on a *midnight* shoot. No problem.
I explained the cover to a seemingly grateful Ali (a preaching Patterson
with a mute Ali), begging him to receive Floyd with grace.
Ali was a sweetheart, but his biting tongue could turn off the sensitive Patterson.
At the stroke of midnight, almost cowering in an oversized
winter overcoat (in *July*) and wearing a longshoreman's cap, Floyd walked into
Carl Fischer's studio. He saw Ali and froze in his tracks.
Muhammad spread his arms, almost trotted up to Patterson, whispered,
"Hiya, Champ," and the two champions hugged...and wept.

AUGUST 1966
PRICE 75c

Esquire

THE MAGAZINE FOR MEN

In Defense of Cassius Clay
By Floyd Patterson

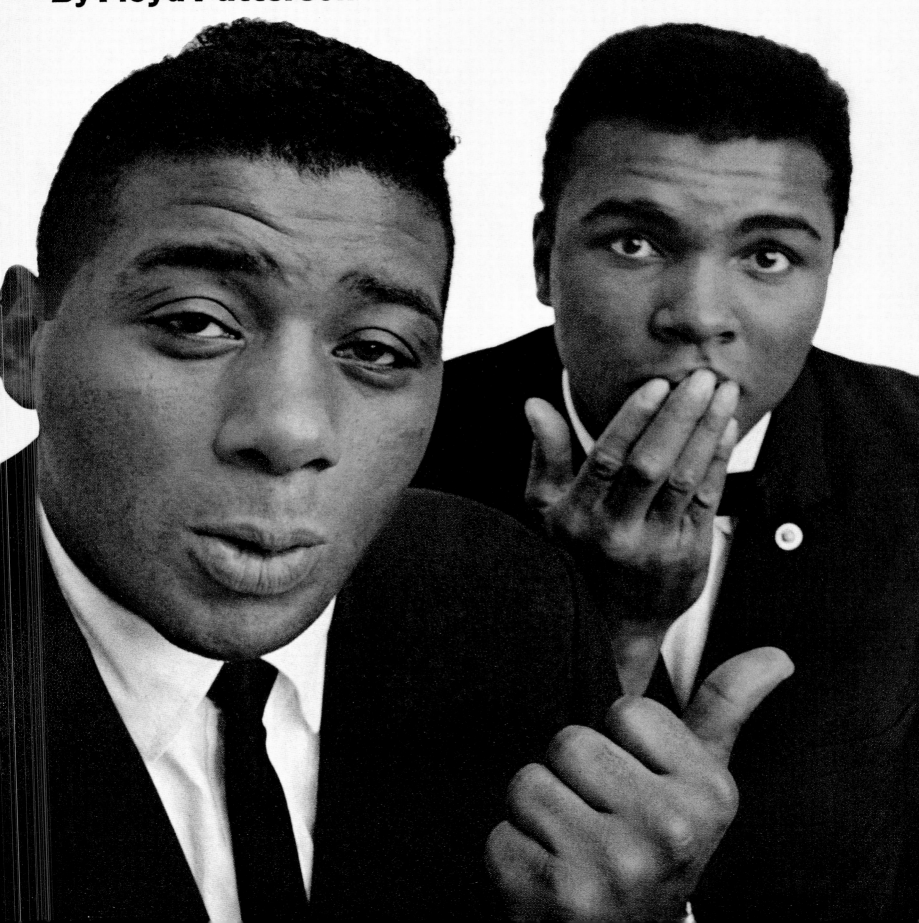

A COOL DUDE SUPERSTAR MODELING CLOTHES

I had promised editor Harold Hayes I would do a men's fashion cover
some day to satisfy the ad sales guys who sold to the fashion ad agencies.
Walt "Clyde" Frazier of the New York Knicks was the world's coolest athlete;
the only question was how to show a dude jock
so that he looked like a superstar rather than a superstiff,
the way male models usually look.
This way: Clyde, the quintessential smoothie, soaring over the court, ball in hand,
being guarded by that hurly-burly Irishman, Kevin Loughery.
Easier said than done. To heroically fly through the air without
a rumple required a harness and wires.
Ordinarily not a big deal. However, a few hours after this shot Clyde would
be on a plane with his teammates headed west to play
the Los Angeles Lakers in the 72/73 NBA finals.
Without Frazier the Knicks' chances would nose-dive.
If the harness slipped or if a wire snapped and something happened to Clyde
(a torn muscle, a stubbed toe, a bruised pinky),
Knicks fans would never have understood that art comes before playoffs.
I held my breath. We shot the best-dressed jock.
We lowered him lovingly. Then I exhaled.
(PS: The Knicks beat the Lakers.)

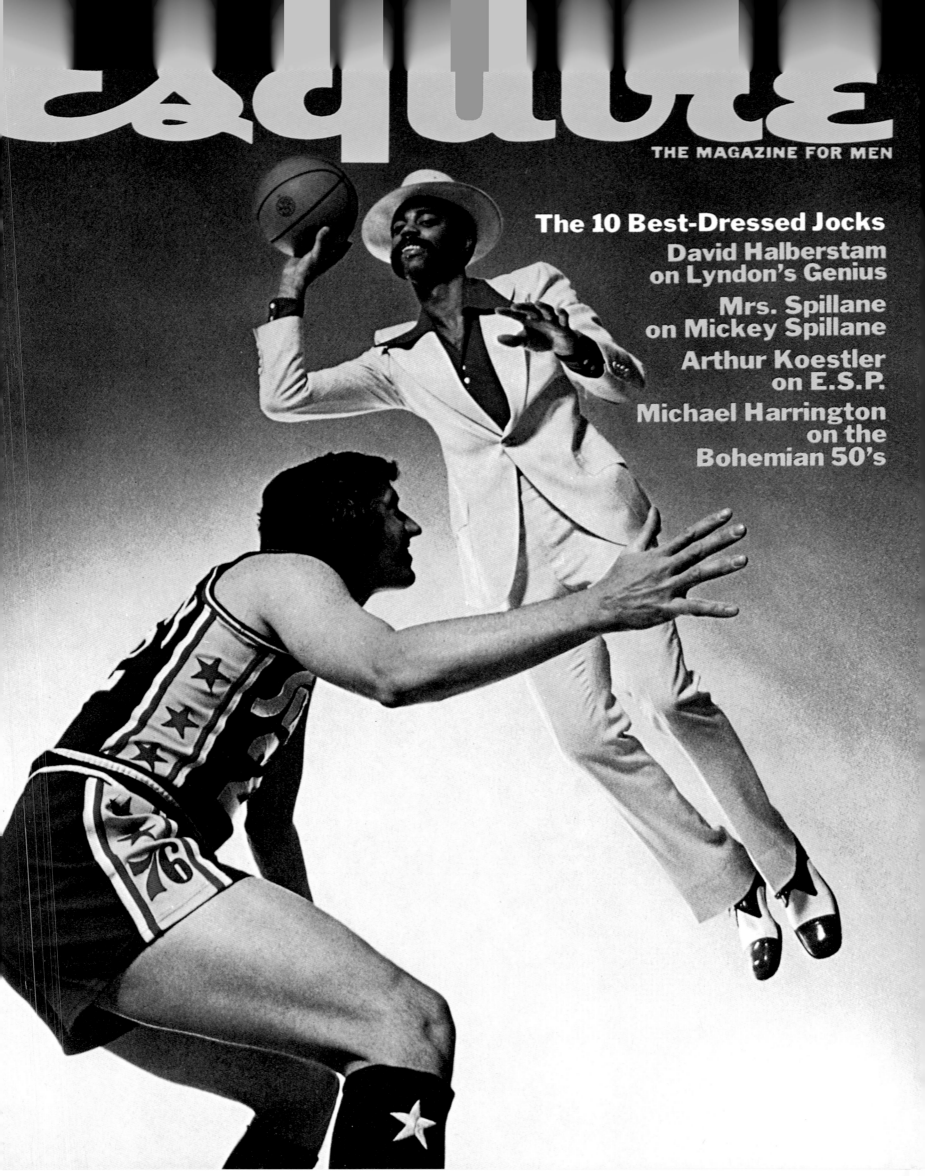

Esquire

THE MAGAZINE FOR MEN

The 10 Best-Dressed Jocks

David Halberstam on Lyndon's Genius

Mrs. Spillane on Mickey Spillane

Arthur Koestler on E.S.P.

Michael Harrington on the Bohemian 50's

THE PROMISE OF THE '60s

In those faraway Kennedy years,
when all seemed possible, Gore Vidal twitted Americans
about what to many seemed inevitable:
that after Jack served his own
eight triumphant years, the firebrand brother
he'd anointed Attorney General would ascend
to that seat in the Oval Office.
Bobby just looked so *right* in Jack's rocker!

MARCH, 1963
PRICE 60c

Esquire

THE MAGAZINE FOR MEN

GORE VIDAL CHOOSES THE BEST MAN, 1968. HEADS, IT'S BOBBY... TAILS, IT'SPAGE 59

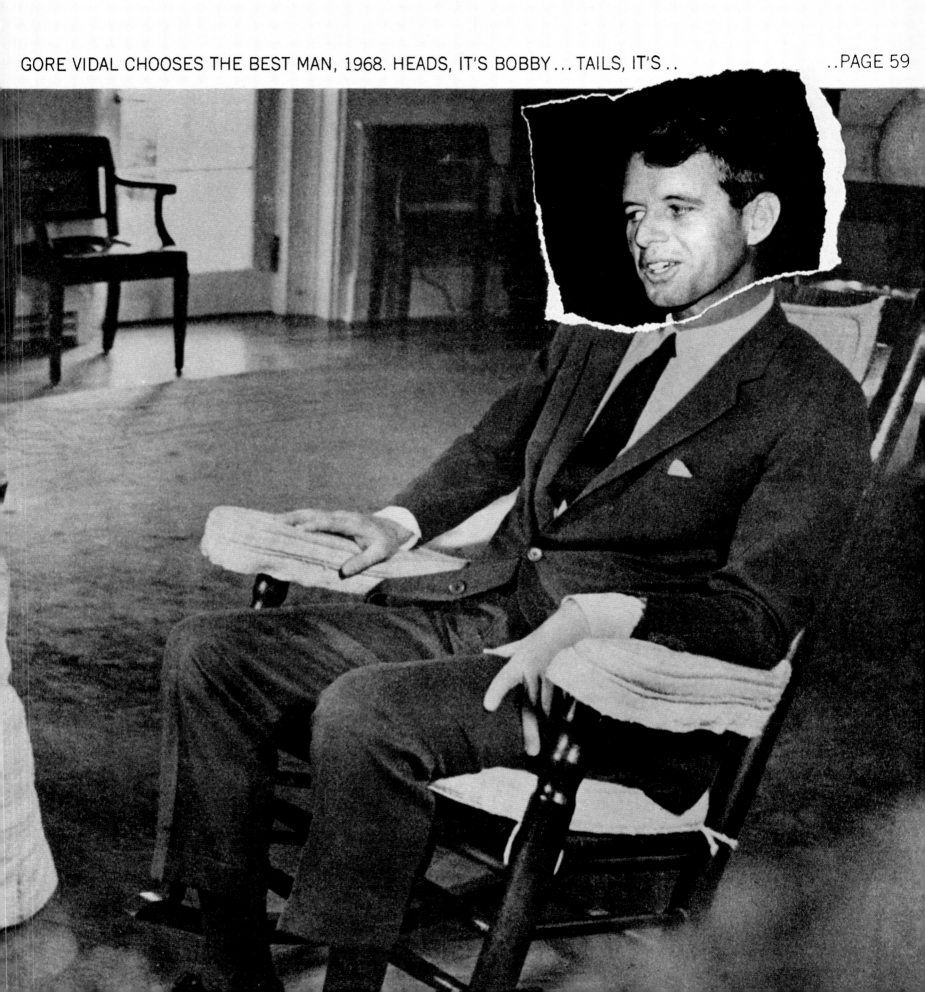

A NATION'S TEARS

Kennedy Without Tears was an article
by Tom Wicker that looked at JFK "objectively,"
seven months after the assassination.
My cover showed the opposite symbolism—
of Kennedy himself, crying for his lost destiny.
(Or are they, after all, the tears of the reader?)
For most Americans the murder
of our President was an unrelieved trauma.
Nerves were apparently as raw in June
as they had been in November.
Even though the issue was a big seller, I caught hell
from a lot of people for being "insensitive."
But this cover still brings a tear to my eyes.

Esquire

THE MAGAZINE FOR MEN

**Kennedy without tears.
See page 108.**

GOING, GOING, GONE

Jack's rocking chair takes center stage
once more as the symbolic throne
of the royal Kennedy family.
How were we to know that one year later
a murdered Robert would join the murdered Jack;
that young Ted would take a fatal dip;
that John-John would never even join the fray.

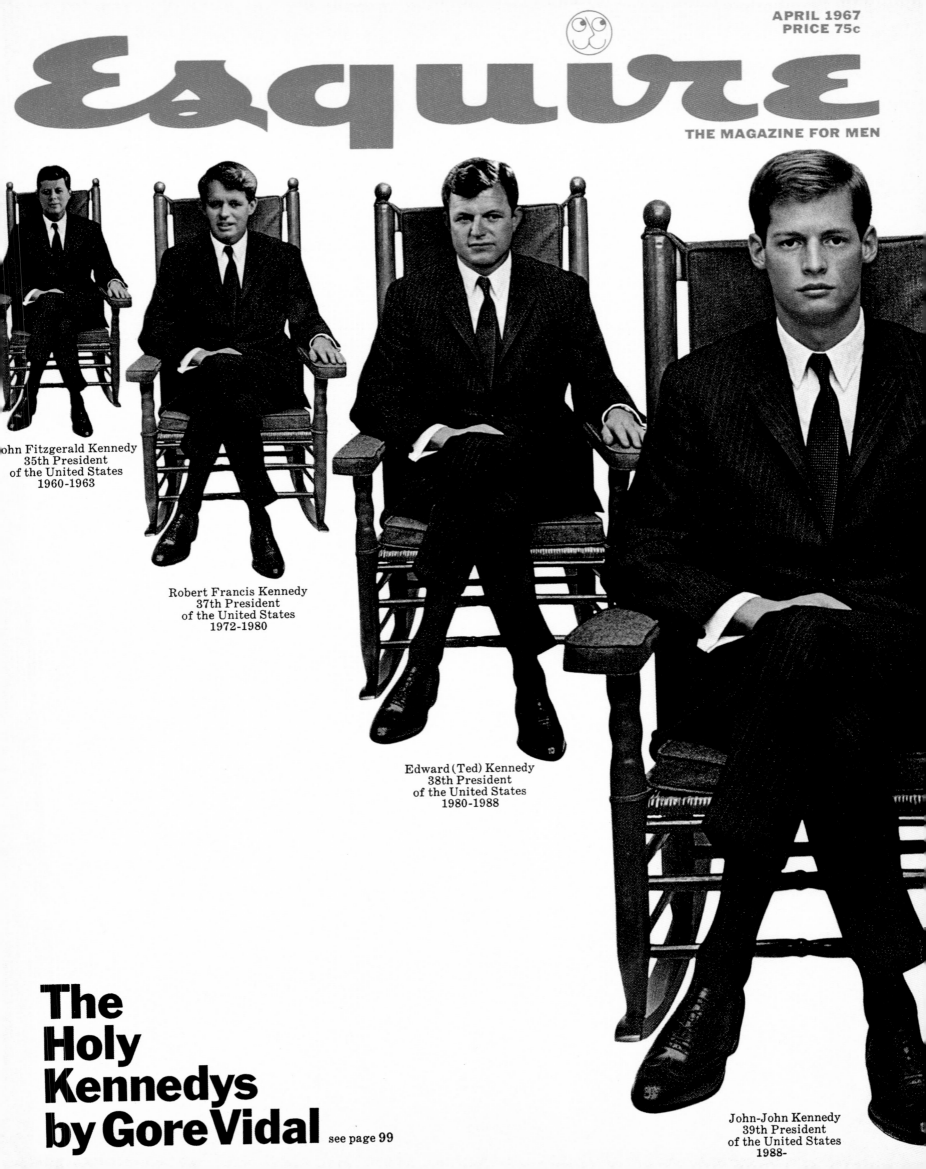

APRIL 1967
PRICE 75c

Esquire

THE MAGAZINE FOR MEN

ohn Fitzgerald Kennedy
35th President
of the United States
1960-1963

Robert Francis Kennedy
37th President
of the United States
1972-1980

Edward (Ted) Kennedy
38th President
of the United States
1980-1988

John-John Kennedy
39th President
of the United States
1988-

The Holy Kennedys by Gore Vidal see page 99

GOOD AND BAD NOSTALGIA

REVISIT BEAUTIFUL WWII

August 15, 1965, commemorated the 20th anniversary of VJ Day.
This tongue-in-cheek travel poster of a cover showing
a hot "native" under a rising sun obviously trivialized
our costly victory over the warlords of the Japanese empire.
But the heroic GIs, Marines and sailors who survived
the slaughter on the bloody beaches and in the steaming jungles
of those infamous Pacific Islands got my meaning.
To my knowledge, not one veteran, then in his forties or fifties,
ever revisited one damn hellish island.

AUGUST 1965
PRICE 75¢
GREAT BRITAIN 4/6

Esquire

THE MAGAZINE FOR MEN

Revisit beautiful Bataan, Guadalcanal, Iwo Jima, Corregidor, Okinawa, Guam, Tarawa, and Wake Island. For details, see page 50.

RIGHT IN DER FUHRER'S FACE

It was the 20th anniversary of the day the 56-year-old
Adolf Hitler blew his maniacal brains out.
Yet a pollster had found that almost half of all Americans
believed he had bamboozled the avenging Russian Army.
They were convinced that he spirited himself
out of his Berlin bunker into the arms of a loving, loyal Argentina.
By the '60s, Neo-Nazism was rearing its appalling head
in Germany and even in America. Resigned to the
brutal fact that fascism and anti-Semitism had never died,
I reincarnated the leader of the Third Reich,
emerging from the shadows of exile, pleading for redemption.
Photographer Harold Krieger and I searched...vainly...
for exactly the unfortunate face that could double as Der Führer.
Eerily, we encountered him in a German beerhall
in Manhattan's Yorkville. Before WWII, Yorkville crawled
with pro-Nazi brownshirts of the German-American Bund.
As he sat there, beckoning for another stein of beer
with a flawless Nazi salute, we knew we had our man.

MAY 1965
PRICE 75¢

Esquire

THE MAGAZINE FOR MEN

"This month I will be 76 years old. Can I come home now?"
(See page 114, Adolf)

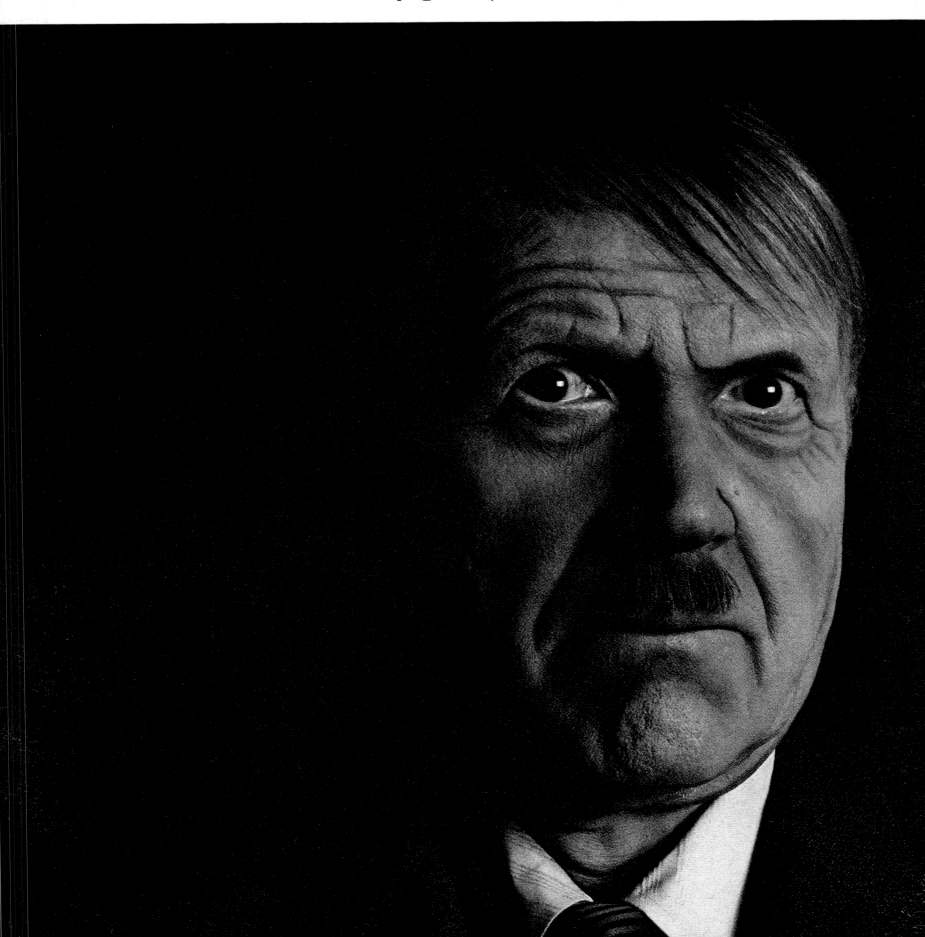

WHEN THE GRADUATE WAS STILL A SOPHOMORE

The great Joltin' Joe DiMaggio, always a private person
but always with an eye for the ladies,
came out of hiding when he surprised the world by marrying
the ultra-visible Marilyn Monroe, Hollywood's sex goddess.
As a husband, he modestly ducked
behind her voluptuous curves and out of the limelight.
Too proud, classy and important to become Mr. Monroe,
he and Marilyn split and the Yankee Clipper was out of sight again.
This cover hauntingly reflected on his absence
(inspired by yet another classic Gay Talese profile).
Carl Fischer caught this dream-like apparition of Joe
in one of his tailored civilian suits, frozen at the apex of the
most classic swing in the history of the game,
hitting one into the empty stands. I almost asked
No.5 himself to pose, but even I don't have that kind of hubris!
So I cast dozens of lithe, athletic 45-year-old men,
but finally chose a 35-year-old who,
as a kid, worshiped the ground Joe D walked on. Me.
Two years later, *Mrs. Robinson*, from the hit movie *The Graduate,*
sported a lyric evoking all the nostalgia of our time,
Where have you gone, Joe DiMaggio?

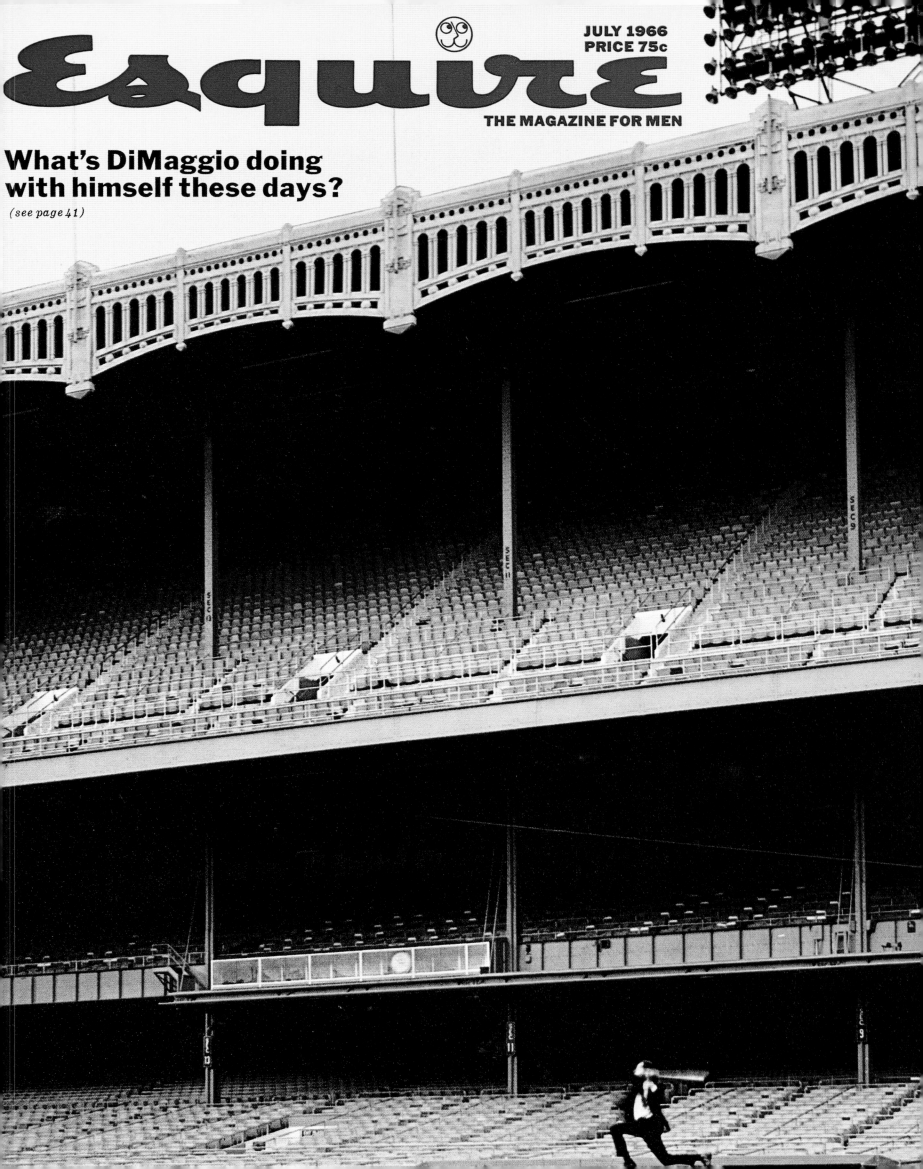

JULY 1966
PRICE 75c

Esquire

THE MAGAZINE FOR MEN

What's DiMaggio doing with himself these days?

(see page 41)

PAPA WRITES AGAIN

From the beginning, Esquire insisted on attracting,
commissioning or breeding the most talented of American writers.
Esquire's first issue hit the newsstands in 1933,
in the penniless days of the Great Depression in America.
Over the years, Esquire's standard bearers included F. Scott Fitzgerald,
John O'Hara, Ben Hecht, William Faulkner, Gay Talese, Tom Morgan,
Norman Mailer, John Sack, Irwin Shaw, Philip Roth, Tennessee Williams,
John Gunther, John Cheever, Saul Bellow, Tom Wolfe, Garry Wills,
Gore Vidal, Truman Capote and the unextinguishable, mythic and grizzled
romantic figure of American Lit in the '30s, Ernest Hemingway.
In 1970, Harold Hayes pulled off a coup by obtaining
the rights to the manuscript of the master's last major work.
The nostalgic power of a montage of Papa's bearded grin,
his actual handwriting and the Esquire logo practically composed itself.

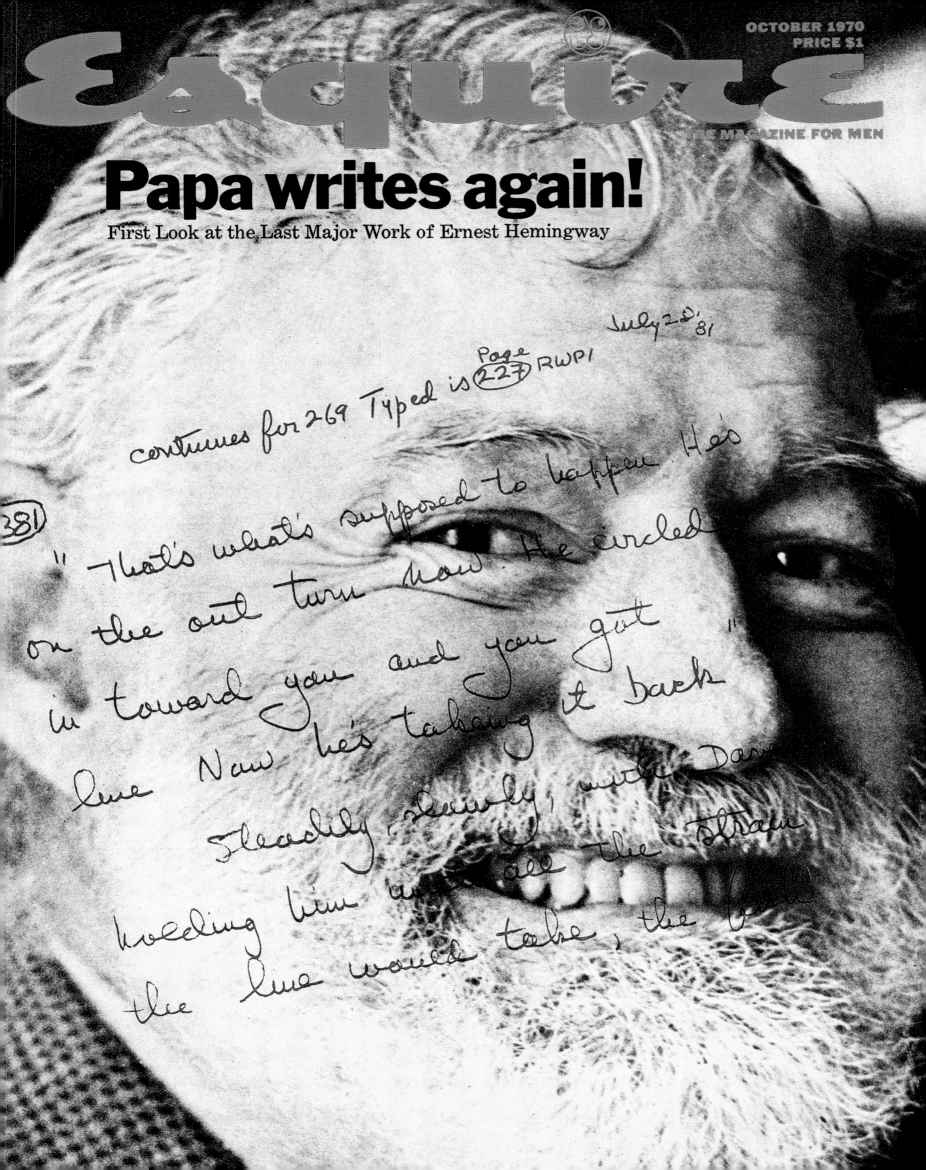

THE FAME GAME

For a full decade I created covers to define the ethos of each Esquire *and* increase sales each month.
With my other hand I worked 14-hour days at my agency, advertising products I was hired to sell.
In the sell-or-die ad game, I've used celebs for shock, irrelevant surprise and stunning credibility...
always a tool to express a startling and outrageous selling idea.
A broke Joe Louis asked maverick stockbrokers Edwards & Hanly: *Where were you when I needed you?*
(Fan dancer Sally Rand called these same stockbrokers *fantastic brokers!*)
Rocky Marciano served up Piel's beer and Rocky Graziano, sporting a Rex Harrison accent,
sold Breakstone, *The more cultured yogurt.*
Sinatra, Gleason, Hope and Dangerfield touted Off-Track Betting as a new team, *The New York Bets.*
For Revlon's Milk Plus 6 shampoo, Susan Blakely preened and mooed, *Like my hair?*
Meet my hairdresser! as a pull-back revealed a cow.
On tippy-toe, Nureyev hawked the New York Post, and I'm the guy who got Henry to say *I'm Fonda the Post.*
For Olivetti, a fast-typing Joe Namath fought off the advances of his female boss.
In one star-studded day, odd couples Salvador Dali & Whitey Ford, George Raft & Hermione Gingold,
Sonny Liston & Andy Warhol, Satchel Paige & Dean Martin Jr., Marianne Moore & Mickey Spillane
and Ethel Merman & Bennett Cerf paired up for Braniff's battle cry, *When you got it, flaunt it!*
Ernie Kovacs and Sid Caesar blew America away for Dutch Masters.
Susan Sarandon became a *Young Mama* for Redbook, the first magazine to sell itself on TV.
Teary-eyed heroes Mantle, Wilt, Oscar, Unitas and Dandy Don cried, *I want my Maypo!*
Dorothy Lamour sang in sarong, *I'm off on the road to Morocco* for Royal Air Morocco.
Spoofing instant glamour, homely Alice Pearce used Coty lipstick to transform into a sexy Joey Heatherton.
For USA Today, Willard Scott, Joan Collins, Diahann Carroll, Mays and Mantle,
Chicago Mayor Jane Byrne and Senator Howard Baker sang out: *I read it every day.*
Non-Greeks E.G. Marshall, Ralph Bellamy, Zsa Zsa, Dave DeBusschere and 35 other celebs announced,
oddly enough, *I'm going home...to Greece* for the Greek National Tourist Organization.
Mick Jagger ordered rock fans to deluge cable operators with *I want my MTV* phone calls.
(Every rocker alive, including Madonna, begged us to be in subsequent spots.)
To transform ESPN from a mickey mouse sports network to one with "attitude," Bobby Bonilla,
Roger Clemens, Dan Marino, Greg Norman and Gabriela Sabatini performed their *In Your Face!* antics.
Along the way, I conceived Senatorial campaigns for gentlemanly Jacob Javits,
crabby Warren Magnuson, avuncular Hugh Scott and charismatic Robert Kennedy.
But no memory is stronger than a few hilarious hours photographing
a failing, but facile, 81-year-old, with a strange dependence on his young female companion.
I've spent days at the races and nights at the opera, but my repartee-filled afternoon with Groucho,
far from driving me animal crackers, turned out to be a memorable duck soup.

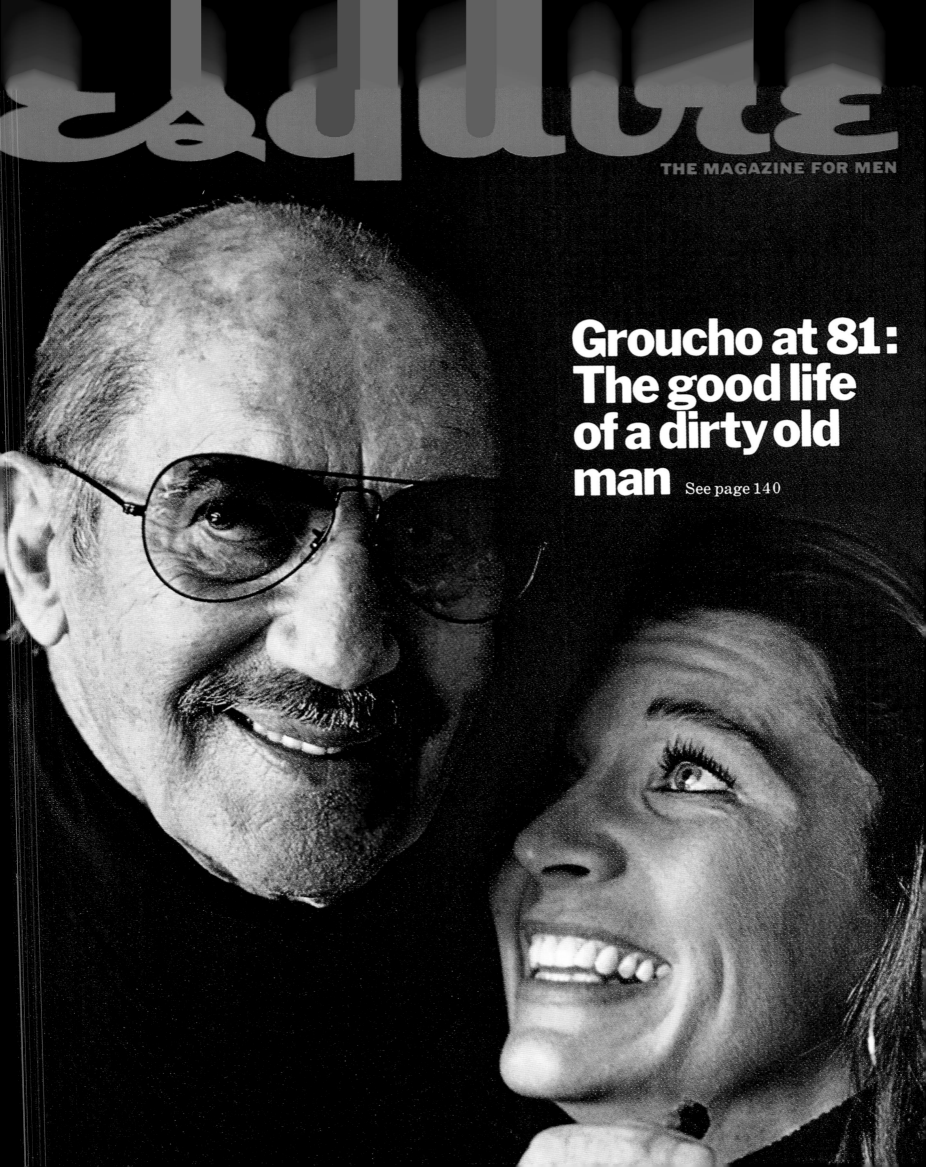

esquire

THE MAGAZINE FOR MEN

**Groucho at 81:
The good life
of a dirty old
man** See page 140

MISSING BOY

When I was growing up in the Bronx in the '30s
my Papa took me to each Tarzan movie, the only movies we
attended together, in an unstudied act of male bonding.
Superman, Batman and Captain Marvel were okay,
but Tarzan was good, brave, fearless, athletic and,
alone among superheroes, a *family* man.
So in an issue that featured a nostalgic look back
at the good guys of the '30s and '40s,
I leapt at the chance to lionize an aging, fully clothed
Tarzan and Jane, the legendary lovers of the silver screen.
Tarzan, the swinging Lord of the Apes,
and Jane, the sophisticated Englishwoman, proved that social
barriers disappeared when hearts beat like native drums.
Still ruggedly handsome, the great Olympic swimming champion,
Johnny Weissmuller, and his mate, the elegant,
high-toned Maureen O'Sullivan (the mother of Mia Farrow),
got a big kick out of posing for an Esquire cover,
along with Cheetah, their faithful madcap companion.
But looking back at this cover always saddens me,
because there's a missing person...Boy.
The only issue of their jungle love match, Boy, played
by young Johnny Sheffield, was the loyal, loving son
all we kids from the Bronx were trying to be.
When John Sheffield expressed reluctance to complete
my family portrait, I had Tarzan call.
John reluctantly agreed to fly to New York for the family reunion.
But he never got on the plane. He was embarrassed
to be seen by Tarzan, Jane, Cheetah or our prying camera.
Boy had ballooned to over 370 pounds.

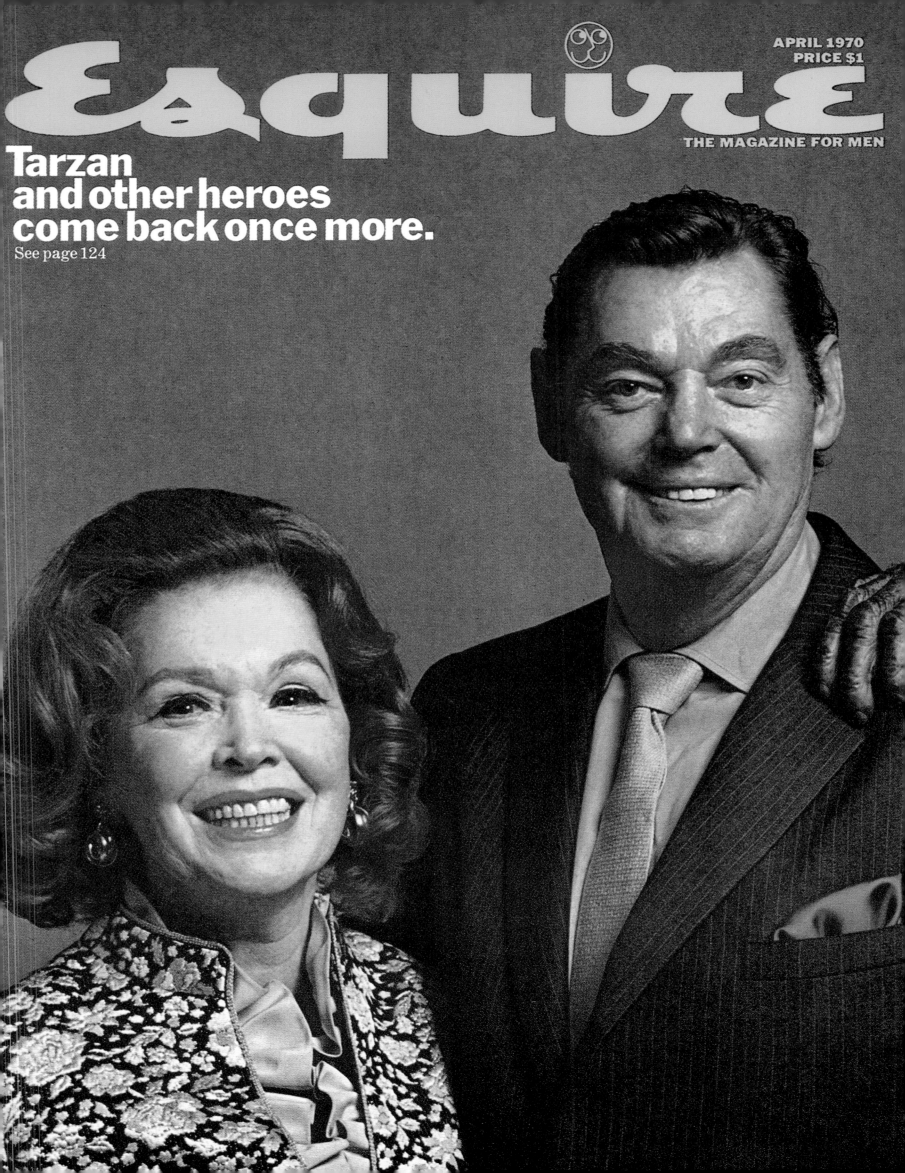

APRIL 1970
PRICE $1

Esquire

THE MAGAZINE FOR MEN

**Tarzan
and other heroes
come back once more.**

See page 124

MORALITY

THE NEW MORALITY

In February, that tender month
of gender feeling, Esquire caught a whiff of the
new sexual ground rules for the '60s:
1 No more stigma to illegitimacy.
2 No more traditional marriages in American society.
My cover crystallized this new, complicated mix
of women's emancipated attitudes,
of aggressive sexual liberation,
of the extinction of the double standard.
To condense it all, we showed this triumphant bride
surrounded by no less than *eight* love-children
and one dumbstruck husband.
(The models were an ethnic Greek-American couple
with two kids of their own, three of my nephews,
two nieces and my four-year-old son, Harry...
the one sitting closest to the beaming mama.)
Take another look and you'll see how this
deceptively innocent portrait proclaims that
common-law marriages were out of the closet
and the sexual revolution was here to stay.

FEBRUARY, 1963
PRICE 60c
GREAT BRITAIN 4/6

Esquire

THE MAGAZINE FOR MEN

JUST MARRIED!? FOR MORE ON LOVE (AND A TOUCH OF SIN) SEE PAGE 83

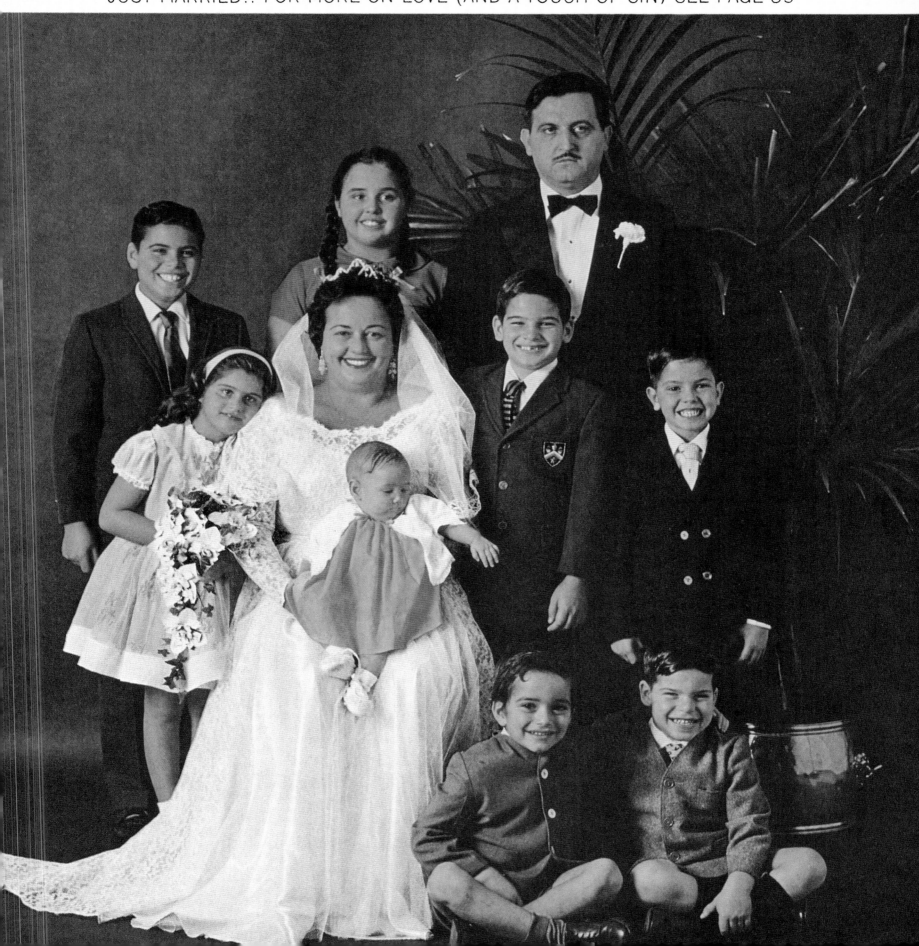

ANN-MARGRET TAKES ON WOODY ALLEN

Harold Hayes and I convinced the sexy Ann-Margret
and the nerdy Woody Allen to spice up
a"traditional" travel issue, but Esquire-style.
In a sexually repressed America,
the only reason I dared get away with showing
a male of the species mounting one
of Hollywood's hottest sexpots was to mate her
with a young, brilliant, *comedy* star.
I knew if we had enlisted an Elvis or a Robert Redford
to go missionary with Ann-Margret, we all would
have been arrested. I needed the realism of a nude liaison,
so Woody went topless and Ann-Margret
came out of the dressing room with
a bath towel wrapped around her abundant chest.
I wasn't sure where I would crop
the photo, so I kept asking the gorgeous redhead
(Ann-Margret, not Woody) to pull the towel down
a touch for each shot. Finally, in exasperation,
she told Woody to "get off," threw aside the towel
and told photographer Harold Krieger to shoot away.
It was the most fun Woody Allen
or yours truly ever had at a photo session!

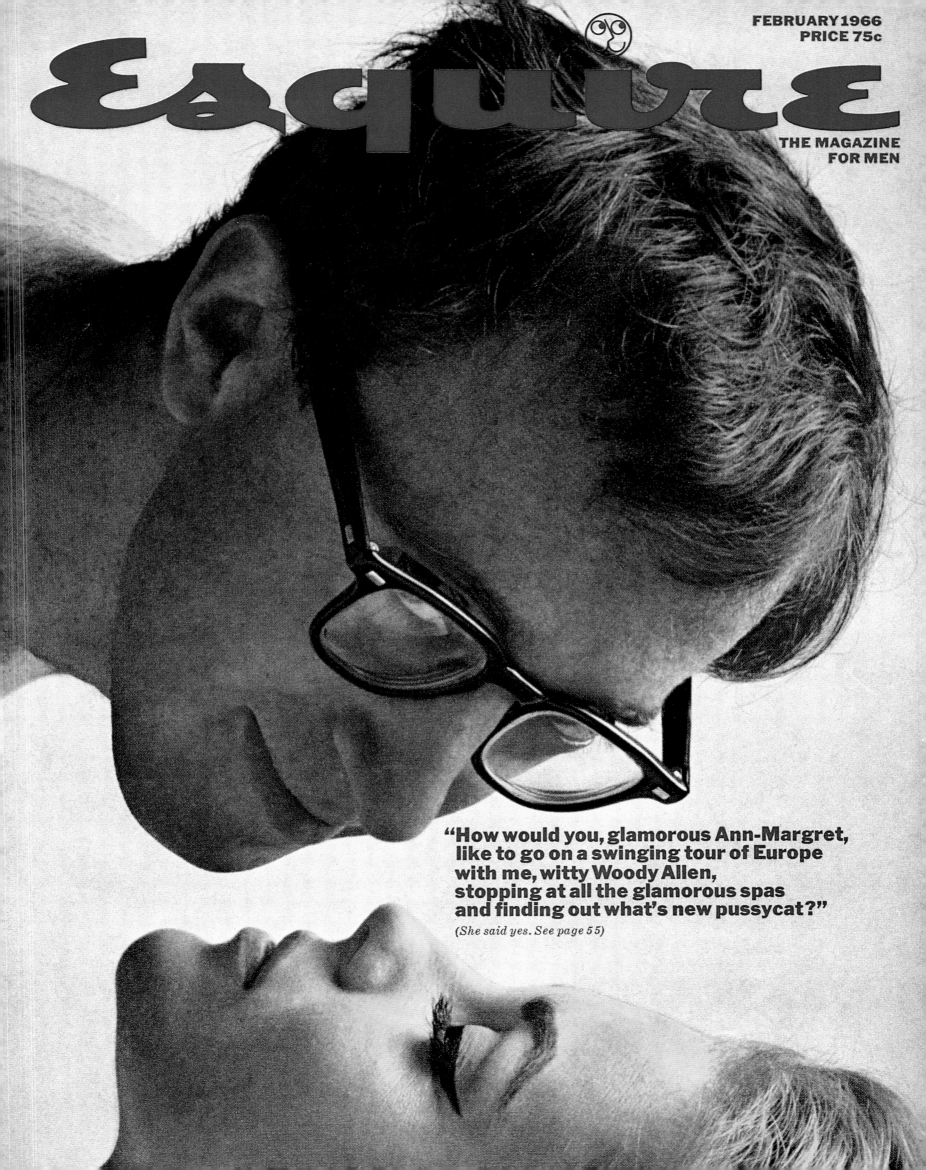

FEBRUARY 1966
PRICE 75c

Esquire

THE MAGAZINE
FOR MEN

"How would you, glamorous Ann-Margret, like to go on a swinging tour of Europe with me, witty Woody Allen, stopping at all the glamorous spas and finding out what's new pussycat?"

(She said yes. See page 55)

THE SHOCK OF THE NUDE

After decades of being fed a bland diet of God, family, country
and the virtues of virginity (when nice girls didn't),
our popular culture began to reflect a changing sexual and moral ethos.
Popular entertainment, including the hair-raising
nudity of *Hair*, the deep-throat depiction of homosexuality
in *Midnight Cowboy*, Brando's buttery probing of *Last Tango In Paris*,
along with the safety of the Pill *and* a budding
drug culture, nonplussed the "decent" people of America.
To dramatize that surprise, I called for the services
of the sexiest stripper in show biz, Angel Ray of L.A. Body Shop fame.
To watch a morally shocked stripper watching a flick
of the day seemed to me not only funny, but wittily far-fetched.
The night before Carl Fischer photographed her,
after flying in from California, Angel had, unbeknownst to me,
gone to the theater to see *Oh, Calcutta!*
"How did you like it, Angel?" I innocently asked.
Almost blushing, Angel answered,
"Geez, George...I was so *embarrassed!*"
Life imitates art.

ESQUIRE

THE MAGAZINE FOR MEN

Public decency on the screen, stage, and in the streets.
The stripper gives her views.

See page 104

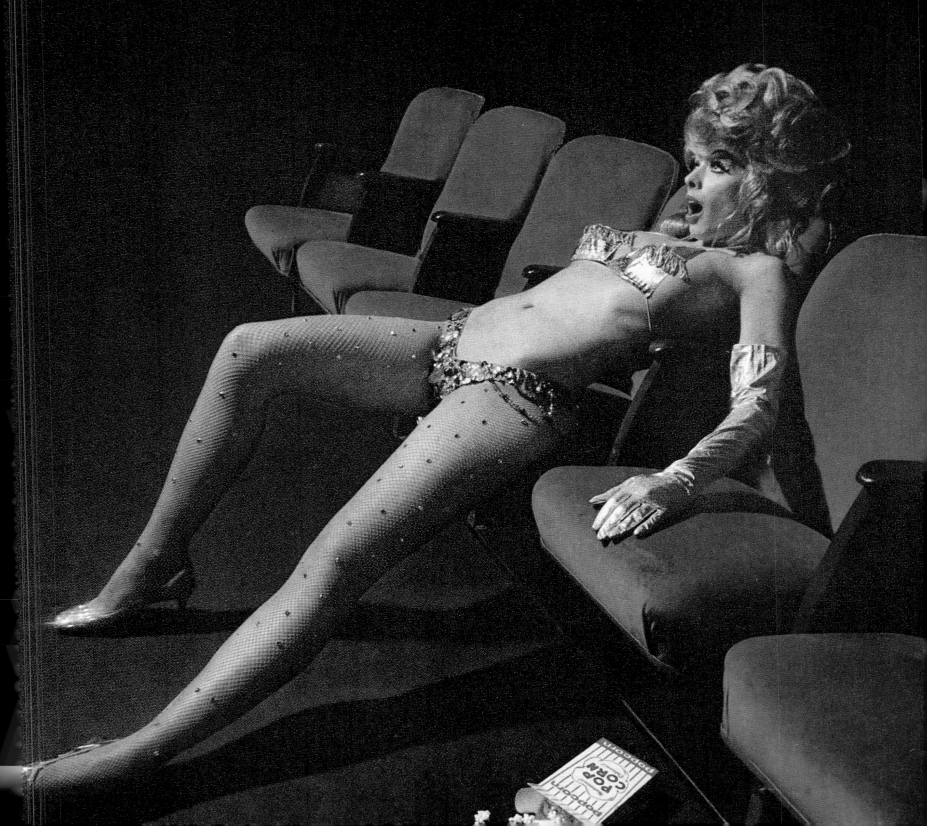

THE MOUTH OF BABES

A coy, polka-dotted Linda Lovelace,
who introduced respectable American women to oral sex,
adorned this issue on where sexuality was headed in America.
Linda was the original and more talented Deep Throat
(unfairly overshadowed by the guy lurking in the shadows of Watergate,
blowing the Nixon administration wide open).
She may have been forced to participate in what became
the most viewed porno movie ever,
but she willingly portrayed a dimpled girl-next-door for Esquire.
Her innocent face on the cover of the nation's foremost men's magazine
was a visual, wham-bam, but sweet dirty joke.
I really wanted to pose Ms. Lovelace ogling the camera
as she brushed her teeth with Colgate toothpaste,
but editor Harold Hayes said "no soap."

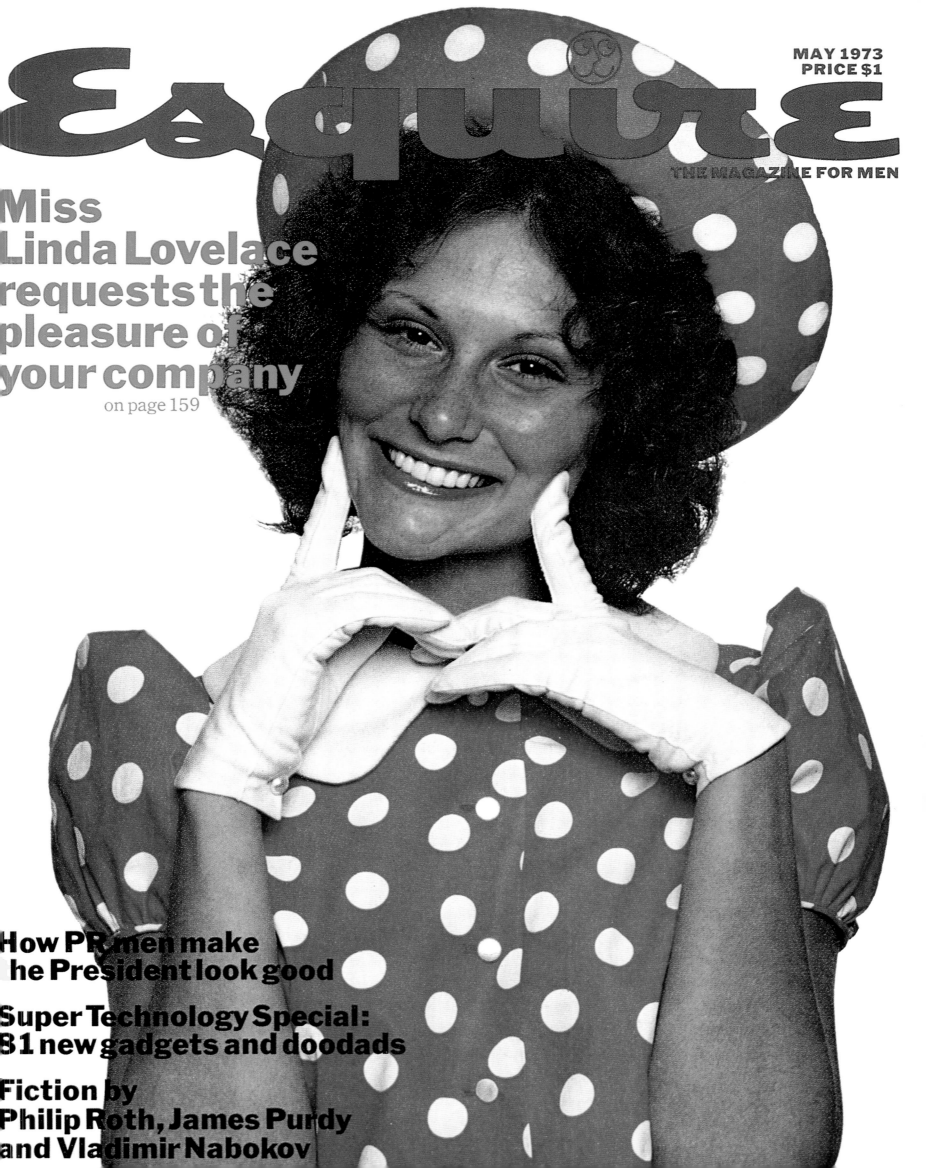

MARTYRS

SHOWING MUHAMMAD ALI AS A MARTYR
FOR REFUSING TO FIGHT IN A BAD WAR

In 1967, Muhammad Ali, the world's heavyweight champion, refused induction into the Army.
He had converted to Islam, and under the tutelage of Elijah Muhammad
he became a Black Muslim minister.
When Ali refused military service as a conscientious objector because of his new religion,
a federal jury sentenced him to five years in jail for draft evasion.
Boxing commissions then stripped him of his title and denied him the right to fight.
Ali was in the prime of his fighting years but wasn't allowed in a ring.
He was widely condemned as a draft-dodger and even a traitor.
When Cassius Clay became a Muslim, he had also become a martyr.
In 1968, while he was waiting for his appeal to reach the Supreme Court,
I wanted to pose him as St. Sebastian, modeled after
the 15th-century painting by Castagno that hangs in the Metropolitan.
I contacted Ali and explained this idea and he agreed to fly to New York to pose.
At the studio, I showed him a postcard of the painting
to illustrate the stance. He studied it with enormous concentration.
Suddenly he blurted out, "Hey, George, this cat's a Christian!"
I blurted back, "Holy Moses, you're right, Champ!"
I explained to Ali that St. Sebastian was a Roman soldier who survived execution
by arrows for converting to Christianity. He was then clubbed to death,
and has gone down in history as the definitive martyr.
Before we could affix any arrows to Ali, he got on the phone with his religious
leader, Elijah Muhammad. Ali explained the painting in excruciating detail.
He was concerned about the propriety of using a Christian source for the portrayal
of his martyrdom. He finally put me, a non-practicing Greek Orthodox,
on the phone. After a lengthy theological discussion, Elijah gave me his okay.
I exhaled and we shot this portrait of a deified man against the authorities.
When I saw the first transparency, I believe my exact words to photographer
Carl Fischer were, "Jesus Christ, it's a masterpiece."
Esquire had a sensational cover, and it was reproduced and sold as a protest poster.
Three years later, the Supreme Court unanimously threw out Ali's conviction.
Allah be praised!

Esquire

APRIL 1968
PRICE $1

THE MAGAZINE FOR MEN

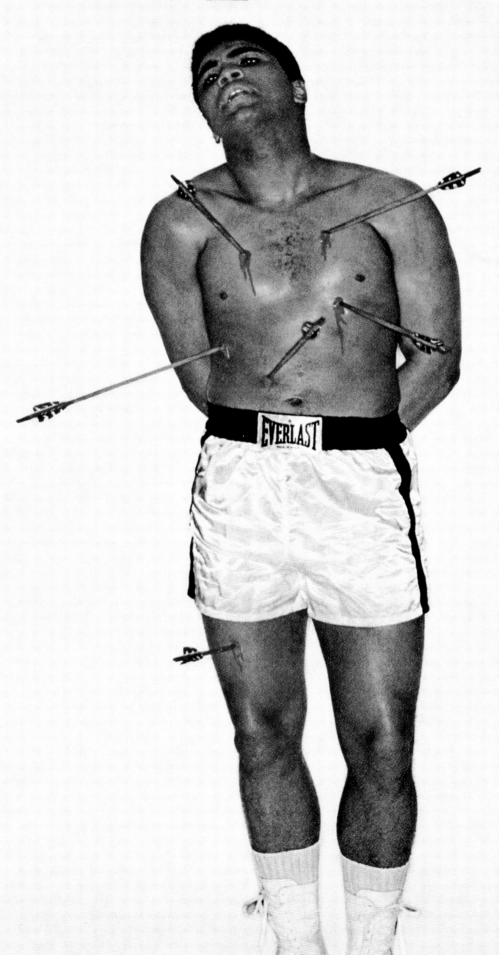

The Passion of Muhammad Ali

APOTHEOSIS!

I plead guilty to shockingly irreverent
concepts for many covers.
But the '60s, at times, pleaded for
equally shocking *reverence.*
Our assassinated leaders, the three most
mourned Americans since FDR,
hauntingly watch over Arlington National Cemetery.
For Esquire's definitive 35th anniversary issue,
in a hagiographic fantasy,
we pay homage to an idealized,
saint-like John Kennedy,
Robert Kennedy and Dr. Martin Luther King
in this dreamlike epitaph on the murder
of American goodness.

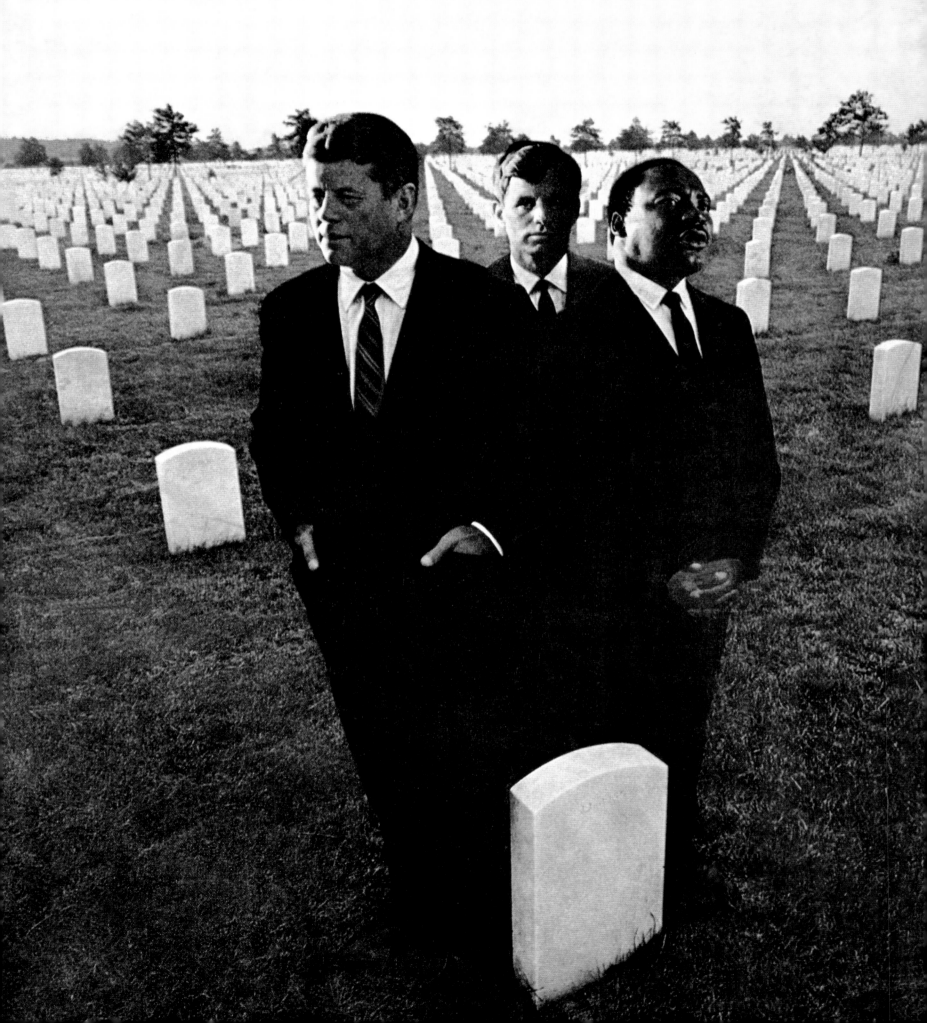

MY RELUCTANT PINUPS

THE COVER THAT TOOK OFF

To make up for my refusal to create
the expected monthly "cover girl" covers for the
leading magazine for men in America,
I went whole hog with a complete beauty pageant
on a 10x13 cover. The feature story dealt with travel,
so I invited 15 of the top international airlines in the world
to send me their hottest stewardesses.
In those Neanderthal days you *had* to be young
and a knockout in stiletto heels to work the aisles.
The 40 working girls had a good time,
and photographer Tim Galfas and I had an eyeful,
as we served cheesecake and coffee, tea or milk all around.
Inexplicably, it became one of Esquire's
biggest-selling issues on the newsstands.
Men, I swear, were actually choosing their overseas airlines
by the women on the cover!

FEBRUARY, 1964
PRICE 60c
GREAT BRITAIN 4/6

Esquire

THE MAGAZINE FOR MEN

Fly to Europe with the stewardess of your choice (below). On the way, read p.69

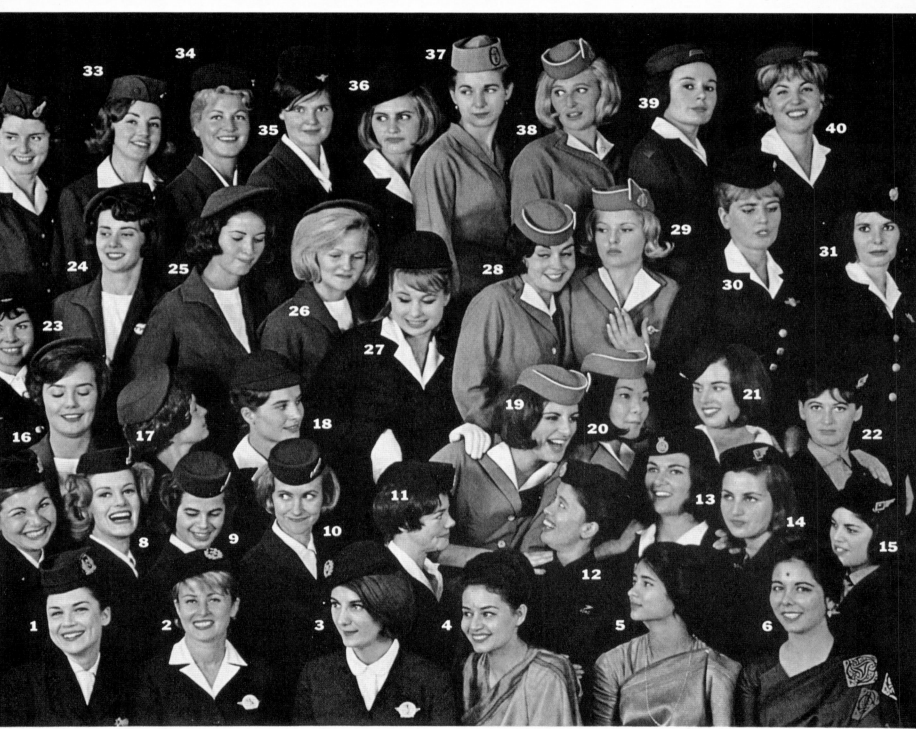

Ettie Housman, El Al

Eliane Gottlieb, Air France

Nicole Savoye, Air France

Zarine Vakil, Air India

Pushpa Nargolwala, Air India

Krishna Mahtani, Air India

Nily Eisner, El Al

Runa Brynjolfsdottir, Icelandic

9 Hildur Hauksdottir, Icelandic
10 Stefania Gudmundsdottir, Icelandic
11 Jill Wolff, BOAC
12 Helen D'Aquino, BOAC
13 Sherry Wing, BOAC
14 Albertina Castellani, Alitalia
15 Maria Monteforte, Alitalia
16 Marie Aspland, TWA

17 Joan Honold, TWA
18 Karin Krahmer, Lufthansa
19 Lillian Frizzole, Pan American
20 May Yasuda, Pan American
21 Jill Edwards, SAS
22 Carlotta Gunther, Alitalia
23 Rose Marie Maisonet, Iberia
24 Mary Lynn McCutcheon, TWA

25 Patricia Price, TWA
26 Bonnie Friesth, TWA
27 Helga Schenk, Lufthansa
28 Barbara Brennan, Pan American
29 Karin Weber, Pan American
30 Anita Appelgren, SAS
31 Irene Hval, SAS
32 Sheila Hansen, Irish Intl. Airlines

33 Una Madden, Irish Intl. Airlines
34 Thérèse Maton, Sabena
35 Danièle Vuylsteke, Sabena
36 Karin Steidle, Lufthansa
37 Barbara Keller, Qantas
38 Annette Carswell, Pan American
39 Doris Hegnauer, Swissair
40 Marlen Menzi, Swissair

VROOOOM

I held out almost three years before
I gave Esquire my second cheesecake cover.
When the holiday issue featured
the classic bikes men loved best,
I asked firebrand Claudia Cardinale if she
would mount a Triumph for me.
She hopped on like a pro, bellowed away
in her lush Italian tongue on all cylinders
and revved up a lot of engines.

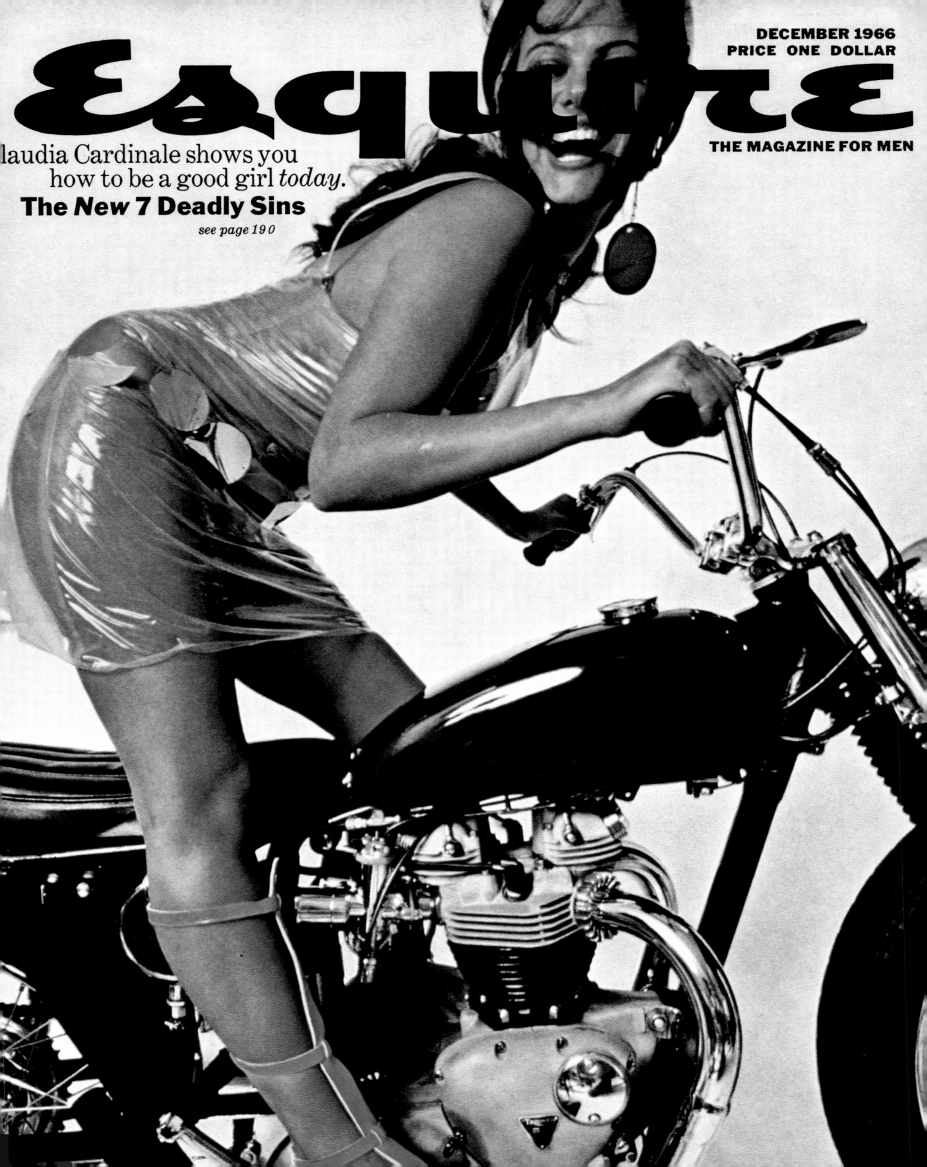

Esquire

laudia Cardinale shows you
how to be a good girl *today.*

The *New* 7 Deadly Sins

see page 190

DECEMBER 1966
PRICE ONE DOLLAR

THE MAGAZINE FOR MEN

"WHAT'S NEW, MR. LOIS, OL' BUDDY?"
"I GIVE UP, MR. HAYES.
I'M SENDING YOU A DAMN GIRLIE COVER."

From the very first cover I created for Harold Hayes,
Esquire newsstand sales and circulation grew dramatically.
Nonetheless, the ad sales gang at Esquire
bitched and moaned, fearful of my "controversial" covers.
Though ad pages also rose dramatically through the Hayes decade,
some of my covers scared some agencies into pulling their
monthly ads. But in the sexist '60s, the ad bunch was comfortable with
"girlie" covers, and hounded Hayes for Lois cheesecake.
Esquire owners, hoping for a pinup trend after the successful
Claudia Cardinale cover, pushed Hayes for yet another.
Though I tell my share of sexist jokes, Hayes knew I didn't intend
to harken back to Esquire's "dirty-old-man" Esky imagery.
So this Southern Baptist preacher's son, once again, politely
asked for tits and ass. He was under a lot of pressure, so I gave him one.
The inspiration for this unchivalrous Esquire cover was a joke:
A young Bronx housewife is hanging laundry on the
roof of her apartment house. She slips and falls off the roof,
landing head first in a garbage pail.
A Chinese laundryman walks by, spots her shapely legs
and peers down. "Americans very funny people," he says.
"In China, good for ten years yet."
As we all know, Asians venerate age, whereas the
"new American woman is through at 21!"
When Hayes slowly and indulgently pulled the cover
from the envelope and saw my stuffed tomato, he ate it up.
(But he never asked for a "girlie" cover again.)

Esquire

FEBRUARY 1967
PRICE 75c
GREAT BRITAIN 4/6

THE MAGAZINE FOR MEN

The New American Woman: through at 21.

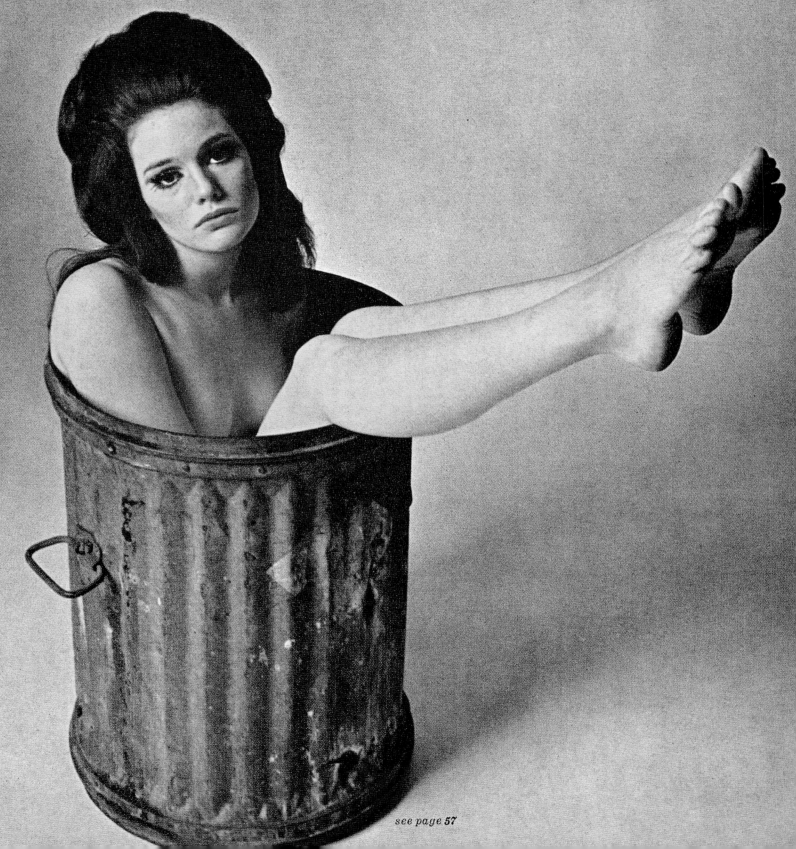

see page 57

MY SWEATY PINUP

In the '60s mine was known as the only ad agency in the world
that gave athletic scholarships. Before we hired
a new man I'd chuck a paperweight at him and study his reflexes
as he went for the weight. If he caught it with style
he was hired, otherwise he kept looking for work.
Fast-pitch softball and fast-break basketball were serious business at my agency.
Our softball team had, I swear to you, a higher-paid infield than the New York Yankees.
We didn't lose a game in three years in the advertising league
and moved up to the best semipro fast-pitch league in the city.
We produced the best basketball team in the annals of advertising, putting away
every ad agency and bank team in sight for four years, with only one loss.
Any guys at the agency too slow or too short to play placed tall bets on every game.
I played full court ball four times a week for 30 years
and took every pass, pick and rebound very seriously.
(I still play full court with the young studs every Saturday morning.)
So when Harold Hayes called me one day begging me,
pleading with me to play on his Esquire softball team for just one game,
I was wary about the quality of the game they played. I found myself
playing alongside writers like Gay Talese, Tom Wolfe and Norman Mailer
(great typing fingers, lousy hands) and, to my shock…women!
The first interminable innings revealed that the Esquire team didn't mind
losing by a dozen runs as long as they "had fun."
To me playing ball is not fun. It is a matter of life and death.
After taking our beating from The New Yorker (yes, The New Yorker!),
I consigned my Esquire T-shirt to a gym bag and never again
uttered the words "soft" or "ball" to Hayes.
A few months later, I heard more complaints from Esquire honchos about
the long absence of sexy females on the covers, so I retrieved
my gamy Esquire softball shirt and threw it on a game Candice Bergen.
Now that's my idea of co-ed sports, and my idea of a "girlie" cover.

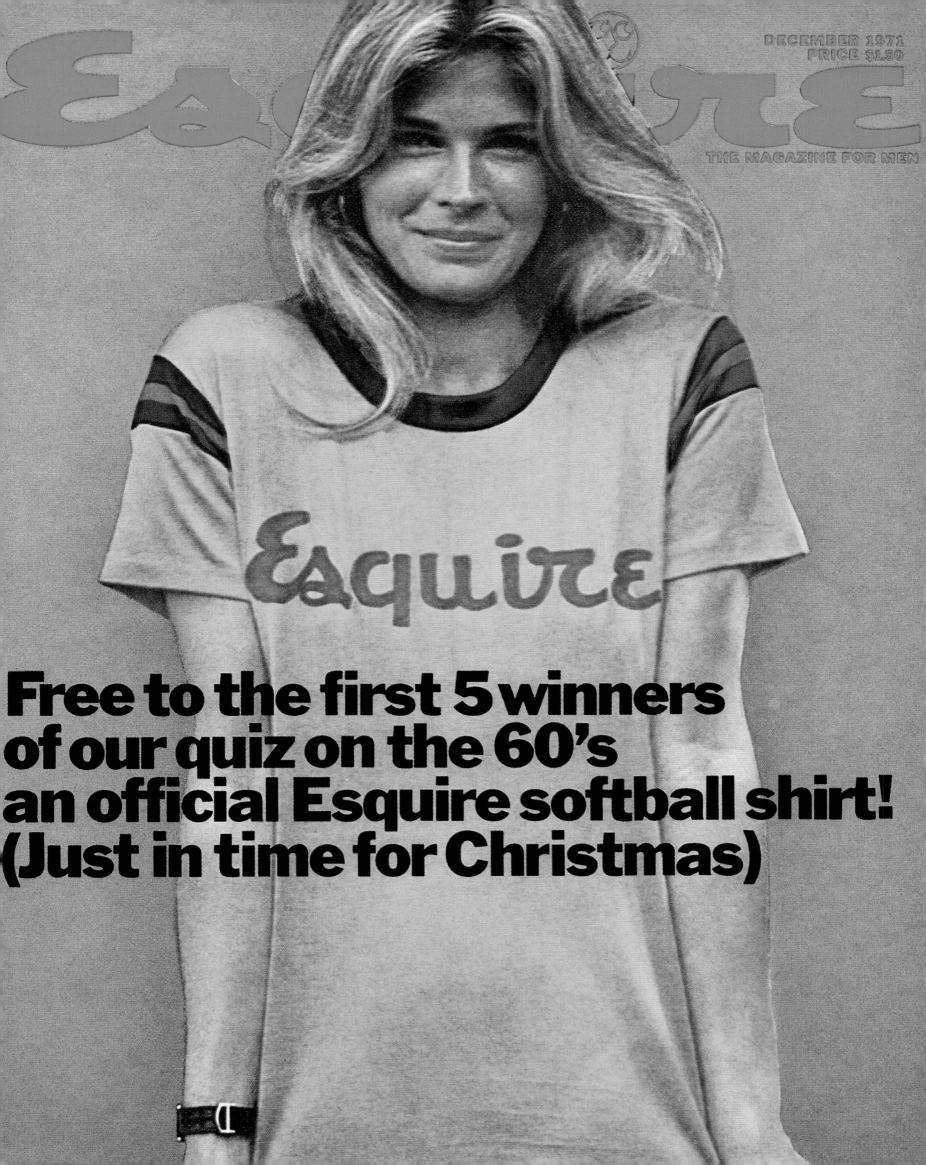

JACK NICHOLSON TAKES A DIVE

The manuscript was all about the high jinks of L.A.'s
Hollywood community. So I convinced the biggest movie star of them all
to be photographed, bareass. Since the story related how hotdogging
Jack Nicholson had greeted the writer wearing nothing but sandals
and a cigar, convincing the irascible rogue to pose in the buff was a cinch.
He loved my covers and wanted to support what he called
"the best magazine ever." Esquire's ad boys, of course,
once again thought "Lois has gone too far."
But this time, even as the covers were roaring off the high-speed printers,
management shouted: "Stop the presses!"
Nicholson hadn't told his agent he had agreed to pose, and the concerned agent
was threatening to sue the magazine. In 1972, nudity was no joke.
Well, when Harold Hayes called to say the owners had killed the cover,
I knew it signaled the end of an illustrious road for Hayes at Esquire.
Due entirely to Harold, Esquire was rolling in profits.
While enriching management, Hayes had single-handedly made the '60s
a glorious period for American journalism.
But now, with contemptuous hubris, the illiterate money boys
decided that *anyone* could edit Esquire. So they plotted
to kill two villains at once: by kicking Hayes upstairs to be publisher,
they would rid themselves of his editorial perfectionism *and* the tsuris of my covers.
Always his own man, Harold Hayes, in swift succession, elegantly
told Esquire's board of directors to kiss off, helped create and
became editorial producer of 20/20 for ABC-TV, served as the chief troubleshooter
for CBS Publications, created a matchless Ali-Frazier III fight program
(with me) and wrote three terrific books inspired by his passion for Africa:
The Three Levels of Time, The Last Place on Earth and *The Dark Romance of Dian Fossey.*
Hayes died of a brain tumor on April 5, 1989,
taken at the flood at the age of sixty-two, eternally undaunted,
sixteen years to the day after he left Esquire.

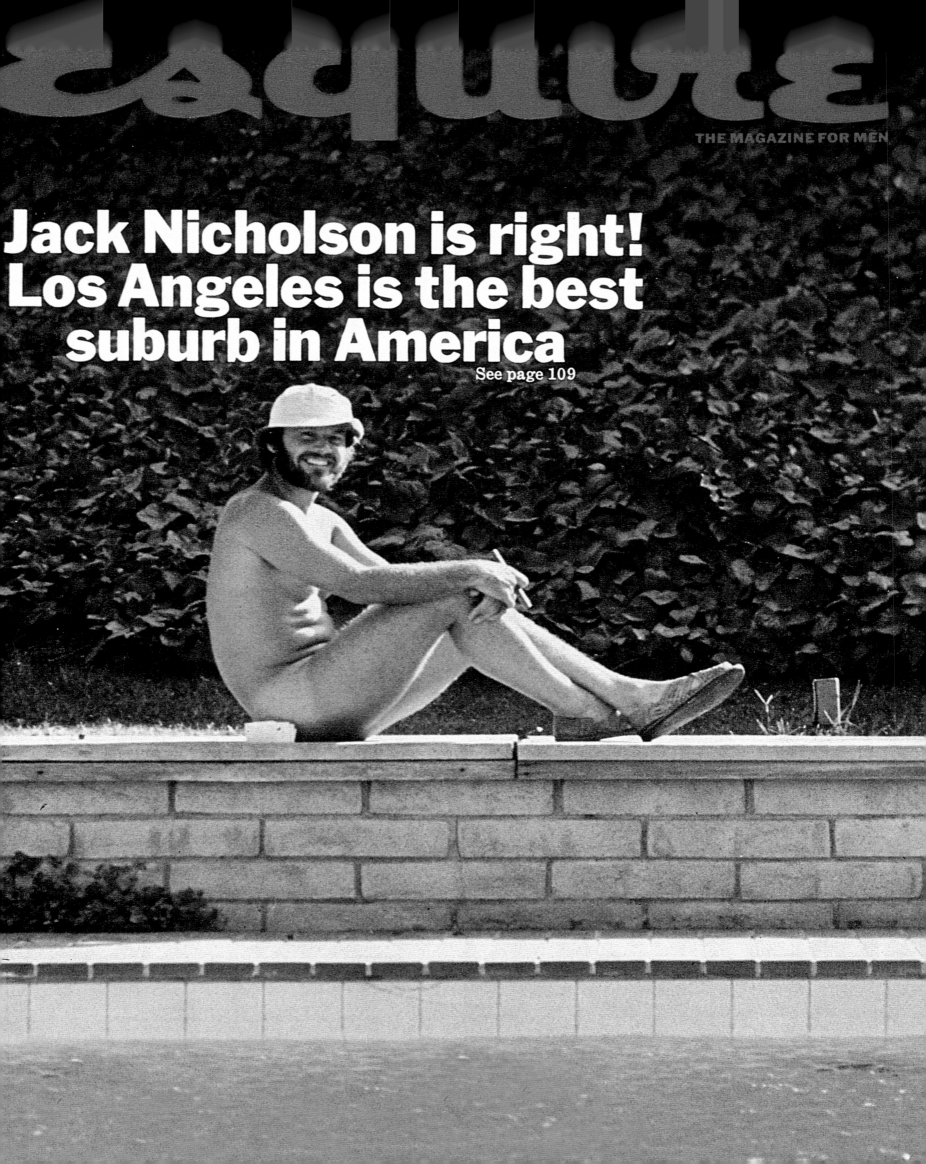

GEORGE PETTY AND ME

"No more Esky dirty-old-man covers!"
(Esky, Esquire's white-haired, pop-eyed playboy mascot,
presided over each issue, symbolizing the intent
of its editors, until the Hayes-led revolution of the '60s.)
For nine years, I had been hard-nosed about giving
Esquire covers more than a periodic touch of their old-time
titillation. But when Harold Hayes created
an issue on America's "happy" 1940s, I put a swinging
George Petty pinup on a swing-out coverfold.
Petty was pre-Vargas and a better designer of women.
When I was a youngster, his lush
American Dream Girls were right up there
with Botticelli's Venus, Rubens' flesh Goddesses,
Manet's picnicking nudes, Lachaise's She-women
and the immortal Betty Page.
Just putting my name next to the great George Petty
gave me a thrill.

Esquire

THE MAGAZINE FOR MEN

OCTOBER 1971
PRICE $1

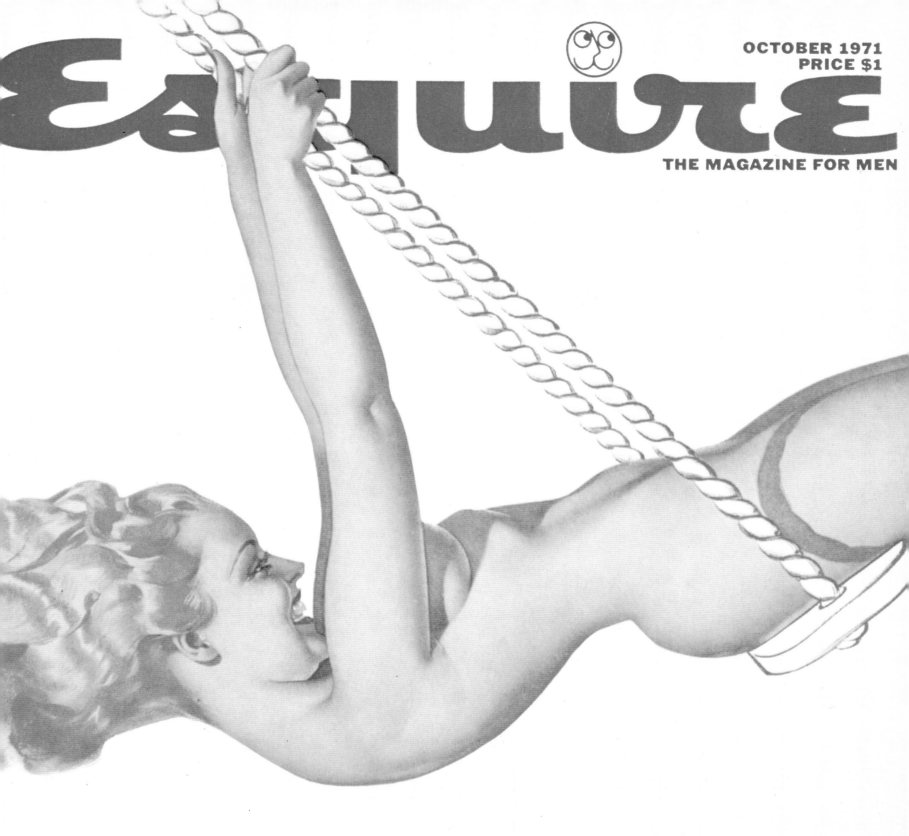

Welcome back to the 40's

The last time America was happy. See Page 98

RACE

TROUBLE ON ICE

In 1968, America once again anticipated a hot, troubled summer in that steamy time
of racial conflict and "civil disorders." The "White-Devil" diatribes of Malcolm X
and the fearsome threats of Huey Newton, Eldridge Cleaver and their Black Panthers
made clear to the white world that the black man, up to no good, had retribution
in his heart. And it was abundantly clear to the black man that the racist
society he grew up in would never blossom into Lyndon Johnson's proposed
"Great Society." The black man in America had no future. So when the
summer came, both jobless fathers and their neglected sons were in the streets,
fuming, fussing and firing. Ralph Ellison had previously written of the
"Invisible Man" of the '50s, but now that black man had become all too visible,
mugging in the alleys and rioting in the streets. White America, in its secret
and bitter heart, wanted black America to just go away. Isolation, assimilation, expulsion,
destruction: any means would do. Back in 1962, with John Kennedy
in the Oval Office and Americans congratulating themselves on having done
something about race relations, James Baldwin published *The Fire Next Time*,
foreseeing the rioting in the summer of 1964 in Watts, Newark, Detroit, Washington,
Chicago and other American cities. Esquire interviewed this powerful
and prophetic spokesman of the "Negro" two days after the funeral
of Dr. Martin Luther King, during a country-wide nightmare of riots and martial law.
Baldwin's biting, embittered and fatalistic attack on the white establishment
appalled the readers of Esquire. And my searing visual image of real life, ass-kicking
young black men, attempting to cool off in an actual Harlem ice house, added to the heat.
It infuriated both African-American leaders and white neighborhoods that feared
an all-out black revolution. It also scared the hell out of New York Mayor John Lindsay,
a no-show after he promised me he would pose in the shadows of the ice house
along with his seven young constituents.
Waiting in the eerie silence of the strangely beautiful ice-filled room, one of the
brooding young men finally chuckled: "You didn't really think that blond, blue-eyed
motherfucker had the balls to show up in our 'hood, did you, Georgie-boy?"

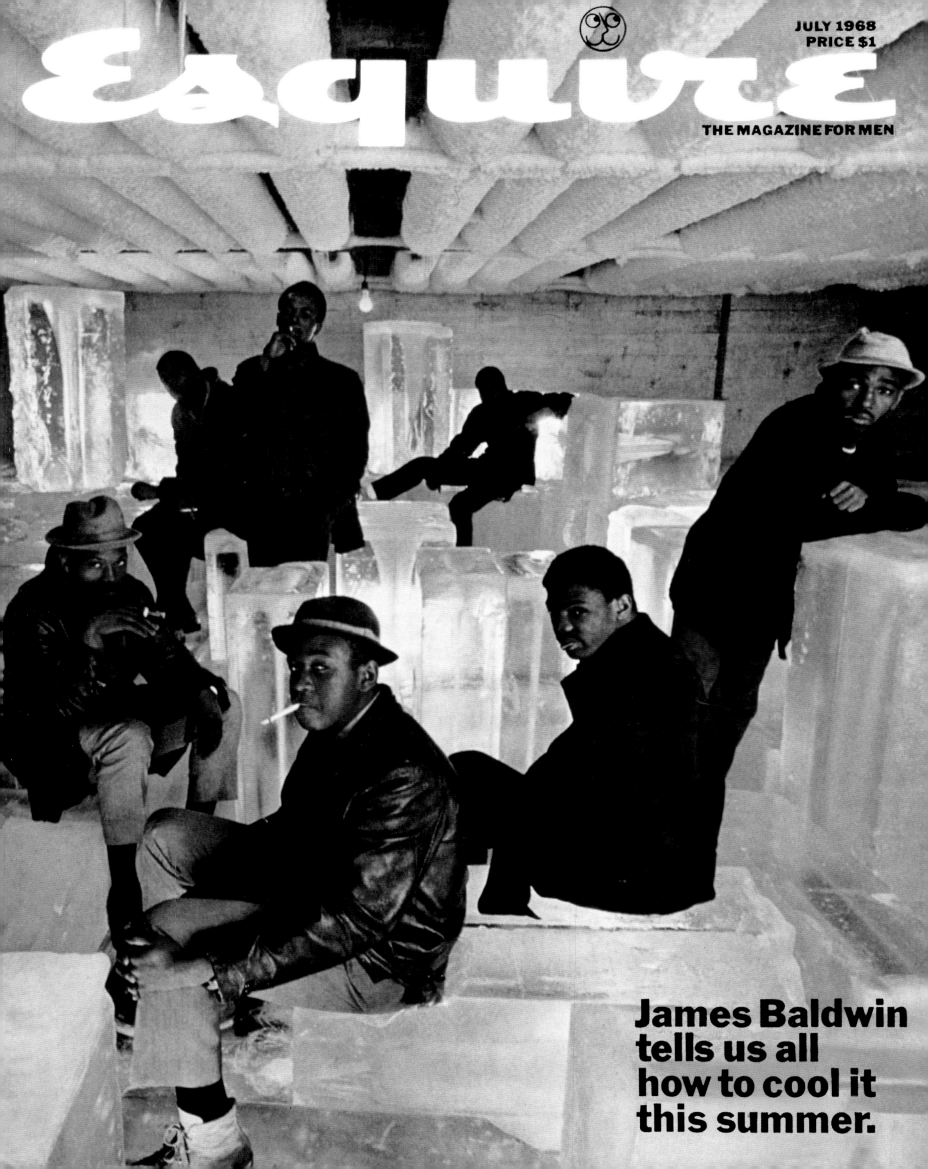

JULY 1968
PRICE $1

Esquire

THE MAGAZINE FOR MEN

**James Baldwin
tells us all
how to cool it
this summer.**

THE FIRST BLACK SANTA

Sonny Liston was perfect for the part. By now he was known by everyone
as the meanest man in the world. He was a sullen and surly champion, a "street nigger."
He had served time for armed robbery and didn't give a damn about his image.
This newest heavyweight champion of the world flaunted his surly,
menacing image at a time when rising racial fever dominated the headlines.
The early '60s were the years of Freedom Rides,
of Dr. Martin Luther King, of black revolution, of rising racial tensions.
I was looking into the eyes of a changing America.
I explained the idea of a black Santa to Liston's adviser and idol, Joe Louis.
"That'll be the day," said Joe skeptically, but he went ahead
and twisted Sonny's arm. For the shooting, Carl Fischer and I went to Las Vegas,
a place Liston called home because he was a notorious dice freak.
We got set up in a hotel room with Carl's photographic gear, ready to capture
the Western world's newest Santa and snapped the first shot.
But Sonny wouldn't stay put. He couldn't resist the crap tables in the lounge.
We snitched to Joe Louis. He lumbered over to Liston's table,
grabbed his ear, wrenched him around and led him back to the elevator.
"Git," he whispered in Sonny's ear. "Git!" Bent over like a puppy on a leash,
Liston returned to the room and we photographed the first black Santa
to our hearts' content. All hell broke loose when the cover came out.
Several advertisers took their money and ran. Subscribers demanded refunds.
Angry letters flowed in. Harold Hayes said that Sonny Liston
created more trouble than any cover since the invention of movable type.
But it set the spirit of the magazine for years to come. Sports Illustrated said:
"Four months after Liston won the title, Esquire thumbed its nose at its white readers
with an unforgettable cover. On the front of its December 1963 issue,
there was Liston glowering out from under a tasseled
red-and-white Santa Claus hat, looking like the last man on earth America wanted
to see coming down its chimney." And Time magazine described
the cover as "one of the greatest social statements of the plastic arts
since Picasso's *Guernica.*" Ho, ho, ho.

December 1963, Price One Dollar

Esquire
The Magazine for Men

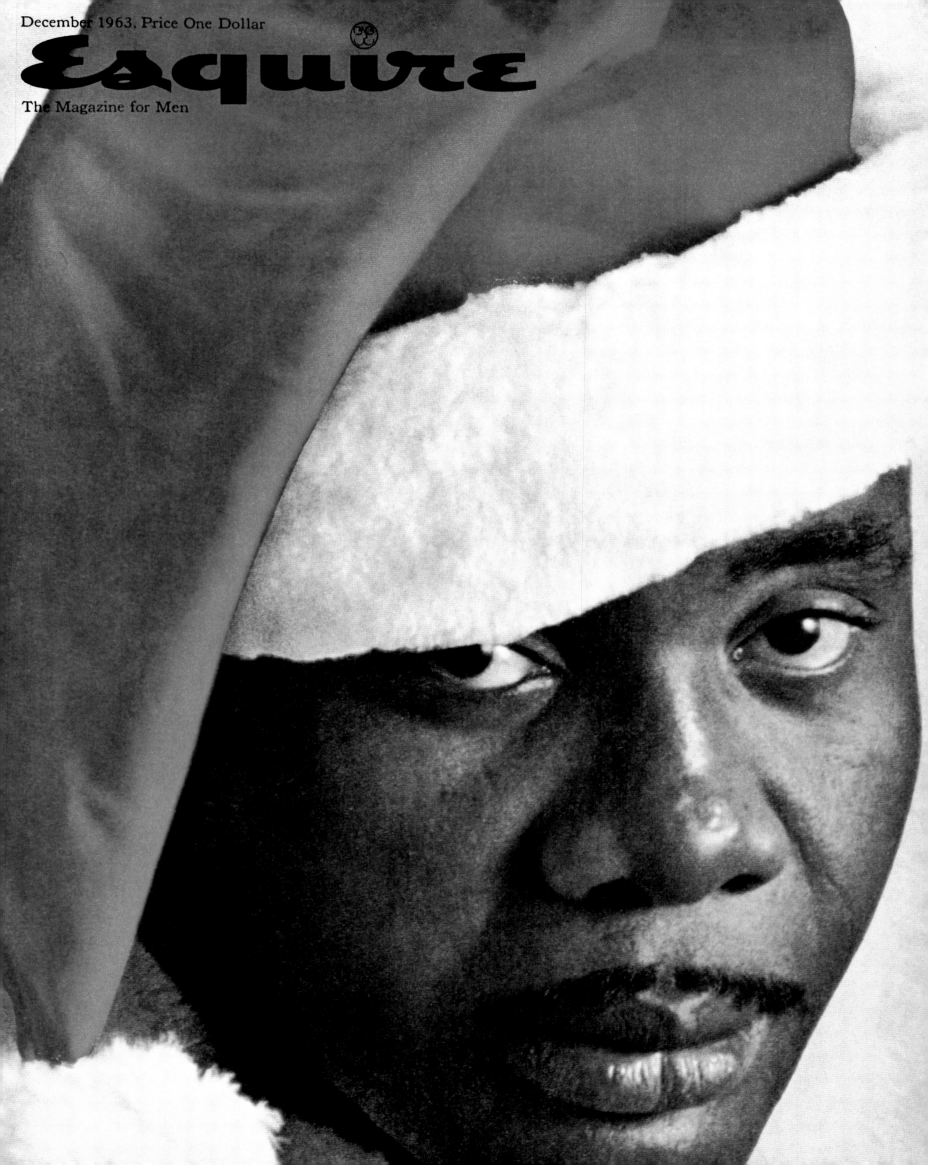

(WHY ARE THESE MEN LAUGHING?)
HAROLD HAYES AND GEORGE LOIS IN 1982,
REMINISCING ON THEIR ESQUIRE GLORY DAYS

MEANWHILE,

"I want my"

BACK AT THE AGENCY...

...I plugged away...every 14 hour day.
Continuing what I'd begun my first day on my first job:
fomenting an advertising Creative Revolution in America.
I *knew,* beyond any marketing fooferaw,
one million dollars could be transformed into *ten million* by advertising
based on a Big Idea that outrageously slices through
the clutter of ad messages and reaches the consumers where they live.
Every instinct told me that great advertising,
in and of itself, actually becomes a benefit of the product!
And I can prove it: great advertising can make
food taste better, cars ride smoother, a suit fit better.
As an advertiser, couldn't you *die* knowing there are
hundreds of products with humongous, multi-million dollar ad budgets
whose advertising is invisible.
(When you zap to a different channel when the commercials begin;
when you rifle through a magazine, past dozens of up-front ads...
you are turning your back on *billions* spent to get your attention.)
But the dreck doesn't stop you. Here and there are a few that succeed
because of a big budget or by combining misplaced
lust and nausea (Calvin Klein's child porn imagery). But only the tiniest
percentage truly treat people as if they're intelligent—
providing drama that gives them the chance to "get" the Big Idea,
falling in love with the advertising, and then adoring the product.
It was my *advertising* that caught Harold Hayes' roving eye.
He saw it was cutting edge, realized it was tapping
directly into (even anticipating) popular culture...
and was thrilled when he found that it also *worked.*
So, from that day we got together, every Esquire cover I created
was meant to stop a passerby in his tracks, then visually
and viscerally, force him to buy the latest Esquire that had just hit
the newsstands. At the same time, these covers both revealed
and enhanced Hayes' brilliant editorial breakthroughs.
So meanwhile, back at the agency, the Revolution hasn't abated.
And here's a smattering of that work, through four decades...
and right up to today.

PHOTO & ARTIST CREDITS

1. CARL FISCHER
2. STOCK PHOTO
3. CARL FISCHER/STAN GLAUBACH (MODEL)
4. ED SOREL
5. CARL FISCHER
6. CARL FISCHER
7. CARL FISCHER
8. STOCK PHOTOS
9. CARL FISCHER
10. CARL FISCHER
11. U.S. ARMY PHOTO
12. CARL FISCHER
14. CARL FISCHER
15. CARL FISCHER
16. CARL FISCHER/STAN GLAUBACH (PUPPET)
17. CARL FISCHER
18. CARL FISCHER
19. STOCK PHOTOS
20. CARL FISCHER
21. CARL FISCHER
22. CARL FISCHER
23. CARL FISCHER
24. IRA MAZER
25. FAMILY PHOTO
26. CARL FISCHER
27. ART KANE
28. CARL FISCHER/STOCK PHOTO
29. CARL FISCHER
30. TIMOTHY GALFAS
31. TIMOTHY GALFAS
32. CARL FISCHER/STOCK PHOTO
33. CARL FISCHER
34. TASSO VENDIKOS
35. ED SOREL
36. CARL FISCHER/STOCK PHOTOS
37. CARL FISCHER
38. CARL FISCHER
39. TIMOTHY GALFAS
40. CARL FISCHER
41. TIMOTHY GALFAS
42. CARL FISCHER/STOCK PHOTOS
43. TIMOTHY GALFAS
44. HAROLD KRIEGER
45. CARL FISCHER
46. CARL FISCHER
47. CARL FISCHER
48. STOCK PHOTOS
49. CARL FISCHER
50. CARL FISCHER/STOCK PHOTOS
51. TIMOTHY GALFAS
52. HAROLD KRIEGER
53. CARL FISCHER
54. STOCK PHOTO
55. CARL FISCHER
56. CARL FISCHER
57. TIMOTHY GALFAS
58. HAROLD KRIEGER
59. CARL FISCHER
60. CARL FISCHER
61. CARL FISCHER
62. CARL FISCHER/STOCK PHOTOS
63. TIMOTHY GALFAS
64. CARL FISCHER
65. CARL FISCHER
66. TIMOTHY GALFAS
67. TIMOTHY GALFAS
68. GEORGE PETTY
69. CARL FISCHER
70. CARL FISCHER

THANKS

In this pragmatic and commercial world,
where money talks and bullshit walks,
I've always depended on a "client" who truly digs
what I'm doing and shows his belief,
and doesn't mess with the work.
So my Esquire era was certainly a two-man tango,
and my lasting thanks must go to editor Harold Hayes,
who always let me lead on the dance floor.
My earthy, defiant, often ribald Esquire covers
that delighted some and outraged others,
exist because of me...
but they appeared solely because of Harold.
He shared my conviction that a big idea on a cover,
touched with insight, wit and freshness,
could make all the difference in selling a magazine.
In addition, I've got assorted thanks for many others,
like the many editors and writers for Esquire
who more than met the challenge
of their great managing editor to think and write
in a new, unique Esquire style.
(Without their work, my covers would have been
package designs for empty pages.)
For the decade that I turned out their covers,
Esquire had three different art directors:
Robert Benton, Sam Antupit and Richard Weigand,
each creating strong and intelligent editorial design.
Harold's decision to have me take over the
creation of covers may have been disappointing
to them, but I never heard a whimper
of complaint, and I belatedly thank them all.
Of course, a well-developed thanks to the photographers
(especially Carl Fischer and Timothy Galfas),
whose talent and technique helped nail down my ideas,
clearly, simply and powerfully.
Heartfelt thanks to Ron Holland, a brilliant writer
who still works side-by-side with me on ad campaigns,
who watched as covers came into being,
and pitched in with succinct advice.
A near lifetime of gratitude to Denny Mazzella,
who assisted me on each cover
(going on to become a great art director in his own right).
A full lifetime of love and devotion to my artist wife,
Rosie, who okayed every cover idea
before I produced them, dependably pressing me
to push each one to the cutting edge.
Extravagant appreciation to a constellation of stars
who willingly (or unknowingly) posed for my covers.
Ed Sullivan for wigging out,
Warhol for spoiling the soup, mean Sonny
as an even meaner Santa,
Ali posing as an infidel Christian, and yes,
even Nixon, for sitting still as we prettied him up.
For those who turned me down, I forgive you.
You were probably right.
Enduring recognition to my retired ad agency partner,
Bill Pitts, who wrote three books with me:
George, Be Careful, The Art of Advertising, What's The Big Idea?.
Much love to Emily Paxinos, my pluperfect assistant.
Yassou to Ted Veru, my partner and fellow Greek,
who runs our ad agency, Lois/USA,
with intelligence and compassion.
And a very current thanks to the Hearst Magazine
Division, which purchased Esquire in 1986,
for graciously permitting Gianfranco Monacelli to publish
this memoir of my Esquire adventure.
Plus a present-and-future thanks to Ed Kosner,
of New York magazine fame, a confessed
fan of my covers, who is now guiding Esquire
toward his '90s version of the glory of the '60s.